The Portrait's Subject

The Portrait's Subject

Inventing Inner Life in the Nineteenth-Century United States

Sarah Blackwood

The University of North Carolina Press CHAPEL HILL

Set in Merope Basic by Westchester Publishing Services
Manufactured in the United States of America

The University of North Carolina Press has been a member
of the Green Press Initiative since 2003.

Library of Congress Cataloging-in-Publication Data
Names: Blackwood, Sarah, author.
Title: The portrait's subject : inventing inner life in the nineteenth-century
 United States / Sarah Blackwood.
Other titles: Studies in United States culture.
Description: Chapel Hill : University of North Carolina Press, [2019] |
 Series: Studies in United States culture | Includes bibliographical references
 and index.
Identifiers: LCCN 2019016541 | ISBN 9781469652580 (cloth : alk. paper) |
 ISBN 9781469652597 (pbk : alk. paper) | ISBN 9781469652603 (ebook)
Subjects: LCSH: Portraits, American. | Identity (Psychology) in art. |
 Identity (Psychology) in literature. | Psychology and art.
Classification: LCC N7593 .B57 2019 | DDC 704.9/42—dc23 LC record
 available at https://lccn.loc.gov/2019016541

Cover illustration: Valerie Hegarty, *Red Curtain 7*, 2015, watercolor on paper,
9 × 12 in. Courtesy of the artist.

Portions of chapter 2 were previously published in a different form as "Fugitive
Obscura: Runaway Slave Portraiture and Early Photographic Technology,"
American Literature 81, no. 1 (2009): 93–125. Portions of chapter 4 were
previously published in a different form as "Isabel Archer's Body,"
Henry James Review 31, no. 3 (Fall 2010): 271–79.

Contents

Figures

Acknowledgments

This project has no single origin point. Maybe it started during the hours I spent in the vault at the Terra Museum of American Art, where I worked in the registrar's office. Or maybe it started in Nina Baym's intensive Henry James graduate seminar, or during an important brief conversation I had with Carl Smith about Lawrence Selden and Lily Bart, where we mostly nodded excitedly at one another in agreement. Just as likely, however, it began in middle school, when I realized that pictures of me did not always feel like me, except for the rare moments they *really* did. Or even more recently, in the time I spend looking at pictures of my children, wondering what I'm seeing.

No matter where I locate this book's beginning, my first thanks go to Betsy Erkkila, Carl Smith, and Jay Grossman who helped me shape it. At Northwestern University and the University of Illinois, I was given support, encouragement, intellectual challenge, and sound advice from Betsy, Carl, and Jay, as well as Ivy Wilson, Julia Stern, Chris Lane, Jennifer DeVere Brody, Blakey Vermeule, Wendy Wall, Brian Edwards, Stephanie Foote, Michael Bérubé, and Tim Dean. A gallery of good cheer and fellowship hung all around me during those years, and I would especially like to thank for that Sarah Mesle, Katy Chiles, Peter Jaros, Marcy Dinius, Joanne Diaz, Gayle Rogers, Dan Gleason, Matt Peck, Jenny Mann, Janaka Bowman, Liz McCabe, Catherine Carrigan, Hunt Howell, Abram Van Engen, Wendy Roberts, Ed McKenna, Rochelle Rives, Scott Herring, Dahlia Porter, and Gabe Cervantes.

This book has benefited from the time granted me in archives and museums, and with fellow scholars of American visual culture. My time as a Patricia and Philip Frost Fellow in American Art and Visual Culture at the Smithsonian American Art Museum was invaluable and I thank Eleanor Harvey, the late Cynthia Mills, and Amelia Goerlitz at SAAM; Wendy Wicke Reaves at the National Portrait Gallery; and my "fellow fellows" at SAAM: Miguel de Baca, Megan Walsh, Leslie Ureña, Sascha Scott, Anna Marley, and Kate Elliott. Kriston Capps made my sojourn in DC feel like home. As a participant in the NEH Summer Institute on the Visual Culture of the Civil War, I had the opportunity to learn from Donna Thompson Ray, Joshua

Brown, Sarah Burns, Greg Downs, David Jaffe, Deborah Willis, Anthony Lee, and Ellen Gruber-Garvey, as well as Aston Gonzalez, Heidi Knoblauch, Catherine Jones, and Molly Mitchell. I thank the librarians, archivists, and curators at The Phillips Collection, SAAM, the American Antiquarian Society, the New York Public Library's Berg Collection and Division of Art, Prints, and Photographs, the Schomburg Center for Research in Black Culture Photographs and Prints Division, the Metropolitan Museum of Art, and the Brooklyn Museum of Art for helping me track down leads and open up new vistas.

Audiences at the McNeil Center for Early American Studies, the New York Public Library, the University at Albany, SUNY, Pomona College, the CUNY Graduate Center, and Harvard University have been provocative interlocutors at different stages of this project. I thank, for inviting me to share with these venues, Megan Walsh, Wendy Roberts, Kyla Wazana Tompkins, Duncan Faherty, and Charmaine Nelson.

At Pace University, I have been blessed to find friends, not only colleagues. Endless gratitude to the denizens of the fifteenth floor: Catherine Zimmer, Sid Ray, Stephanie Hsu, Erica Johnson, Kelley Kreitz, Lauren Cramer, Helene Levine-Keating, Ebele Oseye, Mark Hussey, Gene Richie, and honorary members, Matthew Bolton and Emily Welty. Tom Henthorne, you are so missed. I am grateful for Pace English Professor Emerita Jean Fagan Yellin's work on Harriet Jacobs, every day. Thanks also to the unflagging support of Dean Nira Herrmann, and the invaluable assistance of Carol Dollison. To my students, always balancing work, family, and passion: you blow me away. Thanks especially to my former student Yahdon Israel for unscrewing the doors from the jambs.

All of the knowledge I've pursued over the years would go nowhere without the people who have helped me hone my writing. Thanks to the writers, editors, and Twitter pals who have kept me grounded and, hopefully, concise: Anna Beth Chao, Sarah Bunting, Tara Ariano, Sarah Smith, Daisy Parente, Elda Rotor, Naomi Fry, Silvia Killingsworth, Dan Kois, Jessica Winter, Laura Marsh, Jane Hu, Evan Kindley, Phil Maciak, Stephanie Insley Hershinow, Emily Gould, Meaghan O'Connell, Kathryn Jezer-Morton, and Rumaan Alam. Thank you also to all of the writers who have shared their knowledge and vision with us at *Avidly* and *Avidly Reads*. I am so proud of our collective work. And, to my writing and editing partner, Sarah Mesle: we found love in a Google Doc.

Thank you to Jordan Stein, Janet Neary, Michelle Chihara, Greta La Fleur, Laura Fisher, Brian Connolly, Glenn Hendler, Duncan Faherty, Teresa

Goddu, Paul Erickson, Gus Stadler, Britt Rusert, Jasmine Cobb, Lara Langer Cohen, Toni Jaudon, Dana Luciano, Elizabeth Freeman, Stephanie Foote, Pam Thurschwell, Eric Lott, Shawn Michelle Smith, and many others who make thinking and writing about nineteenth-century U.S. cultural studies so pleasurable. The key to surviving this profession is not only to find your people but also to make new spaces together: scholarly associations, group texts, conference hotels, writing groups and retreats. Thank you to Hester Blum for co-founding C19: Society for Nineteenth-Century Americanists; and to Hester, Kyla Wazana Tompkins, Claire Jarvis, and Sarah Mesle for their gallows humor and good advice; to Lauren Klein, Kyla Schuller, and Karen Weingarten for our especially human and humane writing group; to Marcy Dinius, Peter Jaros, and Katy Chiles for such trusted companionship; to Stefanie Sobelle and the yurts for air and space to breathe. Thank you also, and always, to Pete Coviello: a true friend through it all.

At the University of North Carolina Press, Mark Simpson-Vos and Jessica Newman have been steady editorial hands, generous with their line edits, vision, and more. Grace Hale sent me a wonderfully bolstering note at exactly the right time. My deepest gratitude goes to my anonymous readers, whose reports were exacting and kind. The marketing, publicity, and design team have done the near impossible in getting this book out of my mind and into the world. Thank you also to Margaretta Yarborough for proofreading and Pamela Gray for preparing the index. Contemporary artist Valerie Hegarty, whose art brilliantly reworks commonly held ideas about United States history and culture, created the evocative painting on the cover.

To my dearest friends and family, thank you for not being academics! Lauren Waterman, Margaret Richardson, and Sarah Gallagher are, simply, my best friends and favorite people. My parents David and Elizabeth, and my brothers Dave and Dan and their families, have supported and cheered me on, no matter what strange thing I have chosen to obsess over, from ballet to poetry to graduate school. I owe you all everything.

And, finally, Edward, Ames, and Owen: you have always made me feel seen, just as I am. No words or images could ever capture that feeling, but I'm happy to keep trying.

Acknowledgments xi

The Portrait's Subject

Introduction

In the Portrait Gallery of American Literature

Lily Bart has made a mistake.

Midway through Edith Wharton's tragic 1905 novel *The House of Mirth*, Bart attends an important party. The hosts of the party, the Wellington Brys, are giving a "general entertainment" that will feature a *tableau vivant*—society women posed, costumed, and dramatically lit for the viewing pleasure of the partygoers—organized by the famous (fictional) portraitist Paul Morpeth. Lily Bart is a beauty from a good, old family with social status but no money; penniless, she clings precariously to the luxurious New York society life that has shaped her. To survive she needs to find and marry a rich man; she must comport herself at all times accordingly. Her performed portrait will be scrutinized by the party attendees who can make or break her.

Bart recognizes the stakes, and yet sees the *tableau vivant* as a chance for her "vivid plastic sense" to find "eager expression in the disposal of draperies, the study of attitudes, the shifting of lights and shadows."[1] She believes that by presenting herself to an audience as a portrait—as a work of art— she will have license to play and to ply with her famous beauty, and chooses to dress herself in a scandalously gauzy white dress, modeling herself after the 1776 Joshua Reynolds portrait *Mrs. Lloyd*. Her performance is a declaration of independence in the face of extreme social pressure to conform.

While an aesthetic triumph, Bart's performance is ultimately a personal disaster. She has failed to appreciate the specific form her audience's scrutiny will take. Bart thought she was showing off her posture, the graceful curve of her neck, even her freedom and pliability. But her audience sees something different, something deeper; they look at Bart's performance and see what they perceive to be her "real" self. Her love interest, the bookish bachelor Lawrence Selden, revels in what he believes is her brave authenticity, "divested of the trivialities of her little world."[2] His cousin Gerty indulges in the sense that Lily's performance reveals a truth that Gerty alone is privy to: "It makes her look like the real Lily—the Lily I know."[3] And Bart's voyeuristic cousin Ned Van Alstyn looks through her performance in search of provocative intention: "Deuced bold thing to show herself in that get-up; but, gad, there isn't a break in the lines anywhere, and I suppose she wanted us to know it."[4]

Bart had hoped that her performed portrait would reinvest the principal of her surface beauty; instead, it invited a form of penetrating vision in search of something true about her subjectivity. And so here was Lily Bart's mistake: she thought she and her audience would be on the same page, enjoying how portraiture allowed one to play around with surfaces, likeness, texture, shape. But by 1905, in the United States, portraiture had become enlisted in the project of imagining psychological depth. For a woman like Lily Bart— darting, fearful, desirous in all the "wrong" ways—becoming suddenly penetrable to interpretation was no triumph. Her slow slide downward toward her death begins that night, with her mistake about the power of portraiture.

This book tells the story of how that power developed. Cultural ideas about portraiture shifted dramatically between 1839 and the end of the nineteenth century in the United States. During this period, the United States was awash in portraiture, both literal and imagined: in novels, magazine stories, newspaper mastheads, advertisements, author portraits, early psychology textbooks, phrenological head charts, daguerreotypes, oil portraits, X-ray images, and more. This book examines how portraiture's changing symbolic and aesthetic practices helped produce new ideas about human interiority. I analyze how proliferating representational images of the human body, the soma, began to characterize inner life as "deep." Through readings of the literary, material, and visual culture of the era, I uncover how portraiture's aesthetic representations of the self relate to its emerging psychological explanations. I argue that portraiture not only reflects changing ideas about the self; it produces these ideas by imaginatively shaping and probing the relationship between body, soul, and mind.

THE FICTIONAL LILY BART was in 1905 caught up in a moment not unlike our own. Today we are confronted with new questions about what visual representations (and the new visual technologies that produce them) tell us about human subjectivity. I open with a narrative account of a *tableau vivant* gone wrong because it captures how the cultural values associated with portraits seep into multiple interpretive contexts: aesthetic interpretation, the possibilities of sociability, the ever new "sciences" of the self. The *tableau vivant* is a specific and idiosyncratic form of art in its own right; but, as Lily Bart's choice to emulate the Reynolds portrait makes clear, the germ animating the scene's main conflict is portraiture's longstanding central role in mediating often contradictory ideas about human subjectivity. Lily Bart's failed portrait of herself hangs next to the original *Mrs. Lloyd* in the portrait gallery

of American literature, asking us to consider historical shifts in how we understand the relationship between the self and its visual representation.

Portraiture's representations of surface likeness played a key role in imagining new forms of inner life over the course of the nineteenth century. The relationship between portraiture's representation of human exteriors and shifting ideas about human interiors is not new or historically unique to the era this book addresses. The competing claims of portraiture to represent external appearance accurately *and* to express something deeper about a person that goes beyond mere likeness have long been in tension. But when daguerreotype photography was introduced in the United States in 1839, this tension found new expression. Here was a visual technology that would allow exact representation of external appearance. And yet, should it *only* aim for accuracy? This was a question that thinkers, writers, and artists circled around for much of the era I study.

Painter and daguerreotypist Marcus Aurelius Root attempted an answer in *The Camera and the Pencil, or the Heliographic Art* (1864), one of the first histories of American photography. He explains, "In the course of this work I have repeatedly and most emphatically urged that expression is *essential* to a portrait, whether taken with a camel's hair pencil, or with the pencil of the sun. Nor can this point be pressed too often or too forcibly. For a portrait, so styled, however splendidly colored, and however skilfully finished its manifold accessories, is worse than worthless if the pictured face does not show the *soul* of the original—that *individuality* or *selfhood*, which differences *him* from all beings, past, present, or future."[5] Importantly, Root connects painted and photographic portraiture, emphasizing the importance of genre over medium. He believes that the goal of a portrait should be the same "whether taken with a camel's hair pencil [paintbrush], or with the pencil of the sun [camera]." But what should that shared goal be? Root offers a number of answers: "*soul*," "*the original*," "*individuality*," and "*selfhood*." His list is meaningfully slippery and worth further analysis: how does a portrait come to show "soul"? How will artists and viewers know those things when they see them? Perhaps most importantly, what even *are* these metaphysical qualities, and how did we come to agree that they are, or ever can be, *visible*?

In this book, I probe the spaces between related but not synonymous words like "soul," "individual," and "selfhood." In doing so, I theorize the role of the portrait in offering up a new vision of human subjectivity in the years between the invention of photography and the discovery of the X-ray in 1895.[6] Though I demarcate this study's boundaries with the invention of these

two visual technologies, I do not make its claims about portraiture according to medium or technological innovation. Rather, I begin in 1839 because after that year portraits came within reach of large numbers of Americans, quickly becoming one of the most common culturally expressive forms a middle-class person would encounter. The increasingly *common* experience with photographic portraits—sitting for them, viewing them, even taking them—resulted in a popular, literary, and artistic fascination with what portraits tell us about individuals. I contend that the conjoined effects of nineteenth-century literature's obsession with portraits and the simultaneous explosion of the form's availability to everyday people encouraged new ways for readers and consumers to *imagine* themselves, and the characters that portraits conjured, as subjects with interiority.

Throughout this book, I account for the cultural centrality of the nineteenth-century portrait *in multiple verbal and visual expressive forms*. In the pages that follow, I consider both portraits and representations of portraits in literary and other forms. Recognizing the important material differences between literal and imagined portraiture, I also assert the important similarities between disparate objects crafted within the same representational economy. Art historians generally reserve the term "portrait" to describe a work of art that visually depicts a real individual.[7] But this limited definition does not allow for a full exploration of the omnipresence of portraiture in nineteenth-century American culture. How should we understand the hundreds of short stories featuring portraits of fictional characters that were published? What role did cultural commentary on the symbolic function of portraiture in the nineteenth-century play? Is it possible to consider a daguerreoytpe portrait, a painted portrait, and a textual description of a portrait in a novel together? By not limiting my study of portraits by medium or generic form I have been able to provide a more nuanced account of the many ways portraits came to furnish meaning for nineteenth-century writers and artists, viewers and readers. In short, this book approaches portraiture as a *method* rather than as a set of objects.

Considering portraiture as a method also allows us to understand more fully why portraits were so compelling for writers and artists in the nineteenth century: as a way to both explore the changing relationship between external appearances and inner life *and* shape that relationship through the repeated picturing forth of new aesthetic hypotheses regarding subjectivity. The portrait offered a remarkably useful surface upon which to consider the relationship between exterior and interior, a relationship that also preoccupied thinkers central to the burgeoning new discipline of psychology dur-

ing the same period. The parallel evolution of portrait conventions and psychological explanations of selfhood is vitally important but has generally been ignored. As I will argue, portraiture was a major engine driving the development of new ideas about human interiority during the nineteenth century: exponentially replicating images of external appearances inspired inventive aesthetic rumination about interior life.

The lively variety of portraiture as a method is often flattened in critical discussions. Scholars commonly look *through* portraits, in order to find out more about the person depicted, the world in which they lived, or the artist "behind" them. Portraits are also often analyzed in relation to major aesthetic shifts in figurative representation (for example Pablo Picasso's 1910 *Portrait of Daniel-Henry Kahnweiler* or Cindy Sherman's groundbreaking late twentieth-century self-portraits). Yet when critics and scholars frame portraiture as illustrative and conventional, rather than as inventive, the agility of its speculative method gets lost or deemphasized. Portraiture—in its textual and visual manifestations—is always a mediating aesthetic. It does not merely illustrate or depict already existent ideas about the self. Nor does it merely express already-established beliefs about the relationship between surface and depth. Rather, portraiture also always calls attention to and makes visible the process by which that relationship comes to be through aesthetic representation. Portraits are often exercises in meta-representation. That is, they are representations of the concept of representation itself.[8] And because the subject/object of portraiture is nothing less than the human itself, these refracted representations are always already redrawing the boundaries of subjectivity, and reconfiguring the relationship between inner life and external appearance. When portraiture is considered as a method, rather than a genre or discrete set of objects, we are better able to see the extent to which portraiture does not merely reflect or record, but rather crafts new frames, new structures through which subjectivity comes into focus.

The Spectacle of Expression

These new frames and structures are often difficult to describe or name. We see this specifically in the case of the term "expression," to which nineteenth-century writers often turned in order to describe an almost unnamable "something" that is pictured forth upon a person's face. Portraiture asserts the significance of "expression"—or the bringing forth of the invisible human interior onto a visible, exterior surface—but refuses to define what it is.

Nineteenth-century writers and artists considered "expression" as a contact point between external appearance and inner life. As we saw above, Root asserts that expression is "central" to portraiture. And yet, nineteenth-century discourse about what portraiture's expressive function was shares an intentional vagueness around what expression *is*. The narrator of Edgar Allan Poe's 1838 short story, "Ligeia," exclaims about the term "expression," "Ah, word of no meaning!"[9] Though writers and artists may have agreed that portraits should and do go beyond representing mere likeness, what did that beyond look like? Perhaps even more urgently, what can we even call the beyond that portraiture is supposed to picture forth? Character, animation, essence, disposition, "another sense . . . something besides the mere physical," "a bit of nature," even "inner likeness" are just a few of the descriptions writers in the era employed.[10] Rather than note that these terms are diffuse, and thus of little use in tracing clearly the evolution of the new subject of portraiture, I would argue that these terms are revealing precisely because they *were* so diffuse. That is, writers and artists were unsure of what to call the inner life that portraits were supposed to represent because they were in the process of constructing it.

Importantly, a discipline whose name would come to function as an umbrella term for "inner life" was developing at the same time. Psychology, in its initial nineteenth-century manifestation, meant to bring some order to this rhetorical chaos. Discourses on the "soul" would be replaced by those on the "mind." Subjectivity would become understood as located in the mind rather than the soul, governed by both conscious and unconscious processes, a function of the brain's capacities for thought, reason, and perception. "Character" would give way to "individuality" or "personality" as significant terms.[11] Indeed, the terms "psychology" and "the psychological" caught on almost as quickly as did photography in this era, and psychological understandings of selfhood rapidly became naturalized. Writing in 1913, Henry James recalled seeing a painting by Paul Delaroche in the 1850s: "I had never heard of psychology in art or anywhere else—scarcely anyone then had; but I truly felt the nameless force at play here."[12]

As it was articulated by scientists and explored by writers and artists across the nineteenth century, thought about human inner life produced a wild intellectual landscape. Often unduly dismissed by scholars and historians of science as "pseudo" or "proto" or "pre" (pre-modern, pre-Freudian), the rich somatic theories about inner life that held sway in the nineteenth century sit weirdly adjacent to the contemporary resurgence of the somatic in psychological study today (consider current pop-psychological language around

"the gut" as a "second brain"[13]). Yet I am interested in thinking through these theories of inner life, not on the way to somewhere else (usually, the story about nineteenth-century psychology drives headlong toward Freud), but because these ideas were so rich in their own right. Some somatic nineteenth-century theories that this study will attend to include phrenology, vitalism, materialism, nervousness, electrical psychology, neurasthenia, and hysteria. These raucous theories about inner life have a unique and underappreciated connection to the similarly raucous visual culture of portraiture's representations of inner life across the nineteenth century.

An example here will help. Nearly seventy years before Henry James remarked that he could "feel" the "nameless force" of psychology at work in Delaroche's figurative painting, Walt Whitman published a suggestive ode to portraiture on the front page of the *Brooklyn Daily Eagle*. "A Visit to Plumbe's Gallery" (1846) describes Whitman's experience visiting one of the many daguerreian galleries lining Broadway in mid-century New York City, celebrating the "spectacle!" of a space where "[i]n whatever direction you turn your peering gaze, you see naught but human faces." Whitman wonders "what tales might those pictures tell if their mute lips had the power of speech!"[14] The muteness of the depicted person, it seems, is productive, as it allows viewers and readers to imagine themselves into a sitter's inner world.

Whitman's editorial demonstrates how photographic technology provided the ground upon which writers and artists, readers and viewers could consider the significance of portraiture to changing understandings of inner life. But like many writers in the era, Whitman does not merely comment on the technical or aesthetic specifics of daguerreoytypy. Rather, he slips easily into a consideration of the portrait form writ large:

> There is always, to us, a strange fascination, in portraits. We love to dwell long upon them—to infer many things, from the text they preach—to pursue the current of thoughts running riot about them. It is singular what a peculiar influence is possessed by the *eye* of a well-painted miniature or portrait. —It has a sort of magnetism An electric chain seems to vibrate, as it were, between our brain and him or her preserved there so well by the limner's cunning. Time, space, both are annihilated, and we identify the semblance with the reality. —And even more than that. For the strange fascination of looking at the eyes of the portrait, sometimes goes beyond what comes from the real orbs themselves.

The portrait, here, is a form that goes beyond likeness or technical artistry to potentially enliven the long dead and physically transport the geographically distant. Using the vitalist language of the day—"magnetism," "current," and "electric"—Whitman proposes a relationship between the aesthetic form of the portrait and the "brain[s]" of the viewer and the sitter.[15] The depiction, viewer, and subject collude to produce new ideas about "the brain," which ultimately exceed the "reality" of the figure depicted and "go beyond" literal depiction. Whitman emphasizes the magnetic and electrical connection between the brain of the depicted and the brain of the viewer. It is notable that, in this description of how fascinating portraits can be, Whitman does not yet employ the language of depth: the currents, magnets, chains, vibrations, pursuits, and inferences evoked by the viewing experience coalesce into a dynamic surface exchange between viewer, image, and represented subject. The language of depth used to describe portraiture's representations of authentic, unseen, hidden inner worlds of the human will develop later in the century, but this example demonstrates how the metaphors used to describe or understand inner life (from humors, to electricity, to genes) have the potential to shape the reality of individuals' experiences of inner life (the "semblance" becomes "the reality"). If the ability to express, or represent, inner depth was not yet a value Whitman found in portraiture, the logic of his idiosyncratic celebration of portraiture—which establishes a relationship between semblance and reality—signals how such a value might come to be as powerfully restructuring as the century progressed.

Inventing Psychology

In asserting that the emergence of psychology in the United States was compelled by writers' and artists' fascination with the portrait, I am *not* claiming that nineteenth-century portraiture invented human interiority or selfhood. As Lionel Trilling wryly notes in the preface to *The Opposing Self* (1955), "whoever has read any European history at all knows that the self emerges (as the historians say) at pretty frequent intervals."[16] My argument is not concerned with identifying the origins of interiority (as if that were possible) but rather with the ever-evolving ways that inner life has been represented through aesthetic form. Further, this study—unlike many others that deal with "interiority" in United States literature and art—narrows its focus upon how the terms specific to a particular type of interiority emerged: psychology.

The Oxford English Dictionary provides an informative record of the emergence of psychology. It defines psychology serially as:

1. The study or consideration of the soul or spirit.
2. a. The scientific study of the nature, functioning, and development of the human mind, including the faculties of reason, emotion, perception, communication, etc.; the branch of science that deals with the (human or animal) mind as an entity and in its relationship to the body and to the environmental or social context, based on observation of the behaviour of individuals or groups of individuals in particular (ordinary or experimentally controlled) circumstances.

The dates of these disparate definitions trace the historical shift in the word's meaning. The examples for the first definition are drawn mainly from the seventeenth and eighteenth centuries. Those for the second definition are drawn from the nineteenth and twentieth. The relocation of human subjectivity from "the soul or spirit" to "the human mind" is what I argue is paralleled in portraiture's changing subjects.

Despite the number of excellent critical analyses of pre-twentieth-century American "interiority" published over the last two decades, American literary and cultural studies continues to lack both a full account of the process through which the representation of depth became desirable, as well as a suitable taxonomy of interiority that would help us trace the progress of such a process.[17] Curiously, most critics who have taken historical account of American interiority use the term "psychology" or the adjective "psychological" to help locate and describe the particular qualities of inwardness they are trying to specify. Yet these terms did not *mean* in the nineteenth century what they came to mean in the twentieth and twenty-first centuries. A word search of over one thousand nineteenth-century periodicals cataloged in the *American Periodical Series* scholarly database reveals that the word "psychology" appeared in print nine times between 1800 and 1820, 1,550 times between 1840 and 1860, and 8,611 times between 1880 and 1900.[18] Even if terms such as "psychology" or "psychological" have a certain usefulness in signaling a set of qualities to readers and scholars today, by using these terms *as if their meanings were settled* we overlook the process through which they became viable as criteria of aesthetic judgment.

I focus on psychological discourse before the turn of the twentieth century because given the often teleological thrust of histories of science, these discourses—such as physiognomy, phrenology, mesmerism, and electrical psychology—have often been considered "pseudo" science because they were ultimately abandoned.[19] The physiological psychologies of the nineteenth century—from popular fads such as phrenology and mesmerism to the

materialist approaches of thinkers such as Herbert Spencer and G. H. Lewes—were ultimately supplemented by increasingly nonphysiological psychoanalytic modes of inquiry into the inner life.[20] I return to these earlier theorizations of psychology precisely because of their potential to destabilize and reorganize what many have come to understand about the inner life. Nineteenth-century literature often posited alternatives to what contemporary neurologist and philosopher Antonio Damasio has called "the Cartesian idea of a disembodied mind," offering a consideration of the mind (and its most seemingly metaphysical functions of consciousness and subjectivity) as physiological structure, embodied material.[21] The rich context of nineteenth-century psychological thought was incredibly attentive to the material and corporeal aspects of the experience of subjectivity. The material mind, together with what Justine Murison has called the "open body," were both central to the wildly popular genre of portrait fiction in the nineteenth century.[22]

Certainly the "invention" of a form of inner life is never a benign process, and nowhere is this clearer than in the nineteenth century's often disciplinary coordination of body types with interior "essences." Psychology was invented, in part, out of the convergence of two powerfully disciplinary discourses: the visual and the scientific. Nineteenth-century science and art's interest in coordinating human surface and depth led to more aggressively policed social types. As Shawn Michelle Smith has noted, during the period between 1839 and 1900, "Bodies were mapped as the vehicles of gendered and racialized interior essences; that is, bodies were posed as the surface signs of interior depths. To 'read' a body was to inscribe it with an imagined interiority, an essence that linked one to a specific position in a social hierarchy."[23] Smith here refers to how, as the nineteenth century progressed, visual technologies were deployed in order to catalog and index "types"—for example, the criminal, the insane, the immigrant, the nonwhite, the nonnormative—as well as to shore up middle-class boundaries of propriety and lines of inheritance. Further, drawing a powerful connection between visuality, "the archive of slavery" and contemporary surveillance culture, Simone Browne asserts that "racism and antiblackness undergird and sustain the intersecting surveillances of our present order." From eighteenth-century lantern laws to the branding of enslaved bodies, the history of visual techniques and technologies in the United States has, Browne asserts, always already been about the identification, coordination, and discipline of Black bodies.[24]

Nineteenth-century writers, artists, photographers, and thinkers were not, I suggest in this book, unaware of the extent to which the metastatic quality of modernizing visual technologies was reshaping (in some contexts) and heightening (in others) the representational tension between inner life and its visual appearance. Black writers in the era understood how central visual representation was to what Autumn Womack has called "visual technology's role within an incomplete freedom project."[25] Jasmine Cobb has traced the centrality of the visual to the antebellum project of trying to imagine Black freedom, "proposing Black freedom as a visual problem that Whites and Blacks variously managed with practices of picturing. Different from anti-slavery rhetoric and political documents, visual cultures captivated with the prospect of Black freedom used strange and unexpected practices to resituate Blackness within the transatlantic imaginary." Cobb's brilliant project is anchored in an analysis of "the parlor, as a place for dissimilar groups of people and cultural producers to convene around visions of Blackness separated from slavery," analyzing the symbolic significance of the lithographs, wallpaper, friendship albums (and more) that were produced, purchased and/or kept by both white and Black people in the antebellum era.[26] As Blackness was resituated through the robust visual culture of the era, so was whiteness.

The proliferating representations of white women's bodies in that visual culture — as nationalistic symbols, consumerist aspiration, domesticity's exemplar — were explicitly taken up as what Martha Banta called "idea and ideal" in much of the portrait fiction and modernizing psychological theorizing of the era.[27] The writers, artists, and thinkers who worked with and through portraiture were often self-reflexive about the simultaneously disciplinary and imaginatively excessive power of portraiture as a method of representation. Insofar as this is true, nineteenth-century portrait culture shares much in common with twentieth-first-century selfie culture: in both we find a new visual aesthetic enabled by technological advances, which certainly does much to discipline and make available for capitalist surveillance aspects of human inner life, but which also, many have argued, carves out new and fascinating space for the expression and invention of new ideas about selfhood.[28]

In this book, I work the hinges between portraiture's disciplinary and inventive capacities, focusing on how nineteenth-century writers and artists did so as well. I must admit that at the beginning of this project, I expected to find evidence that both portraiture and the nascent languages of psychology

were, on the whole, limited if not entirely limiting. What I found instead was a veritable riot of terms and rich metaphors—like the scowl worn by Hepzibah Pyncheon in Nathaniel Hawthorne's *The House of the Seven Gables*, or Frederick Douglass's presentation of the head of an Egyptian king as an image of his mother, or Thomas Eakins's exclamation "I'm feeling for bones!" as he painted one of the hundreds of portraits that nobody in the nineteenth century liked, or Hannah Crafts's indelible fictional representation of what happens when an enslaved woman spends time alone in the portrait gallery of a plantation house. These terms and metaphors, I argue, were a signal form through which writers and artists gave expression to psychology before, to paraphrase Henry James, anyone had ever heard of it. I found, also, an irrepressible interest in portraiture as more than just reflective and imitative, but as *productive* of the possibilities of selfhood. Many of these possibilities of selfhood have disappeared, while still others have become entirely naturalized and seemingly transparent. For example, in a surprising counter to the commonsensical idea that inner life is "deep" and generally in need of revelation, the language of art restoration in the nineteenth-century—with its emphasis on patina and overpainting—makes us think harder about a notion of inner life that involves adding more layers rather than "revealing" psychic truth.[29]

This book is structured around a group of nouns—face, head, limbs, mind/brain, and bones—that are central to portraiture's attempt to trace and posit the metaphysical interior through aesthetic representation of the human body. Nineteenth-century portraiture often imagined different versions of inner life through these material parts of the human body. Across these five chapters, I tell a story about how portraiture's depiction of the soma invented ideas about selfhood that figured inner life as hidden, deep, and in need of revelation. I explore how Black writers resisted ideas of deep selfhood in their robust textual considerations of portraiture, and how postbellum artists and psychological thinkers turned to portraiture to speculate about the Civil War's legacy of dismemberment. As the end of the century approached, psychological thought turned to philosophies of consciousness and the mind, and the invention of X-ray imaging achieved the deep penetrating vision that so many across the nineteenth century had fantasized about. These conceptual shifts in the psychological, literary, scientific, and visual cultures of the 1890s drew from portraiture's representations of inner life as hidden and subterranean. Under this now well-developed regime of depth, "mind" and "bone"—like the face, head, and limbs before them—became metonymically rich figures for inner life. Turn-of-the-century por-

traiture's interest in these previously invisible aspects of selfhood helped establish a newly modern form of inner life that figures subjectivity as in need of penetrating revelation.

ALL WIDE-RANGING STORIES must leave some material outside the frame, as it were. My primary object of analysis in this book is the overlap between fields of representation and interior life. Falling outside the frame is what I might describe as the more sociable aspects of portraiture: the way that portraits circulated, were displayed, paid for, sat for, sent in the mail to loved ones or others. Nor do I train an eye specifically on the portrait as mass cultural product: a commodified image that became quickly and easily drawn into cultures of celebrity, advertisement, and fame. The fact is, portraiture was (and still is) a major component of mass culture and public life: portraiture gathers people in public and draws the eye in private. We live in a cultural world where everyone's body and subjectivity are always already available to be visually captured, reproduced, and interpreted/observed; this fact is the unchangeable, high-contrast background to the story that I want to tell here. There are many other stories that flow from this baseline one: about the quotidian irritations of being available to depiction (irritations which fall unevenly upon people occupying various social positions), about the ever-more fine-grained technological innovations that have identified the human face as *the* locus of modern life (unlocking doors, phones, friendships, and romantic possibility), about the rise and fall and rise again of portraiture as variously venerated inside the art world across the twentieth century, and more. I look forward to reading these other necessary stories about portraiture in the United States since the nineteenth century.

The raucous abundance of portraiture that continued after 1895 was met with its own resistance in the first decades of the twentieth century. High art traditions began to disdain figurative portraiture, and some of the most influential political theorists of modernity identified in portraiture a sort of sensuous temptation—it was too *easy* an aesthetic form, it appealed to a viewer's onanistic tendencies. These were some of the concerns underlying Walter Benjamin's important development of thought regarding the intersections of visual art/representation and political economy.

In his 1931 essay "A Short History of Photography," Benjamin introduces a number of important theoretical concepts related to photography and visual art that he would go on to elaborate in "The Work of Art in the Age of Mechanical Reproduction" (1936). In "A Short History," Benjamin theorizes the fundamental difference between photography and traditional art,

introduces the idea of the optical unconscious (teased out of the fact that photography is able to represent things that the human eye cannot see), and offers a reading of the French photographer Eugène Atget's images of urban landscapes. Benjamin asserts that Atget's photographs—absent as they are of human subjects—are emancipatory in their reorganization of the relationship between the human subject and the world. For Benjamin, the emancipatory, political function of photography takes shape when it loosens the connection between the embodied, individual human and the forms and tools of aesthetic representation; in his later essay "The Work of Art in the Age of Mechanical Reproduction," he celebrates how photography "freed the hand from the most important artistic tasks."[30]

But fascinatingly, Benjamin's arguments in "A Short History" are nearly entirely grounded in an analysis of portraiture, the genre most fundamentally connected to (at least the idea of) an embodied, individual human. The essay acknowledges the historical importance of photographic portraiture— "Photography first conquered the field with the visiting card," "The genuine victim of photography, however, was not landscape painting but the miniature portrait"—and sensitively dissects the roles of pose, setting, and prop in the nineteenth-century photographic portrait's communication of social and individual meaning ("There in a narrow, almost humiliating child's suit, overburdened by braid, stands the boy, about six years old, in a sort of winter garden landscape He would surely vanish into this arrangement were not the boundlessly sad eyes trying so hard to master this predetermined landscape").[31]

Benjamin's complex relationship to portraiture in "A Short History"— both disdaining it, to a degree, and yet still undeniably attracted to its power—presages in some ways Roland Barthes's later one in *Camera Lucida*. In his essay, Benjamin embraces portraiture only to the extent that it approximates a "a scientific standpoint," a visual representation that has "moved . . . out of the realm of esthetic distinctions into that of social functions."[32] The portrait, for Benjamin, is most revelatory when considered not as art, but as social/political method.

Yet, in his attempt to shift the photographic frame away from the human subject, Benjamin turns to spiritual, emotional, inward language. He acknowledges the seductive power of the human image, and urges his readers to resist such seduction. He notes that "the renunciation of the human image is the most difficult of all things for photography," referring to the difficulty with which viewers and readers are able to disarticulate visual representations of human exteriors from an understanding of the human as

the unique, individual subjectivity out of which meaning flows, or through which the world comes to cohere. Benjamin believes that this renunciation is a condition necessary (however unlikely) for "a healthy alienation between environment and man, opening the field for politically educated sight, in the face of which all intimacies fall in favor of the illumination of details."[33] It is probably not a stretch to say that Benjamin would be dismayed by 2013's word of the year: selfie.

I cannot claim that this book is interested in making a case for the renunciation of the human image. Yet I do assert that deeper historical knowledge and conceptual understanding of how images of surface likeness became so tightly sutured to understandings of inner life does in fact loosen those ties, allowing for a sort of "politically educated sight." This type of sight focuses how the human body and mind come into surprising new relations with one another and with the world; just as the metal surfaces of early daguerreotype portraits also contained reflections of their viewers within their frame, portraiture — in the process of asserting the boundaries of the isolate self — nearly always makes those boundaries bleed. Renunciation may well be impossible when it comes to imaging selfhood; perhaps we had better turn to abundance to do a similar sort of work. The nearly unimaginable abundance of portraiture has meant that the form has often been overlooked as obvious or banal. For painters, portraiture was (and still often is) money work, vanity work. Every household computer likely contains cluttered digital libraries of portrait after portrait of ourselves and our loved ones. Dusty boxes of old portrait photographs are shoved into the corners of thrift and antique stores. Surely each and every one of these (repetitive) portraits can't really *mean something?*

Rather than renounce these images, these seductive banalities, this book argues that yes, they really do all mean something. Like Marcus Aurelius Root, I believe that the cultural role of portraiture cannot "be pressed too often or too forcibly." The portrait not only reflects changes in the way the self is perceived at certain moments in history, but plays an integral part in constructing that self. The writers and artists I consider in this study were fascinated by the portrait because they believed that selves, like portraits, are aesthetic objects: crafted, sometimes beautiful, and most importantly, changeable and multiple.

CHAPTER ONE

Face

Hepzibah's Scowl

In *The House of the Seven Gables* (1851), a novel that features multiple portraits, Nathaniel Hawthorne provides at least three distinct modes of facial expression: the impenetrable, the revelatory, and the recursive. The Puritan-era Colonel Pyncheon is described as "like most of his breed and generation . . . impenetrable."[1] His painted portrait, which looms oppressively inside the eponymous house, does not "reveal" anything about him as a person. Indeed, at the end of the novel, all the portrait reveals is the futility of trying to penetrate past secrets (the only thing that exists behind his portrait is a "worthless" family deed to long-settled lands).[2] The Colonel's impenetrability, however, is suggestively contrasted with the revelatory nature of nineteenth-century photographic portraiture. The Colonel's nineteenth-century descendent, Jaffrey Pyncheon, walks about town with "an exceedingly pleasant countenance, indicative of benevolence, openness of heart, sunny good humor, and other praiseworthy qualities of that cast" (*Seven Gables*, 92), but his far darker interior essence is laid bare by the daguerreotypist Holgrave's portrait of him. Holgrave explains, "There is wonderful insight in heaven's broad and simple sunshine. While we give it credit only for depicting the merest surface, it actually brings out the secret character with a truth that no painter would ever venture upon, even could he detect it" (*Seven Gables*, 91). Holgrave's comment suggests that this new visual technology will allow for a newly "true" portraiture that indeed reveals something true about the person depicted.[3]

Importantly, however, Hawthorne offers readers yet another vision of the relationship between inner life and external appearance that complicates the Colonel/Jaffrey impenetrable/revelatory dialectic. Describing Jaffrey's cousin Hepzibah Pyncheon's characteristic facial expression, Hawthorne notes its recursive nature:

> Her scowl—as the world, or such part of it as sometimes caught a transitory glimpse of her at the window, persisted in calling it—her scowl had done Miss Hepzibah a very ill-office, in establishing her character as an ill-tempered old maid; nor does it appear improbable, that, by often gazing at herself in a dim looking-glass, and perpetually

encountering her own frown within its ghostly sphere, she had been led to interpret the expression almost as unjustly as the world did. — "How miserably cross I look!" — she must often have whispered to herself; — and ultimately have fancied herself so, by a sense of inevitable doom. (*Seven Gables*, 34)

Hepzibah's scowl, which is caused by her physical near-sightedness rather than a mental attitude, is an expression that *precedes* its own content, and thus confounds the very notion of expression (as a re-presentation of an original feeling) itself.[4] It complicates Marcus Aurelius Root's and other nineteenth-century writers' and thinkers' implications that expression is the manifestation of an inner state or feeling upon an external appearance. In the case of Hepzibah's scowl, the external appearance, or even the somatic sensation of the physical scowl, calls the inner state into being. The scowl emphasizes the recursive nature of expression and, indeed, of inner life itself: the way in which psychology is made, not found or expressed.

This chapter argues that nineteenth-century writers, artists, and thinkers used the portrait to experiment with how to visualize inner life. By exploring the state of psychological inquiry, portrait conventions, and literary representations of inner life at mid-century, I open this study on shifting ground. In the 1830s and 1840s, psychology was still a branch of philosophy, grounded in an eighteenth-century model of introspection. Portrait conventions, too, were still mostly governed by an eighteenth-century focus on goods, emblems, and familial, class, and gender status. But both of these discourses — psychology and portraiture — were subtly changing and, as I will note, beginning to posit an understanding of the mind as conflicted and split, hidden but capable of being revealed.

I begin this chapter with a brief account of the appearance — in the sense of literally coming into view — of psychology. Arguing that "psychological" is a historically situated mode of description, I emphasize the extent to which the anachronistic use of the term "psychological" occludes suggestive alternative modes of description and understanding of what governs the human interior, of what the human interior consists. I continue with an overview of the shifting subjects of both psychology and portraiture at mid-century. Finally, this chapter offers a series of case studies using a central figure caught in the midst of these changing ideas about portraiture and psychology: Nathaniel Hawthorne. Hawthorne wrote about portraits in works that spanned his entire career, and was also a part of the first generation of writers to regularly have their portraits circulated alongside their fiction.[5] I begin with a

reading of Hawthorne's commentary on having his portrait painted, sketched, and photographically recorded. These comments articulate two interrelated key questions: for citizens of the nineteenth century—what did, and what should, a portrait represent about a person? The newish phenomenon of author portraiture in the mid-nineteenth century invited many writers to explicitly articulate their ideas about portraiture. Analyzing these ideas helps us see how portraiture's cultural and personal functions were changing during this era.

Hawthorne took up these changing ideas in his portrait fiction. Through a series of close readings, I suggest that Hawthorne's short portrait fiction explores the unique power of discourses of legibility and visual access (uniquely popular just before and after the invention of photographic technology) as they were increasingly applied to ideas about selfhood. Hawthorne's portrait fiction represents interiority as simultaneously self-evident and opaque, transparently expressed upon surfaces and solicitous of deep exploration. The obvious tensions between these differing representational approaches were reconciled as the century progressed and individualized psychology emerged as an interpretive regime that repeatedly discovered and brought to the surface hidden truths about characters. But the example of Hawthorne's portrait fiction allows us a glimpse into a moment during which there was little consensus about what psychology looked like.

What Psychology Looks Like

Hepzibah's scowl suggests that we return to the nineteenth century to begin teasing out the many ways in which writers and artists attempted to visualize the inner life. A well-known example from the British tradition of late-eighteenth-century aristocratic portraiture, which American artists drew from and American writers were familiar with, helps us frame the question of what psychology might have looked like to a viewer from that era. Sir Joshua Reynolds's *Master Bunbury* (1780–81) (figure 1) depicts a young boy, who is seemingly absorbed and even enchanted by something outside the frame of the painting. From its first appearances (in a textual description in the London *Gazetteer* and then at the Royal Academy exhibition of 1781), the painting was accompanied by an anecdote that has had a remarkably long life in discussions of it. It is said that, since the boy was excitable, Reynolds spun a fantastic tale to keep the sitter's attention while the portrait was painted. Many critics have noted how this portrait differs from Reynold's usual mode of aristocratic portraiture, which focuses on surface artifact and effect, point-

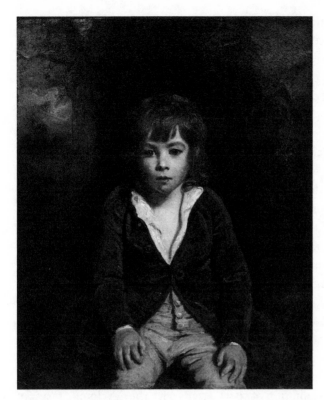

FIGURE 1
Sir Joshua Reynolds,
Portrait of Master Bunbury,
1780–81, oil on canvas,
30 1/8 × 25 1/8 inches
(76.5 × 63.8 cm).
Philadelphia Museum of
Art, The John Howard
McFadden Collection,
M1928-1-29.

ing to *Master Bunbury*'s focus on the sitter's interior life as a significant innovation.[6]

To call this focus "psychological," however, is to elide the fact that the concept of "psychology" is, in fact, largely a nineteenth-century invention.[7] To ask any "psychological" question of a work of art or fiction, then, is to assign a meaning, or a look, to that work of art or fiction that only became possible when a number of discourses—scientific, artistic, fictional—about the human interior intersected. Psychology in this sense is not so much a form of scientific inquiry as it is a mode of description. It is also an aesthetic, a critical system that organizes human understanding and depiction of the human interior.

HOW DO PORTRAITS HELP make the invention of psychology visible? The art form is generally (and often incorrectly) considered a reflective or symptomatic genre, a form through which we see dominant cultural ideals and assumptions expressed rather than debated or produced.[8] A number of eloquent critical cases have been made regarding the dialectical relationship

between the rise of the novel and the rise of modern individualism.[9] Unfortunately, there have been fewer studies linking the equally common and ubiquitous art form of the portrait to such major developments. Given the sheer number of stories and novels that feature portraits as major plot points or thematically significant details, portraits were obviously objects of fascination for writers between 1839 and 1900. Most scholars who have identified this interest have explained it in terms of the history of visual technology (and a form of literary anxiety that accompanied the invention of photography) or in terms of identity categories—what kinds of identities (raced, classed, sexed) portrait fiction attempted to depict, discipline, and/or produce.[10] I am, however, interested in the most basic and fundamental ground underlying this interest in portraiture: how did the newly ubiquitous visual art form spur writers and artists to imagine new forms of human subjectivity?

Given its "long history," portraiture, like the novel, has often responded to historical developments with formal innovations. On the one hand, changing artistic conventions in portraiture—less and less emphasis on the goods one owned, more and more emphasis on the personality or character one embodied—might be understood as similar to the rise of the novel, in which multiple forms of individualism find expression in art. For example, eighteenth-century reception of Reynolds's work emphasized his facility at balancing the representation of social status with the developing taste for portraits of individuality.[11] On the other hand, the representation of individuality differs in substantial ways from the representation of character, sensibility, subjectivity, or psychological complexity. None of these terms are interchangeable with one another. While eighteenth-century critics, artists, and writers may have pursued individualized modes of representing the human subject as a person who has an identity in excess of her social, gender, or familial status, such a pursuit does not, in fact, naturally produce an interest in or testify to the existence of a psychological interior. In other words, psychology does not *necessarily* follow from the invention of the modern subject. It has certainly become a naturalized *aspect* of the modern subject, and it is this process of naturalization that this book addresses.

The questions this book poses have less to do with modernizing subjectivity or the rise of individualism often evident in late-eighteenth-century British and American portraiture and more to do with the developing consensus that an expression such as Master Bunbury's signals an interior life that has a number of by-now familiar characteristics: it is located in the mind (which itself is located in the brain); it primarily takes the form of thought, imagination, and volition; and it is governed by both conscious and unconscious

processes.[12] None of these conclusions seems particularly anachronistic when read into Reynolds's portrait of the boy. But how would our reading of *Master Bunbury* change were we to note that, after discovering spinal reflexes in the 1740s, Scottish physician Robert Whytt concluded that the human mind resides in the spine? Whytt's proposition met with opposition from "cerebralists," who averred that the mind resides in the brain, a conclusion we have no trouble accepting today. These cerebralists, however, held this position not because they had discovered the mind in the brain via experimental science, but because they associated the human mind with the human soul; to locate the soul in the spine would make of it too animalistic or mechanical a thing.[13] Such questions about the somatic quality of the mind were central to the development of psychology as a discourse and a discipline over the course of the nineteenth century.

The discourse surrounding "psychology" in the eighteenth and nineteenth centuries was wild and wonderfully speculative. Taking its experimental nature seriously requires that critics think twice before applying the label "psychological" to eighteenth- and nineteenth-century representations of selfhood. While the subject was a popular one throughout the eighteenth century, consensus regarding two of the most basic of psychological assumptions—that the mind is located in the brain and that it works through both conscious and unconscious processes—took shape primarily during the later time period this book addresses. In an attempt to disprove the impossibility of a science of the soul, scholars and thinkers throughout the first half of the nineteenth century attempted to measure or locate the mechanics of the soul empirically. Through the middle of the nineteenth century, thinkers theorized on subjects as far ranging as spinal reflexes, color perception, motor functions, and reaction times; all while holding beliefs such as Rudolph Hermann Lotze's hypothesis in his 1852 *Medicinische Psychologie* that the soul has measurable mass.[14] It is worth asking, then—before we pose any psychological questions regarding works of art and fiction—what, exactly, psychology's subject was in the United States between 1839 and 1900.

Psychology's Subject

Histories of psychology generally attend to both the development of psychology as a discipline and the gradual definition, within that new discipline, of what the subject of psychology should be. Psychology *is* a subject in the sense that it is a course of study. But it also *has* subjects in the sense that it focuses on studying certain aspects of the human mind, brain, or soul. In this

section, I will argue that in the course of becoming a discipline, the study of psychology invented new kinds of human subjects. These subjects emerged as the developing discipline of psychology weathered what I will term a crisis of observation in the middle of the nineteenth century—a crisis engendered when philosophical introspection began to lose credibility as a way through which to reach conclusions about inner life.[15]

Twentieth-century understanding of the history of nineteenth-century psychology was largely shaped by E. G. Boring's *History of Experimental Psychology*, published in 1929 and revised in 1950. While scholars have refined, revised, and refuted Boring's *History* through the decades, his account remains authoritative. He locates the advent of modern psychology in Germany around 1879, the year Wilhelm Wundt established the first experimental psychology laboratory in Leipzig. Boring's view of science is essentially Hegelian in character, as evidenced in the following quotation from "The Psychology of Controversy," an address he gave in 1928 to the American Psychological Association: "The history of science, like Hegel's view of the history of thought, is one long series of theses, set off by ardently advocated antitheses, with ultimate syntheses terminating controversy and marking a step forward."[16] Boring embraced a teleological view that subsumed prior speculation and theorizing once a set of questions was answered in the laboratory. This emphasis on the ends of scientific inquiry rather than the means of speculation thus devalued the contributions of writers and artists who considered questions of human psychology in aesthetic, rather than scientific, terms. In the twentieth century, the history of psychology became one and the same with the history of experimental psychology, a conclusion related to both the development of the *discipline* of psychology, as well as a conclusion regarding what psychology's subject should be. Regarding this latter point, it is clear that psychology's subject became understood as phenomena, such as reaction times, that would be observable and measurable in a laboratory setting.

What I am interested in, however, is not only how the path to the laboratory was laid, but more importantly, what other available paths the discipline of psychology might have taken. For example, the turn-of-the-century emphasis on observable and measurable data in the development of the discipline of psychology is directly linked with a crisis in observation that is evident in periodical writings (among other forms of discourse) from the mid-nineteenth century. The primary form of psychological inquiry throughout the late-eighteenth and early-nineteenth centuries was an introspective model, in which the human mind attempted to observe itself and articulate

its findings in print. The introspective model generally followed from Scottish Common Sense philosophy, which held that information about one's mind, gathered through introspection, was viable psychological evidence or data. By the middle of the nineteenth century, however, this introspective model of psychological inquiry was beginning to break down.[17]

In 1842, the sometime Transcendentalist Orestes Brownson devoted seven pages at the beginning of his review of S. S. Schmucker's *Psychology, or Elements of a New System* (the second self-declared psychology text to be published in the United States) to bemoan the "low and contracted views of philosophy" held by most Americans, before questioning Schmucker's claim to have written "a genuine psychology."[18] Brownson's review appeared in *The United States Magazine and Democratic Review*, a popular periodical that was an important outlet for Nathaniel Hawthorne's fiction. Brownson's skepticism of Schmucker's text finds precise articulation as he proceeds to ask the very questions that writers, artists, philosophers, and scientists would set themselves to answering over the next sixty years: "For, after all, what is [psychology's] subject matter? Man as a living being? a social being? a moral being? a religious being?"[19] Brownson was skeptical of any text purporting to be a "psychology" because at the time there was no such thing, no discipline with material and theoretical boundaries called "psychology."

What did exist in the United States at this time was a relatively sophisticated set of theories about the "me" and the "not me." Usually associated with Transcendental philosophy, especially that of Ralph Waldo Emerson in *Nature* (1836), the encounter between the self and the external world was also a foundational contact point for developing psychological discourse. Brownson continues his critique of Schmucker's psychology text by calling into question Common Sense psychology's emphasis on the capacity of an individual's introspection to reveal the inner workings of his or her mind, intellect, and emotion. "[W]hat is called *internal* observation is not, strictly speaking, internal. If by *within* is meant the ME itself, we have no power with which to look within. The ME is the observer, and, therefore, must needs be distinct from the object observed. It is all on the side of *subject*, and do the best it can, it cannot, turn it ever so swiftly, get on the side of the *object*. The object observed, be it then what it may, must be, strictly speaking, exterior to the ME, and, therefore, veritably NOT-ME."[20] Likewise did an anonymous reviewer of Frederick A. Rauch's *Psychology, or a View of the Human Soul* (1840) in the *Baltimore Literary and Religious Magazine* find fault in the author's take on what can be gleaned from any contact between the mind and itself: "[Rauch states] 'there can be nothing *merely* internal, but it must be

so only in reference to itself as external. The flesh of an apple is internal only in reference to itself as external.' . . . What sort of insight does all this give us into the nature of the union of soul and body? Does the mind ascertain any substantial fact?"[21] These questions presented to the nascent discipline of the science of the mind would indeed not find satisfactory answer for many decades. Common Sense philosophy held that a mind that attempted to sound its own depths would always end up uselessly skeptical of its own existence, an existence to which simple "common sense" testified. And so mid-nineteenth-century psychology was dogged in the United States by the claim Thomas Reid had offered in 1764 as reason to *accept* Common Sense doctrine—that "when we turn our attention inward and consider the phenomena of human thoughts, opinions and perceptions, and endeavour to trace them to the general laws and first principles of our constitution, we are immediately involved in darkness and perplexity. And if common sense, or the principles of education, happen not to be stubborn, it is odds but we end in absolute skepticism."[22]

For Reid, writing in 1764, the seeming uselessness of this type of skepticism was reason enough to establish a number of first principles. The most important of these first principles was that the mind is apprehended through conscious introspection, and that conscious introspection will deliver reliable news about the self. But by 1842, the insight that a person might find it difficult to be both subject and object of these introspective endeavors was tying writers and thinkers in knots. Mid-nineteenth-century psychology seemed ill-equipped to, as Rauch's anonymous reviewer put it, "sound the bottom of this mystery" of the relation of the mind to itself.[23]

The rapidly deflating authority of introspection was keenly felt because introspection fell out of favor as a mode of psychological inquiry *before* positivist, empirically focused, laboratory-based psychological inquiry became possible. While introspection might remain a useful philosophical tool, it was ultimately not viable as a psychological tool. Oddly enough, the most popular forms of psychology in the United States to precede the 1879 laboratory revolution were physiognomy and phrenology. Both of these modes of studying and making conclusions about the human interior were systems of observation, rather than introspection. They were also both aesthetic systems that attempted to organize the meaning that can be gleaned from visual perception of the human form. These scientific-aesthetic systems drew upon beliefs about the expression of the human interior upon the human exterior that had long steered conventional tastes in portraiture. Physiognomy was a popular theory that averred one could apprehend aspects of

another person's character in his or her facial features. Phrenology was a similar theory that contended one could apprehend aspects of another person's character in his or her *cranial* features. Both were, as Joanna Woodall writes of physiognomy, "predicated upon a 'symptomatic' relationship between external appearance and an invisible, internal self which was the ultimate subject of interest."[24] Yet there were important differences between physiognomy and phrenology.

Physiognomy was a deterministic system of observation. One could not very well rearrange one's facial features. When character is read in the arrangement of facial features, the observer follows a circuitous observational route: George Washington is a great man, which you can see in his features, features that signal to us that he is a great man. Phrenology moved away from this deterministic nature by allowing for the *exercise* or *restriction* of those faculties in the brain one wanted to increase or decrease in influence over the self. The phrenological worldview argues that a trained observer can identify certain character traits in his subject by noticing which areas of the cranium are enlarged or atrophied. The subject can then be advised to embark on a process of self-improvement to fix those aspects of his character that are in need of it. For example, if one were overly amative, by restricting the amative impulses as they arise every day the amative faculty would decrease in size, a withering that would ultimately be expressed by a smaller, less noticeable amative "bump" on the cranium.

While there are obvious similarities between the two systems of observation, phrenology relates more immediately to the crisis in observation underway in the mid-nineteenth century. Phrenology was pioneered by the physiologist Franz Joseph Gall, whereas a theologian (Johann Casper Lavater) articulated the tenets of physiognomy. Though the two theories may appear equally "pseudo" to us today, Gall is largely credited with articulating an approach that begins to establish scientifically the brain as the organ of the mind.[25] As such, Gall's phrenology was one of the most immediate "scientific" precursors of the 1879 laboratory revolution.

In addition to its relevance to the history of science, phrenology was an intensely popular form of discourse, associated with the vibrant visual and entertainment cultures of the mid-nineteenth century. Phrenology was almost from the first received as *both* science and hucksterism.[26] In 1850, Henry Clay and Daniel Webster (along with five other senators) invited the Universalist minister John Bovee Dods to deliver a series of lectures in the Hall of Representatives. In these lectures, Dods introduced what he termed an "electrical psychology" that was based on phrenology and mesmerism.[27] The

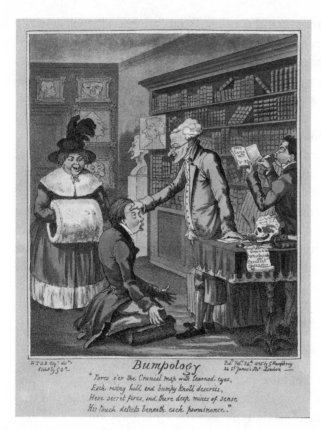

FIGURE 2 George
Cruikshank (after a
design by H.T.D.B.),
Bumpology, 1826,
etching and aquatint.
The Library at
Wellcome Collection.

lectures were well received. While such elected leaders seriously considered the science, however, it had also long been lampooned in the popular press as "bumpology" as in this 1826 George Cruikshank illustration (figure 2).

The Cruikshank print, published in London on February 24, 1826, is a wonderful example of the crisis of observation that accompanied pre-1879 theories about the human interior. The phrenologist in the image lays his hand upon a groveling client's forehead, but the caption informs the reader that he "Pores o'er the Cranial map with learned eyes." The contradiction between hands laid upon a head to gather data and eyes raking across a willing subject is important here as the viewer gazes beyond the figures in the foreground upon a chamber full of phrenological portraits and busts. The space between the engaged hand and the alert eye is exactly the space that the ancient art of portraiture tries to master.

The missing link, as I've suggested, between the mid-century authority of "introspection" and the laboratory revolution of the late nineteenth

century is not exactly "phrenology" or "physiognomy" but rather *the aesthetic*, and even more specifically, the aesthetic of portraiture. Portraiture, like early psychology, asks useful questions about what one sees (and what the significance of this sight is) when one looks at a human being, whether in life or in representation. It asks, how does one translate what the eye sees in a human being who may or may not be projecting or attempting to craft her own imagined idea of herself into a meaningful visual image? What do the various participants in this unique exchange—sitter, artist, viewer—hope to get out of it? How, in this exchange, does the metaphysical (ideas, imagination) interact with the physical (an arm held aloft, paint formed by minerals, a stretched canvas)? What forms of meaning about human subjectivity are produced, and what forms are closed down? In the rest of this chapter, I trace portraiture's significance to the development of psychological thought across the nineteenth century via a case study of Nathaniel Hawthorne's remarkably long-standing fascination with them both (portraiture and psychology) as *aesthetic* categories, in his life and in the imaginative realm of his fiction.

Portraiture's Subject

Portraiture's subject is both simple to define—it is the visual depiction of a real person—and endlessly complex—how can an actual person be captured in a depiction in all her variety? What do the ever-evolving styles of portraiture tell us about the historical and social contexts within which they are crafted? Does the portrait merely reflect dominant social ideals, or does it shape or even revolutionize them? A quick glance at three painted portraits produced in three different centuries, all depicting women dressed in varying shades of pink, helps frame the inquiry.

John Singleton Copley's *Mrs. George Watson* (1765) (figure 3) emphasizes correct bodily deportment, accoutrements, and emblems in order to reinforce the reciprocal relationship between the individual depicted, her deportment and accessory, and her character or personality. Very different, we can see, is Thomas Eakins's *Portrait of Amelia Van Buren* (1890) (to which I will return in chapter 3) (figure 4). Here the sitter also wears an elaborate pink dress, and also is painted in minute anatomical detail. Her interior state is expressed by her posture, setting, and accessory. But, unlike the Copley portrait, the Eakins portrait attends more explicitly to the state of its sitter's mind. This portrait is about how a mind's psychological complexity exceeds representation, is always already in tension with the material world that surrounds it, and is fundamentally alienated from itself and the social codes that are

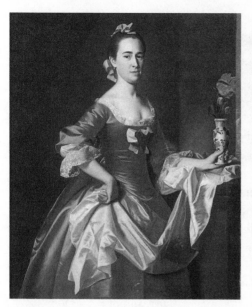

FIGURE 3 John Singleton Copley, *Mrs. George Watson*, 1765, oil on canvas, 49 7/8 × 40 in. (126.7 × 101.6 cm), detail. Smithsonian American Art Museum, partial gift of Henderson Inches Jr., in honor of his parents, Mr. and Mrs. Inches, and museum purchase made possible in part by Mr. and Mrs. R. Crosby Kemper through the Crosby Kemper Foundation; the American Art Forum; and the Luisita L. and Franz H. Denghausen Endowment.

FIGURE 4 Thomas Eakins, *Miss Amelia Van Buren*, ca. 1891, oil on canvas, 45 × 32 in.; 114.3 × 81.28 cm. The Phillips Collection, Washington, DC. Acquired 1927.

FIGURE 5 Gerhard Richter, *Betty*, 1988, oil on canvas, 102 cm × 72 cm. St. Louis Art Museum. Courtesy of Gerhard Richter.

supposed to govern it. Still different is German artist Gerhard Richter's oil-on-canvas portrait of his daughter, *Betty* (1988) (figure 5). This photorealistic work violates traditional portrait conventions by posing its sitter facing away from the viewer. Its multiplying references—to "Old World" portraitists such as Johannes Vermeer and even to Richter himself (the sitter twists to look behind into one of her father's famous monochromatic grey abstracts)—move the subject of the portrait away from the psychology of the sitter and toward a more philosophical consideration of the function and history of portraiture itself. Though admittedly somewhat streamlined and simplified, by considering these three "Pink Ladies" together, one might begin to piece together a narrative about portraiture's subject—the gradual shift in focus from kinship status and goods to psychological complexity to the tradition of portraiture itself.

In the pre-twentieth-century American context, critics have generally focused on the lavish eighteenth-century aristocratic portraiture of, for example, John Singleton Copley, or on the "psychological" portraiture of the late nineteenth century. There has been relatively little critical attention paid to the period between, to the shift from kinship and social status to identity, psychology, and the ultimate aesthetic reorganization of the individual. A critical focus on those portraits that most fully engaged the sets of pictorial codes identified as characteristic of certain eras is almost certainly a result of generalized understandings of portraiture as a reflective or symptomatic art form, a genre through which prevailing or dominant ideas about person-hood are expressed (even when these dominant ideas take the form of a critique of personhood). In emphasizing the reflective quality of the portrait, critics have neglected to attend to the ways in which portraiture is a dynamic, incredibly present, popular, and powerful art form through which writers, readers, artists, and viewers worked out answers to a set of epistemological and ontological questions regarding what, exactly, a person was or could be.

A particularly rich case study through which to see how "the psychological" was constructed by the mid-nineteenth century interest in the portrait is Nathaniel Hawthorne's commentary on having his portrait painted by Cephas Thompson in 1850. Hawthorne often turned to the portrait in his fiction as a figure through which to dramatize the points of contact between the human interior and exterior life. As a writer living in the middle of the nineteenth century, however, Hawthorne also experienced the new centrality portraiture would have in both his personal and professional life as a vibrant visual culture bloomed in print.[28]

It was, at mid-century, quickly becoming *de rigeur* for magazines to publish engraved portraits of authors alongside those authors' texts.[29] In 1851, Herman Melville, always the contrarian, refused to supply his friend and publisher Evert Duyckinck a daguerreotype portrait of himself from which an engraving could be made.[30] We can take such a refusal, and Melville's famously annoyed claim that "everybody is having his 'mug' engraved nowadays," as evidence that writers were walking a thin line between necessary publicity and a newly desired exclusivity.[31] Nathaniel Hawthorne could be similarly cranky about the public appearance of his own image. He did not like woodcuts, writing in 1851 that "if a man's face is to be cut in wood, he cannot reasonably expect to look like anything but a block-head."[32] But his complaints tended to be specific, lodged against the particular appearance of a single image; he never protested, as Melville and Emily Dickinson did, the *idea* of a publicly circulated portrait.[33] In this way, Hawthorne seems a usefully neutral case.

Before 1850, Hawthorne had had a set of relatively common experiences with portraiture. He had his portrait done in oil by a local artist to commemorate a major life moment (in his case, the start of college), miniaturized for a keepsake for his doting mother and sisters, and sketched in crayon and chalk by Eastman Johnson at the request of his friend Henry Wadsworth Longfellow. He also likely had a daguerreotype portrait of himself taken at the popular studio of Southworth and Hawes in 1841.[34] These experiences summarize almost point-by-point the reasons why one had one's portrait done or taken in the mid-nineteenth century: portraits marked and recorded life transitions, idealized a sitter for selected intimates, forged friendships and testified to the sitter's participation in a particular guild or society, and increasingly, after the invention of photographic technology, came to function (in Roland Barthes's terms) as a "certificate of presence."[35] Importantly, they did not function in the way they do in Hawthorne's fiction: as visionary and penetrating works of art likely to reveal the secrets, guilt, and mania hidden beneath the surface of the person(s) depicted.

But the progressively more common practice of reproducing author portraits in popular periodicals did introduce a significantly new portrait function, which was undoubtedly part of the larger cultural shift in portraiture's subject. The author portrait came to function as both celebrity veneer and figure through which readers could learn to *read into*. On the one hand, a through line can be traced from eighteenth-century printed portrait galleries (which aimed to instruct and idealize by reproducing images of statesmen and heroes) to nineteenth-century collections like Matthew Brady's

Gallery of Illustrious Americans (1850) or Duyckinck's *National Portrait Gallery of Eminent Americans* (1862) (which also focused heavily on "great men") to the new fad for author portraits.[36] On the other hand, the new interest in author portraits introduced a unique way for readers to interact with the texts that they read. For the first time, readers could link a piece of fiction with an image of the person who conjured that fiction; it was a short step from there to learning how to read an interior into that portrait image. What is that author like? How could his imagination produce such a work? So, where a portrait may have been produced for any number of conventional reasons — to commemorate a marriage, for example — once engraved and reproduced and published alongside a piece of fiction, that portrait became more and more likely to convey information to the public about what would come to be termed the "psychology" of the author in question.

Take the case of the Cephas Thompson portrait of Hawthorne (figure 6). This is the image that the public would come to know as "Hawthorne." The first portrait of the author to appear in print was an 1851 engraving from the Thompson portrait. The engraving appeared in both the illustrated weekly *Boston Museum* and on the frontispiece of the first edition of *Twice-Told Tales* in the same year. Three more engravings from this portrait by different craftsmen came out within a year, and others soon followed.[37] By the end of 1851, it is safe to say that a good portion of the reading public knew what Nathaniel Hawthorne looked like, and this knowledge was based on Thompson's depiction.

But what connection did Nathaniel Hawthorne's appearance have to the interior life of the author? While in the midst of sittings for this portrait, Hawthorne remarked in his journal that "I have had three portraits taken before this; a picture, a miniature, and a crayon-sketch; neither of them satisfactory to those most familiar with my phiz."[38] His criteria of judgment in this remark seem limited to questions of accuracy in representation of his physical features. About halfway through his required sittings for the portrait, however, Hawthorne goes on to remark, "The portrait looked dimly out from the canvass, as from a cloud, with something that I could recognize as my outline; but no strong resemblance as yet" (*AN*, 491). The tension between the sketchy "outline" and the deeper possibilities of "resemblance" results in a typically Hawthornian ambiguity where the portrait is a form with the capacity to be both utterly literal and suggestively expressive. Hawthorne's ambivalence about the possibility that his portrait would represent something more than just his features continues, as his journal shows him clearly in thrall of Cephas Thompson's artistic process. In particular,

FIGURE 6 Cephas Giovanni Thompson, *Nathaniel Hawthorne*, 1850. Oil on canvas, 75.2×59.5 cm. The Grolier Club, gift of Stephen A. Wakeman, 1912.

Hawthorne notes the frenzied "glow of composition" (*AN*, 491) that came over Thompson while working in front of the canvas. That a set of physical materials (canvas, brush, pigment) might, in the hands of an artist, be transformed into a representation of a unique human subjectivity seemed a lovely possibility for Hawthorne. Yet, he nearly immediately undercuts his own aesthetic optimism by abruptly concluding his ruminations with the claim, "In fact, there is no such thing as a true portrait; they are all delusions" (*AN*, 491).

Hawthorne's interpretations of his own portraits are usefully inconsistent. He repeatedly expressed both enthusiasm for and skepticism of the art. He recalled that "before having my first portrait taken, there was great bewitchery in the idea, as if it were a magic process" (*AN*, 492–93), but ultimately the process disappoints: he claims in a note to Longfellow anticipating his appointment with Eastman Johnson that "all previous attempts at my 'lineaments divine' hav[e] resulted unsuccessfully."[39] Even more curiously, despite all of his doubts about the form, he wrote George Ticknor in 1852 with a sur-

FIGURE 7
Thomas Phillibrown,
Nathaniel Hawthorne,
1851, steel engraving
after portrait by Cephas
Giovanni Thompson,
commissioned by
Ticknor and Fields.
Library of Congress,
LC-USZ62-93807, Prints
and Photographs
Division.

prising request. When returning the page proofs of *The House of the Seven Gables*, he asked that copies of a Thomas Phillibrown engraving of the Cephas Thompson portrait be tipped into presentation copies of the novel and sent to a selection of friends (figure 7). Had Hawthorne come to think of this representation as a "true portrait" so shortly after declaring that such a depiction was impossible? Or was his request that this portrait be included with copies of the novel (sent to friends he could just as easily get a portrait to by post) a resignation to, or even embrace of, his newly found literary fame?

The discursive life of the Cephas Thompson portrait does not end here. In 1883, twenty-odd years after Hawthorne's death, George Parsons Lathrop, *Atlantic Monthly* editor and husband of Hawthorne's daughter Rose, described the Thompson portrait in this way: "the eyes look a little weary, as with too much meditation in the brain behind them Here the face is pensive, timid, fresh and impressionable as that of some studious undergraduate unusually receptive of ideas, sentiments, and observations: it is, indeed, quiet and thoughtful to the verge of sadness."[40] Lathrop, it is clear, quite easily

fuses the portrait and the person, the portrait has become "psychological," since the viewer sees through the depicted Hawthorne's eyes straight into the "brain." Lathrop's encounter with the portrait is unmarked by the ambivalence that characterized Hawthorne's reception of his own portraits. While there is, to be sure, an extent to which it is always difficult to recognize an image of oneself as one's *self*, I would like to suggest that Hawthorne's uncertainty about whether or not a portrait can be "true" is ultimately connected with a crisis of observation evident in the fiction, visual culture, and psychology of the mid-nineteenth century.

Hawthorne's contradictory comments raise a number of questions about the social and cultural work performed by portraiture in the mid-nineteenth century; specifically, what constitutes a "true" portrait in a culture obsessed with whether human interiors were evident upon human exteriors. For Hawthorne, the subject of the Thompson portrait was unclear; the subject could be the author's moral character, it could be the author's family lineage, it could be his romantic heroism, or it could be simply testimony that he exists. Because he was unsure what the subject *should* be, it was impossible for it to ever be "true" or more than a "delusion." By the 1880s, however, the subject of this portrait was undoubtedly Hawthorne's interior life: sadness, meditation, ideas. That this came to be this way was a cultural phenomenon, a converging of a set of discourses whereby the human interior came to be recognized in certain pictorial and fictional codes, which in turn constructed the way in which we understand how the mind works even today. Turning next to Hawthorne's fictional portraits, which are far more sophisticated in their engagement with the traditions and conventions of visual portraiture than usually credited, I will argue that Hawthorne's emphasis on the *process* of portrait composition—"No strong resemblance as of yet"—helps us identify how portraits came to describe a mind that did not yet exist.[41]

"The Eye Aptly Directed"

Hawthorne was familiar with seventeenth- and eighteenth-century painted portrait conventions.[42] Art historian Margaretta Lovell claims that "it is important to note that although capturing 'a good likeness' (a recognizable face) was one of the key measures of a painting's success in the eighteenth-century, there seems to have been little emphasis on penetrating the sitter's inner character, or psychological state. These are works that record, above all, the physiognomy of individuals and the posture, material attributes, and 'manner' appropriate to broad class, age, and gender groups."[43] But how,

then, did "penetrating the sitter's inner character, or psychological state" become an aesthetic aim for writers and artists over the course of the nineteenth century?

Hawthorne's portrait fiction served a key literary historical function in establishing "inner life" as a suitable (and ultimately preferred) subject for literature. Reviewers of Hawthorne's fiction in the 1840s noticed that the author concerned himself with unusual subject matter when he explored the inner life of his characters: "His writings, like those of all strictly original writers, are the solution to a new problem, the exhibition of the human heart and intellect, under a new array of circumstances," one anonymous reviewer somewhat cryptically asserted in 1841. The reviewer continues, "If he shows the skilful touches of a physician in probing the depths of human sorrow, and noting the earliest stains of guilt upon the soul, he has too a fund of cheerfulness and sympathy to minister to the mind diseased."[44] The reviewer intuits that Hawthorne was ambivalent about the sort of intrusion "psychological" narration requires, describing his narrative approach in unusual but apt medical terms that highlight an interest in the complex relationship between surfaces and depths during the period. In 1852, another reviewer, writing in *Littel's Living Age*, latched on to Hawthorne's explicit ambivalence over this "new" approach. The reviewer points his readers to a passage in *The Blithedale Romance* (1852) in which Miles Coverdale reflects on his interest in penetrating the intriguing but laconic surface of Old Moodie, concluding that "it was unaccountable to myself, the interest I felt in him."[45] The reviewer concludes that the episode is evidence that Hawthorne had an "apprehension that it was no healthy employ, devoting ourselves too exclusively to the study of individual men and women."[46]

While some reviewers were concerned over the healthiness of Hawthorne's interest in "probing the depths" of his characters, other contemporary reviewers celebrated it and began to identify Hawthorne as what Henry Tuckerman labeled in 1851 a "psychological writer." Tuckerman analogized what he found to be Hawthorne's literary insight into the human interior with new visual technologies that allowed viewers to see more and more minute details of specimens placed under glass: "What the scientific use of lenses—the telescope and the microscope—does for us in relation to the external universe," Tuckerman argues, "the psychological writer achieves in regard to our own nature. He reveals its wonder and beauty, unfolds its complex laws and makes us suddenly aware of the mysteries within and around individual life."[47] For Tuckerman, "the new array of circumstances" Hawthorne concerned himself with in his fiction were an increased attention

to states of emotion and consciousness, a narrative technique less "melo-dramatic" (i.e., rooted in action and adventure) than "meditative" (i.e., rooted in subtle shifts in mind and subjectivity), and a belief that reading and writing fiction are opportunities for introspective self-exploration. Tucker-man notes, "[Hawthorne] always takes us below the surface and beyond the material [H]e makes us breathe the air of contemplation and turns our eyes inward" ("NH," 346).

As Tuckerman's analysis suggests, two of the most powerful discourses that intersected during the period in which Hawthorne wrote were those that surrounded new visual technologies and those that addressed literature's role in "probing . . . depths." Returning to Tuckerman's analogy of Hawthorne's "psychological" approach to technologically assisted sight, we can see how new ways in which to represent surfaces solicited new desires to know inte-riors. Upon peering through a microscope, Tuckerman rhapsodizes, "The eye aptly directed, the attention wisely given and the minute in nature enlarged and unfolded to the vision, a new sense of life and its marvels seemed cre-ated. What appeared but a slightly rough surface proved variegated iris-hued crystals; a dot on a leaf became a moth's nest with its symmetrical eggs and their hair penthouse; the cold passive oyster displayed heart and lungs in vital activity" ("NH," 344). In Tuckerman's analogy, Hawthorne's fiction is a lens, and "our own nature" is a substance that perhaps at first appears "cold [and] passive" but which, upon inspection, reveals a warm interior engaged in "vital activity." Crucially (though Tuckerman seems to elide this fact), a microscope can only see surfaces, albeit seemingly supernaturally enlarged and particularized. But just as with photographic portraiture, the micro-scope's ability to depict particulars leads to a sort of mania to see *more* par-ticulars, or to imagine the workings going on behind those particulars.

Prophetic Pictures

The portrait stories that Hawthorne wrote in the 1830s take on exactly this mania for revelation. "The Prophetic Pictures" (1837) tells the story of Wal-ter Ludlow and his fiancé Elinor, who each have a wedding portrait completed by this unnamed artist. The portraits and preparatory sketch (which only Eli-nor glimpses) foretell future unhappiness; the artist advises Elinor to forgo the marriage and avoid the conclusion he seems to have foretold in his de-pictions. Neither Walter nor Elinor heed the warning; they marry, and we are told that as the years pass they begin to resemble their images more with each day. The artist one day returns to their home, just in time to find Walter

in the precise pose of the preparatory sketch—with knife raised and pointed at Elinor's bosom—and Elinor's face exhibiting the same expression of terror as in her formal portrait. The question is posed to the reader whether it was the artist's prophecy, "Fate" (the term Walter invokes), or simply bad romantic decision-making that led to this turn of events.

Hawthorne performs two sleight-of-hand tricks in composing "The Prophetic Pictures." The first is simply in making the artist of that story a portraitist at all, and the second is in characterizing this portraitist as visionary. Neil Harris notes that "the portrait [in colonial America] was a craft product, not intrinsically different from a chair or a set of candlesticks; only in exceptional cases did the craftsman achieve his immortality" and points out that artists throughout the eighteenth century had to negotiate a conflict between the financial necessity of portrait commissions and the relative disdain in which the form was held.[48] Painters painted portraits for money, not out of inspiration. The unnamed European artist of "The Prophetic Pictures" has traveled to the United States "to feast his eyes" on the sublime natural world, hoping to become a landscape painter—the most popular and respected branch of American painting in the 1820s and 1830s. But the artist cannot turn away from what truly inspires him—the human form: "In truth, it was seldom his impulse to copy natural scenery, except as a frame work for the delineation of the human form and face, instinct with thought, passion, or suffering."[49] Hawthorne's artist maintains a singular focus and interest in the human form and face in contradistinction to a dominant artistic preference for landscape in the 1830s.

The unnamed artist is also characterized as visionary, rather than craftsman. "The Prophetic Pictures" was famously inspired by an anecdote about the painter Gilbert Stuart that appeared in William Dunlap's *The History of the Rise and Progress of the Arts of Design in the United States* (1834), the first critical work on art in America to be published.[50] Embedded in a chapter on Stuart's career in London, Dunlap tells the story of how Stuart painted a portrait of a seemingly sane man who later committed suicide. The man's brother was shocked at the appearance of the portrait: "I see insanity in that face," he said. Dunlap concludes that because the man did ultimately go mad that "It is thus that the real portrait-painter dives into the recesses of his sitter's mind."[51]

This source for the story, while often noted, is little analyzed. It is important to note the context of Dunlap's story. For, immediately before and after this anecdote about visionary portraiture, Dunlap dwells at length on Stuart's practice of aristocratic portraiture. He details the artist's financial dealings,

and relates a story about how Stuart described his work as a portraitist in this way: "I dress hair, brush hats and coats, adjust a cravat, and make coats, waistcoats, and breeches, and likewise boots and shoes *at your service*."[52] The "prophetic" artist of Hawthorne's story is clearly drawn from Dunlap's claim that "the real portrait-painter dives into the recesses of his sitter's mind." But this claim is surrounded, in its original telling, by accounts of the business of portraiture, which involved assistants, cosmetics, costuming, and serving a sitter's needs and desires. Hawthorne's *choosing* between these two different "types" of portrait artist is a key part of his fiction's role in creating the imaginative space in which psychology would develop.

For a story premised on dramas of revelation—the revelation of what was depicted in the artist's prophetic sketch, the revelation of what Walter and Elinor will do to one another—"The Prophetic Pictures" in fact reveals very little. At the end, Walter Ludlow has "relapsed" and Elinor answers the artist's question as to why she didn't heed his warning with what amounts to little more than a shrug: "But—I loved him!" ("PP," 182). Walter does not actually kill Elinor, and so the sketch turns out to have simply revealed a pose that appears murderous, rather than an action that really was murderous. The story's deflated ending raises the interesting possibility that the tale is less interested in the experience of revelation—for the story's characters and readers alike—than it is in a new point of view that believes in hidden aspects of the self that always must out. A conventional colonial or Revolutionary era marriage portrait would not be expected to "reveal" anything of this kind. And so it is useful to ask just what the unnamed artist has unveiled in his art.[53] By the end of "The Prophetic Pictures," it seems that the artist has mainly exposed his own egomaniacal fantasy in which his art has the power to make something happen and that Walter and Elinor assume the appearance of "quiet grief" and "sullen gloom" ("PP," 182) that is brought about by their belief in the painter's power of revelation.

Indeed, the story's arresting opening, plunging the reader suddenly into Walter's "animated" testimony to the portraitist's excellence, sets Walter and Elinor up as the perfect subjects for this artist's skillful physician's touch. They seem primed for the experience of being read by the artist with "an acuteness almost preternatural" ("PP," 180). This marks them as citizens of the nineteenth century, rather than of the earlier time in which the story is set. Their expectations are not in line with what clients of their era would desire from a marriage portrait. Hawthorne sets these unusual expectations against the narrative emphasis on how external appearances can inscribe themselves upon interior states of being. The "grief" and "gloom" in Elinor's

and Walter's countenances are less expressions of emotional truth flowing from the inner to the outer, than poses that code an external appearance as if it were an interior feeling, rising to meet the expectations of an artist looking for secrets from subjects who do not realize their own transparency before such a sensibility. Like Hepzibah, their "expression" of some kind of inner truth is in fact constructed via a series of external cues.

While appearing to craft a story about the revelation of a murderous secret, Hawthorne has in fact crafted a story about the production of those "recesses" into which a portrait painter dives. It is tempting to conclude that "The Prophetic Pictures" is an *example* of the widely shared nineteenth-century belief that the inner is reflected in the outer. Such a belief required a static sense of the characteristics of the "inner" and the "outer" that spread after the invention of photographic technology in didactic instructional manuals such as Marcus Aurelius Root's. But "The Prophetic Pictures," I have been suggesting, has no grounding in static ideas about the relationship between the inner and outer self and so is inconclusive about questions regarding what Root called "the soul of the original." The story's selective emphasis on an unrepresentative anecdote from Dunlap's volume demonstrates how the social function of portraiture changes over time as writers and artists continually shuffle and revalue qualities such as surface likeness, expressiveness, and commodity value. The gothic structure of revelation that undergirds "The Prophetic Pictures" is undone by its own ambivalence over what exactly it is that the portraits revealed about the sitters, even while it maintains, anachronistically, that what Walter and Elinor most wanted from their marriage portraits was to have their "mind[s] and heart[s]," their "secret sentiments and passions . . . throw[n] . . . upon the canvass" ("PP," 167). Finally, Walter's and Elinor's anachronistic desire to have an inner truth exhibited upon an external surface complicates the simpler ideal of "expression" endorsed by Marcus Aurelius Root. For Root, portraiture's work is in *capturing* the original; in "The Prophetic Pictures" the very notion of an original inner truth is *produced* by the promise of depiction itself.

Blank Canvas

The question of whether portraits reveal something "true" is also addressed in another of Hawthorne's portrait stories, "Edward Randolph's Portrait" (1838). This is the "story of a black, mysterious picture" that hangs in "one of the apartments of the Province-House." It is "an ancient picture, the frame of which was as black as ebony, and the canvass itself so dark with age, damp,

and smoke, that not a touch of the painter's art could be discerned. Time had thrown an impenetrable veil over it, and left to tradition, and fable, and conjecture, to say what had once been there portrayed."[54]

As the story opens, Thomas Hutchinson, who was lieutenant-governor of colonial Massachusetts from 1771 to 1774, is considering signing "an official order" that will give British troops permission to occupy Castle William in Boston. His beloved niece Alice Vane and his right-hand man Captain Lincoln (both fictionalized characters) lodge various protests against his doing so. The reader comes upon the three characters arrayed in a still tableau, "gazing up thoughtfully at the void blankness of the picture" in the title. Alice Vane breaks the silence and asks, "Is it known, my dear uncle . . . what this old picture once represented?" ("ER," 258–59). With this question, Alice Vane opens up a series of interpretive stabs that attempt to make the murky canvas tell a story that will be meaningful for Hutchinson's decision. Captain Lincoln provides a number of imaginative possibilities: the painting either depicts Satan, a mischievous demon, or a face that viewers cannot bring themselves to talk about after perceiving ("ER," 260).

The painting's resistant blankness produces multiple interpretations and vivid imaginations of the dark history of the colonial state; the withholding of meaning, as in Hawthorne's well-known "The Minister's Black Veil" (1836), emerges as the most powerful incitement to narrative. Alice Vane, after listening to Captain Lincoln's yarns, recognizes this and wonders whether it would be "worth while to wipe away the black surface of the canvass, since the original picture can hardly be so formidable as those which fancy paints instead of it" ("ER," 261). Hutchinson, however, intrudes upon their romantic fantasies and conclusively resolves the interpretive question. He declares "my antiquarian researches have long since made me acquainted with the subject of this picture" and that it is Edward Randolph, "a person famous in the history of New England" ("ER," 261). Since Randolph is famous as a late-seventeenth-century colonial agent who trampled the rights of the people, Alice Vane postulates that his portrait continues to hang in the Province-House to remind successive generations of "the awful weight of the People's curse" ("ER," 262). She undertakes to restore the painting and reveal the image.

Vane, we are told, has learned the science of art restoration in Italy. Readers of the tale today likely do not find it unusual that an act of art restoration would attempt to recover (or restore) an "original" depiction.[55] At the time in which Hawthorne wrote, however, art connoisseurs often agreed with British art patron Sir George Beaumont's (1753–1827) famous claim that "a

good painting, like a violin, should be brown."[56] Indeed, consensus seemed to be that "pictures, like coins, obtained a patina from age that mellowed their tone, and made them more valuable than in the state they left the painter's easel."[57]

Whether or not Hawthorne was aware of the specifics of what art restoration entailed in this period, his narrative emphasis on a painting in which layers of opaque history obscure an original depiction is significant. There is an important difference between the idea of wiping away dust and grime in order to reveal the origin or original beneath, and painting over in an attempt to breathe life into the dimmer depiction. The former action asserts the existence of a truth behind a representation (which it is the representation's job to evince), while the latter asserts that the truth exists only in the representation itself. When the representation in question is a portrait, such differing ideas about where meaning resides (in the subject himself or in the representation of that subject) have potentially radical implications for cultural conceptions about selfhood.

"Edward Randolph's Portrait" contains multiple references to characters throwing veils back or off, which echo its figuration of Alice Vane "restoring" a painting by peeling back layers to get closer to an original surface. Crucially, the painting she restores is a portrait, and the depiction she reveals is one in which the sitter's soul has revealed itself upon his face: "The expression of the face, if any words can convey an idea of it, was that of a wretch detected in some hideous guilt The torture of the soul had come forth upon the countenance" ("ER," 267). However, just as "The Prophetic Pictures" undercut its own narrative thrust of revelation, so does "Edward Randolph's Portrait." The revealed truth in the latter tale—the appearance of the "hideous guilt" upon Randolph's countenance—is only temporary. The painting assumes its darkened appearance once again after Hutchinson signs the order authorizing occupation: "If such a miracle had been wrought, no traces of it remained behind; for within the antique frame, nothing could be discerned, save the impenetrable cloud, which had covered the canvass since the memory of man" ("ER," 268–69).

As the story fades, as well, back into history, the Province-House narrator returns to suggest that since the painting is now "supposed to be hidden in some out-of-the-way corner of the New England Museum" that "[p]erchance some curious antiquary may light upon it there, and, with the assistance of Mr. Howarth, the picture-cleaner, may supply a not unnecessary proof of authenticity of the facts here set down" ("ER," 269). The "restorer" of a previous era has been supplanted by the "picture-cleaner" in the present

day, it now being assumed that an original is always discoverable underneath a representation. This picture-cleaner will presumably facilitate a process of repeated revelation. Edward Randolph, even in death, must repeatedly "gloom[] forth again" ("ER," 267), his interior state of guilt and psychological torture working its way outward toward the surface of the canvas only to then again disappear back into the gloom in an endless cycle of revelation and perilously willed forgetting.

Just as he selectively emphasized Dunlap's romantic account of a portraitist's preternatural powers of insight rather than Dunlap's reportage on the business of portraiture, in "Edward Randolph's Portrait," Hawthorne initiates a way of reading the art object—involving the peeling back of layers—that was unusual in the mid-nineteenth-century world where an idea of the original was accessed by piling on new layers, new colors, new meaning, rather than by stripping away to reach an earlier truth. This is not only a new way of reading the art object but also a new way of reading the person. In "Edward Randolph's Portrait," the person depicted in a portrait is "truly" revealed only once layers of history and discourse have been removed. This is a different version of personhood than the one he offers via Hepzibah's scowl, where there seems to be no "true" self outside of the cycle of representation. The difference, I want to suggest, is not incoherent but crucial: though Hawthorne's portrait fiction "probed . . . depths" and often endorsed the ideal of the truth hidden beneath layers, it also displays deep suspicion of that version of the expressive relationship between inner life and external appearance.

Hawthorne's portrait stories from the 1830s and 1840s highlight the portrait as a representational plane upon which cultural expectations about the human interior become visible. In these stories, I have been arguing, we see evidence that such expectations were slowly shifting to include the sense that the human interior is hidden but capable of being revealed, that such a revelation would take the form of a peeling back of layers, and that what is found behind those layers is the original. Crucially, however, these tales that indulge dramas about *finding* a true, inner self are always, as we have seen, also engaged in *making* the sorts of selves they purport to find. So, while Marcus Aurelius Root's advice to painters and photographers assumes that inner life can be coaxed out onto the plane of representation, and while Jaffrey Pyncheon's daguerreotype portrait shows us that photographic technologies promised to reveal that inner life even when it tried to hide, Hepzibah's scowl, in fact, emerges as the most suitable image for the complicated and recursive ways in which "psychology" was brought to the surface in the nineteenth century.

"I Veil My Face"

In "The Old Manse" the introduction to his short story collection *Mosses from an Old Manse* (1854), Hawthorne offers a number of extended metaphors that work as figures for aesthetic practice, artistic interpretation, understandings of the soul, selfhood, and community, and the relationship between history and present. The introduction is set amidst the Old Manse itself (Hawthorne's family's home at the time), the "slumbering river" upon which he and his companion Ellery Channing float, the vegetable garden, and the neighboring Revolutionary battleground, and Hawthorne brings the reader on a walk around the property on which he lives, and spins these metaphors out, wondering what "lesson" may be drawn from blossoming summer-squashes, from attics crowded with books, from the reflective images on the surface of a slow-moving river.[58] At the end, curiously, Hawthorne draws back from the implication that he has revealed anything about himself—nothing "too sacredly individual" ("Manse," 25)—in the process of writing this sketch. Though the entire piece is framed as an entrance (the reader passes through "two tall gate posts of rough-hewn stone" in the first sentence ["Manse," 3]), and the bulk of the narration figured as though the narrator is taking the reader *inside* various places and situations, at the end Hawthorne avers: "Has the reader gone wandering, hand in hand, with me, through the inner passages of my being, and have we groped together into all its chambers, and examined their treasures or their rubbish? Not so. We have been standing on the green sward, but just within the cavern's mouth, where the common sunshine is free to penetrate, and where every footstep is therefore free to come" ("Manse," 25).

The "green sward" is just where Hawthorne wants his readers, aesthetically; it is a new place that would come to shape not only literary imagination but also psychological knowledge: a place where one is always poised to—yet never quite managing to—find out a hidden truth, a precarious emotional state that almost always incites discourse about the self. Crucially, as Hawthorne makes the rather astounding claim that, despite "The Old Manse's" structure of revelation *nothing has been revealed*, he asserts "So far as I am a man of really individual attributes, I veil my face; nor am I, nor have ever been, one of those supremely hospitable people, who serve up their own hearts delicately fried, with brain-sauce, as a tidbit for their beloved public" ("Manse," 25). This veiled face, absent expression, echoes another face in the introduction that also remains a blank: that of the clergyman whose portrait, "a tattered and shrivelled role of canvass" ("Manse," 13), hangs in the attic. When the narrator is surprised by the vibrancy of the worlds represented in

"a few old newspapers, and still older almanacs . . . as if I had found bits of magic looking-glass among the books, with the images of a vanished century in them" he asks the clergyman in the portrait whether the clergy "after the most painful rummaging and groping into their minds, had been able to produce nothing half so real, as these newspaper scribblers and almanacmakers had thrown off, in the effervescent of a moment" ("Manse," 16).

This accused old portrait, symbolic of a lineage of religious guilt and shame, remains silent. Hawthorne had long registered dislike for these kinds of old portraits; as mentioned above, he goes into great detail describing in his notebook a selection of seventeenth- and eighteenth-century portraits he saw during a visit to the Essex Historical Society in 1837, the same year he composed "The Prophetic Pictures":

> Governor Leverett, a dark mustachioed face, the figure two-thirds length, clothed in a sort of frock-coat, buttoned, and a broad swordbelt girded round the waist Sir William Pepperell in English regimentals, coat, waistcoat, and breeches all of red broadcloth, richly gold-embroidered; he holds a general's truncheon in his right hand Endicott, Pyncheon, and others in scull-caps, etc. Half a dozen, or more, family portraits of the Olivers, some in plain dresses, brown, crimson, or claret, others with gorgeous gold embroidered waistcoats Ladies, with lace ruffles, the painting of which, in one of the pictures, cost five guineas. (AN, 67)

The details he notes situate the depicted individuals in varying social roles and label them as belonging to certain classes; he does not mention details of facial expression or any indication that these portraits communicate information about their sitters' psychological or emotional states. He follows up his description of the portraits with this editorial comment expressing dissatisfaction with the aims of aristocratic, familial, or military portraiture from previous eras: "Nothing gives a stronger idea of old worm-eaten aristocracy, of a family's being crazy with age, and its being time that it was extinct, than these black, dusty, faded, antique-dressed portraits" (AN, 155). Even a cursory glance at the portraits he describes here might leave a twenty-first century viewer scratching her head (figures 8 and 9).

These do not appear to be images of the kind of maniacal patriarchs that haunt his fiction. Hawthorne's production of such a back story for them has everything to do with the increasing emphasis in his plots on moldering personal and familial secrets, an emphasis that plays a large part in relocating truths about individuals inside.

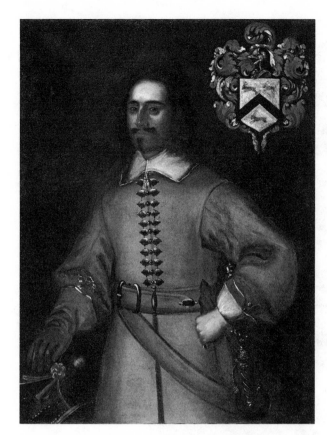

FIGURE 8 Sir Peter Lely (British), *Portrait of John Leverett*, 17th century, oil on canvas, English, Massachusetts Bay Colony, 43 1/2 × 35 in. (110.49 × 88.9 cm). Courtesy of Peabody Essex Museum, gift of John Treadwell, before 1822, 106819. Photography by Mark Sexton.

The production of such a backstory also demonstrates how malleable the social and cultural functions of portraiture are. Regardless of their aesthetic standing, portraits were *the* works of art individuals and families in colonial and eighteenth-century America commissioned. Of the dominance of the portrait in this previous era, Margaretta Lovell notes that Americans "did not buy landscapes, still lifes, or genre scenes; they did not even branch out into portraits of horses or houses. They focused solely—but enthusiastically—on portraits of individuals, couples, and, occasionally, families Portraits, it seems, occupied a different niche in mimetic ecology; they did not so much displace rivals as actively fulfill a specific, chronic, social need."[59] Hawthorne, in his fiction of the 1830s and 1840s, offers portraits in his fiction that, rather than fulfilling conventional needs (marking time in a life, evidencing wealth, recording lineage) produce new "chronic" needs in himself and his readers. Hawthorne's portrait stories stand out because of their

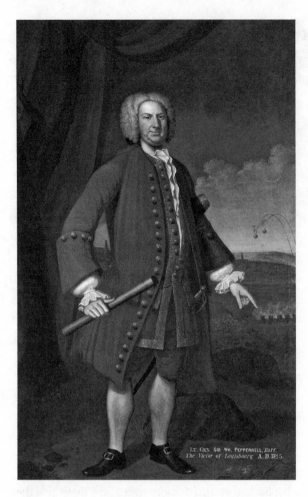

FIGURE 9 John Smibert (American, 1688–1751), *Portrait of Sir William Pepperrell*, 1746, oil on canvas. Boston, Massachusetts, United States, 96 × 56 in. (243.84 × 142.24 cm). Courtesy of Peabody Essex Museum, gift of George Atkinson Ward, 1821, 106806. Photography by Mark Sexton.

insistence — at a time when the practice of portraiture was a burden for ambitious artists — that portraits convey important meaning about sitters, viewers, and the world in which each lives; meaning that goes beyond mere information about class status and gender norms.

Significantly, these silent and veiled faces from "The Old Manse" simultaneously destabilize established portrait conventions (the old clergyman's portrait is powerless, tattered, hidden) but also introduce new portrait functions (the representation of depth) as similarly unstable. The new portrait function — to provide access to the winding depths of an inner chamber — is anchored not in stable markers of class or gender identities, but in faces — changeable expressions, interactive and malleable. Like the surface of the river that Hawthorne describes in detail in "The Old Manse," the face

can be reflective and still, occluded by strange weather and mud, a thing of its own volition or representative of some deeper truth. "Which, after all, was the most real—the picture, or the original?" ("Manse," 22) the narrator in "The Old Manse" asks, of the river's reflection of the world around it. Hawthorne's haunted portraits and veiled faces create new forms of portraiture and new ways to understand inner life.

Hawthorne's fiction has long been read in the context of changing ideas about subjectivity. Critics and theorists have read in its gothic elements, proto-modernity, and affective political structures traces of fascinating invention that prodded "common" sense ideas about selfhood, history, national belonging, and a burgeoning sense of the unconscious.[60] Other more historicist thinkers have identified the importance of the invention of photography and especially of daguerreotype portraiture to Hawthorne's aesthetic innovations.[61] Sustained analysis of portraiture as one of Hawthorne's fundamental *methods* reveals how closely linked these two lines of analysis are. Hawthorne's fiction enacted innovations in "psychological" representation through the visual depiction of subjectivity that portraiture allowed him to capture and explore.

I have described my interest in Hawthorne's fiction repeatedly as a "case study," because beyond his status as a canonical, exceptional writer, the archival richness that exists around his aesthetic interest in portraiture allows us access to a wide-ranging cultural conversation about subjectivity—what it is, and why it might (or might not) matter *how* (by what methods, in what mediums, through what genres) we represent it. The 1840s witnessed the rapid and destabilizing proliferation of new portrait technologies, and writers, artists, and culture consumers were engaged in the process of figuring out what these technologies would provide and what they would mean. The effects of the invention of photography reached into every aspect of life and art production. What I have argued here is that, rather than a niche development that mostly affected popular and visual cultures, the invention of photography—as it sent its waves of influence and excitement through most all aesthetic forms and branches of the study of knowledge—generated new forms of interest in prising apart and renaming aspects of inner experience (from "soul" to "mind," for example). Hawthorne's portrait fiction works as a "case study" of this abundance of conceptual energy around the visualization of subjectivity, giving us new purchase on some of the key aesthetic developments in the mid-nineteenth century United States—new visual technologies, a gothic interest in the revelation of secrets, somatic psychologies—and how they intersect in the figure of the portrait.

CHAPTER TWO

Head

Writing the African American Portrait

At the end of "Benito Cereno," Herman Melville offers his readers a brutal image of the executed Babo, the self-liberated Black leader of the revolt aboard the *San Dominick*: "Some months after, dragged to the gibbet at the tail of a mule, the black met his voiceless end. The body was burned to ashes; but for many days, the head, that hive of subtlety, fixed on a pole in the Plaza, met, unabashed, the gaze of the whites."[1] Babo's ultimate voicelessness is a troubling end to Melville's novella, the only work of Melville's to directly address slavery.[2] His executioners place Babo's severed head on display to reassert the authority that the revolt had resisted. The substance of the ending, however, is not simply coincident with the events of the ending: the authority that brutalizes Babo's body and voice is clearly destabilized as the tale of race and reading, racism and epistemology comes to a close.

This final scene dwells on the visual/speculative economy of slavery in which whites survey Black bodies and in which Black people are rarely afforded the opportunity of self-representation (whether legal, aesthetic, visual, or textual).[3] The end of *Benito Cereno* highlights how Babo, as a Black man, is always *represented* by others, rarely *representing* himself.[4] This truth was deeply felt by Black writers in the nineteenth century, who understood themselves, always, to be writing *against* the racist depictions that appeared in print and popular culture, in text and in image.

In this chapter, I explore the cultural significance of portraiture for nineteenth-century African American writers who addressed racist visual culture in their texts. Writing in *The Liberator* in 1832, Maria Stewart used the phrase "head work" to enjoin Black women to turn their attention to education: "The Americans have practiced nothing but head work these 200 years, and we have done their drudgery."[5] Though Stewart specifically refers to self-improvement through education, the phrase "head work" is a useful one for the study of nineteenth-century Black writers' engagement with portraiture. What sort of "head work" did portraiture encourage or allow for Black individuals in the nineteenth century? How do nineteenth-century African American conceptions of selfhood and subjectivity intersect

(or not) with the forms of "recursive selfhood" that Hawthorne's portrait fiction helped create?

Black American writers engaged the portrait in their texts to both question and reframe the connections between portraiture and personhood. In speeches, editorials, novels, and autobiographical writing, many Black writers—here I consider writing by Frederick Douglass, Hannah Crafts, Frank J. Webb, and Harriet Jacobs—used the example of portraiture to highlight how central race and racism were to emergent ideas about selfhood at mid-century. They championed the power of portraiture to assert and document a sitter's humanity while also remaining skeptical of the Hawthornian fantasy of revelatory portraiture. The head work of nineteenth-century African American writers' commentary on portraiture asserted an ethics of visual representations of the Black body and offered provocatively fresh visualizations of subjectivity and inner life. Perhaps most interestingly, Black writers often deliberately toyed with the question of "likeness," holding out for what Douglass called "a more perfect likeness," that, in its perfection, seemed to come untethered from likeness altogether. In this way, these writers presaged later proto-modernist ones like Henry James, who saw the portrait as a form through which to *sever* the connections between exterior appearance and inner life.

Frederick Douglass's *My Bondage and My Freedom* (1855) captures the complicated relationship African American writers had to the portrait in the nineteenth-century. In this version of his autobiography, Douglass directs his readers to an engraved portrait in James C. Prichard's *The Natural History of Man* (1843) as part of his painfully slender recollection of his mother. "My knowledge of my mother," Douglass writes, "is very scanty, but very distinct. Her personal appearance and bearing are ineffaceably stamped upon my memory. She was tall, and finely proportioned; of deep black, glossy complexion; had regular features and, among the other slaves, was remarkably sedate in her manners. There is in Prichard's *Natural History of Man*, the head of a figure—on page 157—the features of which so resemble those of my mother, that I often recur to it with something of the feeling which I suppose others experience when looking upon the pictures of dear departed ones."[6] The image to which he refers (figure 10) is a rather crude engraving of a statue of the Egyptian Pharaoh Ramses II.

This odd reference to an ancient male ruler has puzzled readers from its first appearance. In his landmark 1855 introduction to *My Bondage and My Freedom*—which was the second of three different retellings of Douglass's

EGYPTIAN RACE. 157

Rameses. It is thought by Mr. Martin* to resemble the
second Egyptian type described by Blumenbach, namely,
that which approaches the Hindoo.

Fig. 48.

Head of Rameses.

In this figure, it is observed that "the general expres-
sion is calm and dignified; the forehead is somewhat flat;
the eyes are widely separated from each other; the nose is
elevated, but with spreading nostrils; the ears are high;
the lips large, broad, and turned out, with sharp edges;
in which points there is a deviation from the European
countenance."†

* See Mr. Martin's " Natural History of Mammiferous Animals,"
&c. 8vo. Plates. London, 1841.
† Ibid.

FIGURE 10 "Head of Rameses," etching, in James C. Prichard, *The Natural History of Man* (London: Hippolyte Bailliere), 1848. HathiTrust. https://hdl .handle.net/2027/njp .32101068189628 ?urlappend=%3Bseq=11

life—James McCune Smith noted quizzically that "The nearness of [the en-graving's] resemblance to Mr. Douglass's mother, rests upon the evidence of his memory, and judging from his almost marvelous feats of recollection of forms and outlines recorded in this book, this testimony may be admit-ted."[7] Critics have always been confused by the disconnect between Doug-lass's textual portrait of his mother and the visual portrait to which he directs his readers. Those critics who have addressed this weird moment directly tend to dwell on Douglass's views on racial identity, racial ethnography, and his "psychological" motivations for making such a comparison.[8]

Yet while critics have puzzled over the specific meaning of Douglass's ref-erence to the Ramses image, no one has noted the complexity of the seem-ingly simpler point that Douglass chose to introduce a portrait (i.e., any portrait) here at all. I justify such an abstracted reading of the portrait because

Douglass himself does as well; he characterizes his relationship with this portrait as like the one "others" have with depictions of "dear departed ones." His remarks succinctly capture the peculiar relationship many antebellum African Americans had with the portrait. Frederick Douglass, obviously, does not have in his possession a portrait of his mother. All too aware of the form's cultural ubiquity, and of the affective uses to which the ubiquitous product was put by white Americans—here as a *memento mori*—Douglass recognizes that his *not having* a portrait of his mother is both limitation and opportunity. This particular sort of aesthetic disenfranchisement simultaneously denies African American claims of intellectual and emotional parity *and* allows for remarkable acts of imagination like the one discussed here, in which Douglass is simultaneously dead serious and tongue-in-cheek in suggestively presenting himself as looking to an image of an Egyptian pharaoh the way Hepzibah looked at Clifford's Malbone miniature in *The House of the Seven Gables.*[9]

Tracing the appearance of the portrait in a selection of writings from the 1850s and 1860s by African American writers Frederick Douglass, Harriet Jacobs, Hannah Crafts, and Frank J. Webb, this chapter focuses on the specific ways that these authors employ the figure of the portrait and the language of portraiture to mediate the same vexed questions about subjectivity, interior depth, and the developing language of psychology with which Hawthorne was concerned. Confronting the white-authored "portrait" images of Black people that circulated in the antebellum period in the form of fugitive advertisements and other print ephemera, and offering their own alternatives to such "portraits," these authors arrived at insights regarding the social construction of sight, or "ways of seeing." Further, they reclaimed the power that inheres in looking *and* depiction, and offered a series of counternarratives to the developing consensus about what function visual technologies and portraiture would play in American culture as the century progressed.[10] The portraits that appear in the fictional and editorial writings considered here repeatedly make visible the aesthetic processes through which surfaces come to represent depths in the nineteenth century. In multiple textual genres (essays, speeches, letters, novels, narratives of enslavement), Black writers employ portraiture as a form of "head work"—an assertion of Black humanity, a manifestation of consciousness and imaginative rumination.

Crania Americana

One of the most likely reasons Douglass invoked Ramses II as his maternal forebear in *My Bondage and My Freedom* was as a direct counter to popular

"scientific" conclusions that ancient Egyptians were Caucasian rather than African. Samuel George Morton, Philadelphia physician and anthropologist, had published his *Crania Americana, or, a Comparative View of the Skulls of Various Aboriginal Nations of North and South America. To which is Prefixed an Essay on the Variety of the Human Species* in 1839. Morton's study is often considered to mark the origin of modern scientific racism in the United States; in its own day, it wielded great influence over the even more vicious "science" of polygenists Louis Agassiz, Josiah Nott, and George Gliddon.[11] In the prefatory essay, Morton ranks the human races by cranial capacity and provides scientifically racist descriptions that link physical appearance with intellectual and emotional endowment: "The Caucasian Race," he writes, "is characterized by a naturally fair skin, susceptible of every tint; hair fine, long, and curling, and of various colors. The skull is large and oval, and its anterior portion full and elevated This race is distinguished for the facility with which it attains the highest intellectual endowments," while Native Americans are "marked by a brown complexion; long, black, lank hair; and deficient beard. The eyes are black and deep set, the brow low, the cheekbones high, the nose large and aquiline In their mental character, the Americans are averse to cultivation, and slow to acquire knowledge; restless, revengeful, and fond of war." And still further, Africans are "[c]haracterized by a black complexion, and black, woolly hair; the eyes are large and prominent, the nose broad and flat, the lips thick, and the mouth wide In disposition the Negro is joyous, flexible, and indolent; while the many nations which comprise this race present a singular diversity of intellectual character, of which the far extreme is the lowest grade of humanity."[12] One of the most basic gestures of mid-century scientifically racist ethnography was the correlation of "complexion" and "character."

The contemporaneous reviews of Morton's volume crowed about the thorough nature of his research methods and the lavish illustrations that appear in the book. Describing Morton's approach to his subject as one characterized by "zeal and industry," one anonymous reviewer goes on to note in the first paragraph of the review that "no labor or expense has been spared to render it worthy of the subject. 'Many of the plates have been drawn the second and the third time; and in several instances the entire edition has been cancelled, in order to correct inaccuracies which had previously escaped observation.'"[13] The illustrations that appeared in Morton's volume, along with later iterations of such images in compendiums such as Nott and Gliddon's 1854 *Types of Mankind*, are early articulations of the visual racism that would structure the eugenicist movement later in the century. Indeed, the

importance of visual typologies is explicitly noted by most of the participants in the mid-century American School of Ethnology. Nott declared, "However important anatomical characteristics may be, I doubt whether the *physiognomy* of races is not equally so. There exist minor differences of features, various minute combinations of details, certain palpable expressions of face and aspect, which language cannot describe: and yet, how indelible is the image of a *type* once impressed on the mind's eye!"[14]

Frederick Douglass addresses the American School's use of "portraits" as scientific "evidence" of racial inferiority in his speech "The Claims of the Negro Ethnologically Considered," delivered at Western Reserve College on July 12, 1854. He opens the speech by mimicking the "scientific" discourse of the day. He provides his listener with a hypothesis that he finds printed in a Richmond newspaper, the theory that "the Negro" is not a man. He then proposes three ways to address such a hypothesis: "one is by ridicule; a second is by denunciation; and a third is by argument."[15] Douglass proceeds to "argue" the point that "Negroes" are, in fact, people. The cumulative effect of his beginning with a number of pointed references to the inanity of having to make such an argument formally and rhetorically echoes his content. After providing "evidence" in the style of Morton and Nott to counter these men of science's attempts to "read the Negro out of the human family" ("Claims," 295), Douglass concludes by eviscerating such "scientific" approaches to the question of race by offering an analysis of the portrait images printed in volumes such as Morton's:

> It is the province of the prejudice to blind; and scientific writers, not less than others, write to please, as well as to instruct, and even unconsciously to themselves, (sometimes) sacrifice what is true to what is popular. Fashion is not confined to dress; but extends to philosophy as well—and it is fashionable now, in our land, to exaggerate the differences between the Negro and the European. If, for instance, a phrenologist, or naturalist undertakes to represent in portraits, the differences between the two races—the Negro and the European—he will invariably present the *highest* type of the European, and the *lowest* type of the Negro. ("Claims," 298)

He continues with a long description of the ways that images of the "European face" are calculated to convey "beauty, dignity and intellect," while "The Negro, on the other hand, appears with features distorted, lips exaggerated, forehead depressed—and the whole expression of the countenance made to harmonize with the popular idea of Negro imbecility and degradation"

("Claims," 298). He provides a unique glimpse into his own experience of popular visual culture when he mentions that he has "seen many pictures of Negroes and Europeans, in phrenological and ethnological works" and ultimately concludes that "[t]he importance of this criticism [of popular images of African Americans] may not be apparent to all; — to the *black* man it is very apparent. He sees the injustice, and writhes under its sting" ("Claims," 299).[16] Douglass sees clearly that texts like *Crania Americana* employ portrait depictions precisely because this type of "head work" is so deeply resonant.

Habits and Types

In "Claims of the Negro," Douglass focuses on the portraits of Black people that appear in phrenological and ethnological texts. He also subjected the standardized image that illustrated many fugitive notices to his own scrutiny. Fugitive notices advertising and soliciting the capture of the self-emancipated formerly enslaved were by far the most ubiquitous depictions of African Americans in the antebellum period (figure 11).[17]

Marcus Wood identifies the fugitive notice in particular as a perfect example of just how incoherently the enslaved were represented in antebellum print culture. Wood observes that "the texts of the runaway advertisements challenged the abstraction of slave into property because they foregrounded the personal peculiarities of slaves," an observation that antebellum abolitionists made as well.[18] In their view, these advertisements "provid[ed] an ever-rolling, self-generating flood of evidence which damned the slave owners out of their own mouths" (*BM*, 83). But fugitive advertisements often at least partially preserved their ostensible purpose by suturing a repetitive, standardized illustration to a much more specific textual description of the fugitive person. Wood argues that the use of these icons, repeated from one particularized description of an enslaved person to the next, both defused the individualizing power of the textual description and "possessed a terrible semiotic inertia, the reassuring familiarity of a currency worn smooth with handling" (*BM*, 92). In Wood's account, the possibility that coheres in the particularizing *text*—that an enslaved person might be human and unique—is defeated by the dehumanizing and abstracting *image* in fugitive notices.[19]

Wood's term, "semiotic inertia," referring to the seemingly static nature of the visual symbol, is perhaps not quite accurate, given that both elements of the fugitive notice (text and stock image) seemed to possess a remarkable semiotic *fluidity*. For example, the image was used to illustrate both advertisements for the capture of the self-emancipated, as well as to illustrate up-

FIGURE 11 "Runaway," *Columbus Democrat*, August 18, 1838. Library of Congress, Chronicling America: Historic American Newspapers, http://chroniclingamerica.loc .gov/lccn/sn83016867/1838-08-18/ed-1/seq-4/

coming auctions and advertisements of "negroes for hire" (figure 12). That the same typographic character is used in connection with both the sale and recapture of enslaved people implies that a person at auction is a person who will flee, an implication that at least partially undoes the logic of slavery. This representative column of advertisements from *The Mississippi Free Trader* of June 11, 1851, displays the slippery boundaries and unstable meanings this supposedly inert image could take on. The absurdity of illustrating an advertisement of "a large lot of NEGROES" for sale with a depiction of a person in flight from this system of enforced labor is abundantly clear. This is the sort of incoherent visual/textual representation of slavery that Wood notes abolitionists seized on to prove their case. But directly above an advertisement of "Negroes" for sale is a notice for Bennett's Daguerrian Gallery, claiming the ability to produce "*better* Daguerreotype Portraits, than can be procured, at any other establishment in the South." The absurdity of *this* juxtaposition—of the "superior picture, in regard to resemblance, natural expression, and gracefulness of arrangement" offered to Bennett's white clients with the "portraits" of slaves stamped just below—is particularly suggestive. The

FIGURE 12 *The Mississippi Free Trader,* June 11, 1851.

visual rhetorics of nineteenth-century American selfhood take shape through these juxtapositions. Who gets to be depicted with gracefulness and natural expression? What would a "superior" portrait of a Black American look like?

Douglass set about trying to answer these questions. In an issue of *The North Star*, Douglass launches a textual-visual assault on the fugitive stereotype, employing both his pen and his eye to critique the hybrid form. The stock image was particularly vexing to Frederick Douglass, a fugitive himself, as both a newspaper printer and antislavery activist, and on February 22, 1850, Douglass editorializes against it. The editorial begins by registering the standard abolitionist shock at fugitive notices and advertisements appearing in the *St. Louis Republican*, "a *respectable* newspaper" (emphasis in original) and points out the obvious contradiction between these advertisements and slaveholders' disingenuous claims to be "hind [sic] and amiable master[s]." Importantly, however, Douglass reserves special comment for the images that originally illustrated the fugitive notices but which he has omitted upon reprinting in *The North Star*: "We have copied the following list of advertisements from a single number of the St. Louis Republican. To each of the advertisements, as it stood in the Republican, is prefixed the figure of a human being, as if in the act of running. We have no such figures nor prints in our office, to enable us to follow copy; but the reader must supply them for himself."[20] Douglass offers a noteworthy reading of the images, emphasizing that the figure depicted is, indeed, a "human being," while simultaneously destabilizing the relation between representation and reality—"*as if* in the act of running" (emphasis added).

Most remarkable of all is Douglass's explicit statement that the image is a graphic element that *The North Star* had not purchased from type suppliers. Wood traces the development of the image from its European origins as an advertisement for missing persons or servants to its flourishing in antebellum American print culture: "[The image] was standardized to the extent that it was quite simply a typographic character. The printer's stock books which came out in the big Northern cities, from the 1830s right up until the eve of abolition, carried this image at a variety of prices in a variety of sizes Northern printing firms sent their specimen books down South and printed up orders for the Southern market" (*BM*, 87). Douglass highlights the suggestive connection between the production of the stereotype in the North and the deployment of the figure through mechanical reproduction throughout the South. He calls attention to the reader's likely familiarity with the image as a common material object manufactured by print foundries and bought by printing offices. While Douglass made a point of claiming that he

FIGURE 13
George A. and
J. Curtis (Boston),
*Specimen of Modern
Printing Types and
Ornaments, Cast at
the New England
Type and Stereotype
Foundry,* 1841.
Newberry Library.

had never purchased such a piece of type, he certainly had flipped past it while deciding which others he would purchase out of the circulated specimen book. This representative page from one such specimen book (produced by a foundry in the North) (figure 13) shows how the fugitive stereotype was just one among many everyday illustrative elements that a newspaper office would or could use in any given issue.

Significantly, Douglass's direct commentary on that piece of type in his February 22 editorial was not that issue's only reference to the stock image of the fugitive who has liberated themselves from enslavement. The issue also

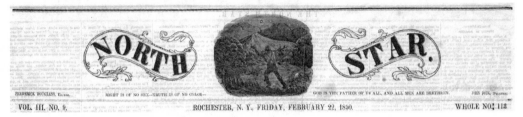

FIGURE 14 Masthead, *The North Star*, June 2, 1848. Library of Congress, Serial and Government Publications Division.

FIGURE 15 Masthead, *The North Star*, February 22, 1850. Special Collections, Lavery Library, St. John Fisher College, Rochester, NY.

contained a powerful visual commentary on the stereotype. The month before, in January 1850, *The North Star* had changed its masthead, replacing the plainly typographic masthead the paper had borne for two years (figure 14) with an elaborate new version (figure 15).

Not much is known about the decision to switch to this new masthead, nor about the paper's return in the early fall of 1850 to a slightly different version of the original typographic title, but the image that graced the cover of *The North Star* each week for nine months is a striking one. Depicting a man in work clothes running through a claustrophobic nightscape, the image plays on the stock typographic figure used to illustrate fugitive notices, and against which Douglass editorialized in his February 22 column. Replete with stick and bundle, the figure in the image cites the recognizably static figure only to explode it. Pushing off one foot, the man is in motion, his arms outspread with his back to the reader as he rushes toward the North Star, the guidepost to freedom glowing above the threatening landscape. The stick and bundle rest lightly on his shoulder, his burdens metaphorically lifted through the act of self-liberation. Unlike the emancipated person depicted on the masthead of William Lloyd Garrison's *The Liberator* (figure 16), who kneels in passive supplication to the figure of a white savior, the man atop *The North Star* is caught in motion, depicted as taking control of his fate without external

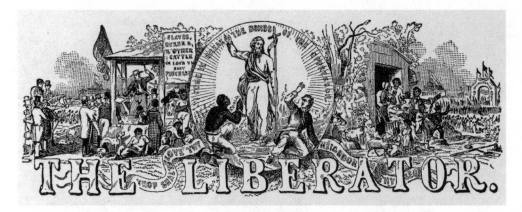

FIGURE 16 Facsimile masthead, *The Liberator*. General Research & Reference Division, Schomburg Center for Research in Black Culture, The New York Public Library, Astor, Lenox and Tilden Foundations.

assistance, white or Black. The conventions of the image teach the viewer to regard him as in flight from enslavement, but the image itself makes no concessions to the man being any type of chattel. The issues of *The North Star* bearing the new masthead deliberately align text and image to powerful effect. The image illustrates the meaning of the paper's name and emphasizes the connection between the fugitive act and subsequent power of self-representation. The masthead offered readers of *The North Star* a way to read fugitive iconography against its own grooves; it offered a different sight.[21]

Douglass launched a multimedia assault on the standardized visual representation of enslaved persons, the images that were *the* iconic visual representations of the enslaved in the 1840s and 1850s. Other antebellum Black writers also wrote *against* this image. Assuming that their readers could picture the stereotype in their minds, Black writers exploited this perversely shared visual literacy to rework the volatile semiotics of the image. Harriet Jacobs does so by composing a fictional advertisement in the pages of *Incidents in the Life of a Slave Girl* (1861). When Jacobs fled enslavement by Dr. James Norcom in 1835, her former enslaver ran an advertisement in *The American Beacon* offering a hundred dollar reward for her capture (figure 17). Norcom dwelled almost luridly on embodied details such as Jacobs's skin tone, "thick and corpulent habit," "thick covering of black hair," and "gay and fashionable finery."

In her modification of this advertisement drafted for inclusion in the narrative about "Linda Brent," Jacobs makes a number of key changes:

$300 REWARD! Ran away from the subscriber, an intelligent, bright, mulatto girl, named Linda, 21 years of age. Five feet four inches high. Dark eyes, and black hair inclined to curl; but it can be made straight. Has a decayed spot on a front tooth. She can read and write, and in all probability will try to get to the Free States. All persons are forbidden, under penalty of the law, to harbor or employ said slave. $150 will be given to whoever takes her in the state, and $300 if taken out of the state and delivered to me, or lodged in jail.

— DR. FLINT

Most notably, Jacobs raises the reward to three hundred dollars, and the first adjective she uses to describe the self-liberated Linda Brent is "intelligent."[22]

By revising the "real life" text in this way, Jacobs presents an ekphrastic self-portrait that simultaneously increases her value and disembodies herself by emphasizing the mental acuity of the escaped Linda Brent rather than her physical features. She then re-embodies the same figure by including the following strangely affecting detail not in Norcom's description: "Has a decayed spot on a front tooth" (*Incidents*, 97). Fugitive advertisements often read as litanies of identifying infirmities and injuries, offering self-indicting evidence that enslavers cruelly marked their captives' bodies—whether by whippings and wounds or through malnourishment and chronic illness. The "decayed tooth" interrupts the notice's descriptions of Linda Brent's intelligence and her ability to read and write; that is, the power of her mind. Like Norcom's luridly embodied description, the detail is meant to be arresting in a literal sense—the "decayed spot" is offered as a tool for detection. But in the narrative twilight that exists between Brent's life and Jacobs's life, the "decayed spot" is a clue, an identifying mark that perhaps links the real woman to the imagined. Directly contrasting the stock figures used to illustrate fugitive notices, the "decayed spot" is private, personal, and individualized, providing visual testimony of a bodily depravation that is also keenly felt by the mind.

Norcom uses the word "habit" to refer simultaneously to Jacobs's dress, bodily appearance, and disposition. His description fuses external appearance with internal character and implies that Jacobs was thick of mind as well as of frame.[23] Norcom claims that Jacobs has a "thick and corpulent habit" to offset the fact that "she speaks easily and fluently," a phrase that only barely conceals the implication that she is able to read and write. Norcom's physical description of Harriet Jacobs is minutely calibrated as a counterweight to the threatening possibility that his "property" has a life of the mind, a mind that is its own. Jacobs, in rewriting her own fugitive notice, interrupts the indexing of Brent's intellect (which is expressed textually, through an assertion of her literacy) with a visual reminder of malnourishment and bodily neglect. The original notice urges *white* eyes to detect Jacobs's enslavement in the sluggish "habit" that confirms her natural state as bondswoman; Jacobs's revised notice urges *human* eyes to detect the mistreatment suffered by a woman wrongly enslaved and insists that her "habit" is one of mind.

When read together, Douglass's multimedia re-vision of the distressingly familiar standardized images of enslaved persons and Harriet Jacobs's rewriting of James Norcom's textual portrait of her give us a sense not only of the visual culture Black writers were writing *against*, but also, and more importantly, of the sort of visual culture they were, in turn, cultivating.[24] In the

next sections, I'll turn my attention to the latter, in order to explore the imagery and metaphors that flowered out of Black writers' engagement with portraiture and portraiture's evolving role in representing inner life.

The Luxury of a Likeness

"Daguerreotypes, Ambrotypes, Photographs and Electrotypes, good and bad, now adorn or disfigure all our dwellings Men of all conditions may see themselves as others see them. What was once the exclusive luxury of the rich and great is now within reach of all. The humblest servant girl, whose income is but a few shillings a week may now possess a more perfect likeness of herself than noble ladies and even royalty, with all its precious treasures, could purchase fifty years ago."—Frederick Douglass, "Lecture on Pictures" (1861).[25]

In a speech given as part of the Parker Fraternity Lectures at the Tremont Temple in Boston, Frederick Douglass celebrated photographic technology for its role in democratizing portraiture. Placed in relation to his critique of the fugitive stereotype, Douglass's embrace of the photograph almost certainly had to do with the form's ability to represent the "real" person. His class analysis of the form, however, also implies that he embraced the photographic portrait because it offered visual evidence of self-ownership. Harriet Jacobs also was intrigued by the relationship between social status and portraiture. In *Incidents in the Life of a Slave Girl*, Jacobs narrates her alter-ego protagonist Linda Brent's arrival in Philadelphia after fleeing enslavement in North Carolina. This wonderful chapter, titled "Incidents in Philadelphia," finds Brent taken in by the Reverend Jeremiah Durham and his family. Among the many eye-opening experiences Brent has upon arrival in the city, one stands out. Mrs. Durham, Jacobs writes, "took me to an artist's room, and showed me the portraits of some of her children. I had never seen any paintings of colored people before, and they seemed to me beautiful" (*Incidents*, 162). This experience articulates a foundational moment that can be found in African American literary production from Jacobs to Toni Morrison. This is the complicated moment of "facing"—of a Black American finding confirmation of her humanity in positive and nonracist visual representations of the Black self.[26] Jean Fagan Yellin speculates that in this scene Mrs. Durham and Linda Brent visit the Philadelphia painter Robert M. J. Douglass Jr., an African American artist who had been trained by white portraitist Thomas Sully. Samuel Otter offers a convincing reading of this scene as "self-reflexive": "Linda sees a kind of self-presentation that she has

not seen before. Commissioned by those with means, preserving their visages, such portraits convey a status, a permanence, and a visual authority. In some ways, this is a self-reflexive passage describing Jacobs's own artistic effort: her book, which she hopes will grant her a durable presence."[27] Otter's is an accurate reading of one aspect of the vignette as Jacobs is almost certainly invoking the portrait here as representative of a certain way of life. But the "seemed" in Jacobs's remark that the "colored" portraits "seemed to me beautiful" also contains an entirely different narrative about the nineteenth-century portrait. This narrative is less about the reflective qualities of the portrait and more about the portrait process, about the cultural literacy the production and reception of portraits requires or presumes, and about the possibilities for misrecognition, subterfuge, and evanescence (as opposed to "status," "permanence," and "visual authority") inherent in visual depictions of the contested self.[28]

The portraits, as Jacobs describes them, "seem" beautiful rather than "are" beautiful. The modesty of Jacobs's phrase is surprisingly suggestive as what at first appears to be a deauthorized aesthetic judgment evolves into critical commentary. Having never seen a portrait of a "colored" person before, and so having no basis for comparison, Jacobs seems uninterested in declaring whether or not the image "is" beautiful. Her phrasing is both a critique of how enslaved Black people were also aesthetically disenfranchised, in being disallowed contact with and expertise in aesthetic forms such as portraiture. But the phrase also carries within it an assertion of an artistic value system outside of the "visual authority" that has undergirded white supremacy in artistic and cultural expression. Portraits appear in nearly every canonical text written by an African American in the nineteenth century. On one hand, this is evidence that these writers were working in a nascently "realist" mode, describing the world as it exists (since in this world, many portraits existed). But on the other hand, we might allow that the portrait was a provocative form for these writers because it facilitated a self-reflexive exploration of what it means to have a face, to have that face represented, and to represent that face. And further, portraiture's centrality in Black writing from this era shows these writers, too, thinking hard about what, if anything, the appearance of a face indexes.

The reflexive quality of many Black writers' descriptions of portraiture is evidence that these writers found portraiture's developing cultural role as the visual representation of inner life and "deep" humanity to be at least partially troubling and definitely precarious. These writers were perceptively attuned to portraiture's cultural role in reproducing and consolidating the privileges

of whiteness. They understood portraiture to be deeply politically meaningful, and asserted that simply adding portraits of people of color to these perverted galleries of whiteness would never undo the visual logic that underpinned scientific racism, racial typologies, and lines of inheritance—all racist systems propped up, at least in part, by portrait conventions and aesthetics. There were more than enough good reasons for Black writers of the era to refuse portraiture as a valuable cultural aesthetic altogether. More than enough reasons to refuse its surveillant assumption that exterior appearance expresses something "true" about interiority.[29] More than enough reasons to refuse its function in reproducing the sentimental and financialized fantasy of "family" lines. Yet, for many Black writers, refusal interested them less than did speculative re-vision of how portraiture might participate in modernizing ideas about the human.

Portrait of a Lady

Consider, for example, how Jacobs's savvy revision of her own fugitive notice centers on a simultaneous solicitation and refusal of developing ideas about the portrait's ability to represent inner qualities. Like Hawthorne, repeatedly returning to the portrait in his fiction as a form through which he might theorize the relationship between the human interior and its representation in various literary forms, Harriet Jacobs exploited the portrait in her own fiction and correspondence as a figure through which she might do the same. Quite conscious of the demands, limitations, and opportunities of her own genre—the narrative of enslavement—Jacobs finds in the portrait a figure through which to challenge increasingly popular understandings of portraits as "windows into the soul" and of the enslaved person as an object that can be possessed by another.

In addition to being the year in which daguerreotypy was introduced in the United States,, 1839 also marked an aesthetic uprising of another sort. According to William L. Andrews, the number of published narratives of enslavement jumped from nine in the 1830s to twenty-five in the 1840s and continued rising until the end of the 1860s.[30] The simultaneous popularization of photographic portraiture and stories about enslavement was not merely a coincidence.[31] Textual descriptions of both the daguerreotype and of the enslaved in the antebellum periodical press often center on questions of truthfulness and objectivity in representing the human subject. Daguerreotype portraits quickly came to be associated with the revelation of certain truths about their sitters, even while these portraits were perceived as

magical and illusory.[32] Contemporary reviews of published narratives of en-slavement often emphasized the importance of what has come to be termed the "truth requirement." This truth requirement—the necessity that authors not take liberty with the facts of their enslavement lest proslavery apologists refute their testimony—insisted that authors of narratives of enslavement document their experiences as faithfully as possible, even though many for-merly enslaved narrators claimed that the horror of slavery was indescrib-able, that words failed to provide an accurate picture.[33]

The contention over the documentary nature of narratives of enslavement begs comparison with similar debates being waged in the novels, news-papers, and periodicals of the period over the photographic portrait's capa-city as "an agent of deeper spiritual revelation."[34] Formerly enslaved authors often turned to the language of visual portraiture to mediate the demands for truthful revelation, demands most powerfully evident in the "authenti-cating" editorial apparatuses by white figures of authority that framed their stories. These authenticating documents, however, were almost always in conflict with the subtle ways that narratives of enslavement made dynamic the interplay between truth and illusion, transparency and opacity.[35] Portrai-ture could be frank and tricky at the same time. It became a useful figure through which authors such as Harriet Jacobs evinced skepticism of the genre's truth requirement.

In 1853, eleven years after her escape from slavery, Jacobs was forty years old and in the domestic employ of well-known magazine writer Nathaniel Parker Willis and his second wife Cornelia in Cornwall, New York. That fall she took the eldest of her three charges, Imogen Willis, to New York City to have Imogen's portrait painted. While there, Jacobs and Imogen stayed with Nathaniel's journalist brother Richard, three miles from the studio where Imogen's likeness was taking form. Jacobs frequently was forced to walk the three miles to and from the artist's studio because Manhattan streetcar con-ductors often refused to allow a Black passenger aboard. Jacobs reported this inconvenience in a characteristically laconic remark to her friend, antislav-ery and women's rights activist Amy Post: "I had a long distance to go to the Artist and they refused one day to take me in the cars."[36] Richard Willis, meanwhile, publicly and dramatically denounced the injustice in the pages of his journal: "Occasionally, in the evening when completely exhausted, doubling her veil she could succeed, by the help of the little white, cherub face at the side of her, to gain admittance to a car or omnibus unchallenged. At other times, when she stood at the corner of a street and beckoned, the

driver would pass her by unheeded or the conductor would not seem to see her."[37] Willis's commentary explicitly highlights the visual currency that whiteness holds.

At thirteen, Imogen Willis was just two years younger than the formerly enslaved Jacobs had been when her predatory "master began to whisper foul words in [her] ear" (*Incidents*, 27). The contrast between Jacobs's "Perilous Passage" (*Incidents*, 53) at the age of fifteen and Imogen's upper-class experience of sitting for her portrait could not be starker. The portrait of Imogen would memorialize her shielded and unsullied girlhood, representing not only her physical appearance but also her innocence and quietude. Her deceased mother, Mary Stace Willis, had been known as "a girl of uncommon beauty and sweetness. In appearance she was of the purest Saxon type, a blonde, with bright color, blue eyes, light brown hair, and delicate, regular features. She had a gentle, clinging, affectionate disposition."[38] This memorial verbal portrait of Mary collapses "appearance" and "disposition," the outward beauty expressing inner purity, and indicates what sort of "Saxon" portrait would come of Imogen's sitting.

Back at the Willis estate in Cornwall, Jacobs sought out time to write what would become *Incidents in the Life of a Slave Girl*, telling Post in March 1854 that "with the care of the little baby the big Babies and at the household calls I have but a little time to think or write." In the same letter, Jacobs continues, "Yes dear Amy there has been more than a bountiful share of suffering given enough to crush the finer feelings of stouter hearts than this poor timid one of mine but I will try and not send you a portriature [sic] of feelings" (quoted in *Incidents*, 260). Jacobs here satirizes mid-century sentimental portraiture as an aesthetic form for which she has no use.[39] Having been forced to veil her own countenance so that she could accompany Imogen Willis as her young charge's "little white, cherub face" was being immortalized on canvas, Jacobs was no stranger to the ironies inherent to the very concept of African American portraiture. And yet simultaneously with this veiling, Jacobs had already begun to construct her textual self-portrait. The tension between Jacobs's skepticism about her own ability to engage in self-portraiture and her faith in the necessity of writing her personal narrative shapes her commentary on the early drafts of her text. Jacobs introduces the possibility that, unlike the "Saxon" portraiture of the Willis women, Black portraiture might be characterized by a disconnect or uneasy relationship between exterior "appearance" and interior "disposition." Rather than capitulate to this "Saxon" portraiture that required full disclosure, Harriet Jacobs begins

to articulate a theory of African American portraiture that exploits the potential of visual depiction to both reveal and conceal truths about the experience of enslavement.

In the March 1854 letter to Post relating the difficulty she was having finding time to write, Jacobs declares

> just now the poor book is in its Chrysalis state and though I can never make it a butterfly I am satisfied to have it creep meekly among some of the humbler bugs I sometimes wish that I could fall into a Rip Van Winkle sleep and awake with the blest belief of that little witch Topsy that I never was born but you will say it is too late in the day I have outgrown the belief oh yes and outlived it too but you know that my bump of hope is large. (quoted in *Incidents*, 260)

In this remarkably rich passage, Jacobs invokes Washington Irving's ironic story about the nation's founding, "Rip Van Winkle" (1819–20), in which the hen-pecked title character literally sleeps through the revolution that gave birth to a new nation. For Rip Van Winkle, the Revolutionary War was politically a zero-sum game; a new George was simply traded for the old, and "the changes of states and empires made but little impression on him."[40] Jacobs, however, sharpens the good-humored edges of this myth of national founding by whetting it on the stone of slavery, comparing Rip Van Winkle's pleasure at sleeping through a generation with Topsy's slavery-induced genealogical amnesia.

The repeated motif of thwarted transformation in this letter—the never-maturing caterpillar and amnesiac desire—implies not that Jacobs felt herself to be on the cusp between remaining veiled (as she was on the streets of New York) and tossing the veil aside, but instead that she was already in a position from which to critique the idea of her narrative as revelation. This critique here takes the form of her juxtaposition of stasis and narrative, space and time. She claims that "It is too late in the day" for her Rip Van Winkle fantasy, time has both progressed and stopped. When Jacobs writes, "I have outgrown the belief and outlived it too" she deftly contrasts the stasis of a belief left behind, of the stillness of a life already lived, against the onward motion of growth. Her phrenological "bump of hope" puns on the playful push her hope will give her, while again contrasting image and story by pitting the visually static "bump" against the temporal motion of "hope." Jacobs's humorous, intimate ("you know") invocation of phrenology takes the steam out of phrenology's potential for self-serious racism; Morton's skull "science" looks silly from this perspective.

Like Douglass, Jacobs confirmed the centrality of portraiture's social func-
tion as marker of middle-class status and expression of legally granted and
affectively felt personhood. But she troubled the developing cultural ten-
dency to coordinate the portrait's depiction of exterior appearances with an
expression of interior characteristics. Such a resistance both countered what
Bill Brown has called the "ontological scandal" of slavery, the confusion of
persons and things, as well as offered a critique of developing realist modes
of representation that would come to demand a "photographic" coordination
of depiction and reality.[41] Jacobs's literary offerings, fascinatingly, not only
articulate the reasons Black writers resisted such modes of representation,
but they also offer a wholesale reinterpretation of terms such as "realist" and
"photographic," proposing that both are socially constructed ways of seeing
the world, rather than teleologically arrived-at revelations of truth.

Jacobs's repeated invocations of portraiture and its proximate relation-
ship to the revelation of inner life are rich and pliable. She exploits the con-
ventional nature of portraiture to draw stark contrasts between her own
"portrait" as depicted by the disgusting Norcom and Imogen Willis's; she
resignifies the mid-nineteenth-century's intrinsically racist visual culture by
refusing its terms of revelation and evidence. As a text, *Incidents* is famously
framed as a salacious set of sexual revelations by Jacobs's editor Lydia Maria
Child. Because of a variety of material realities surrounding its publication—
the necessity of authenticating documents, for example—Jacobs did not
have full control over these presumed "revelations" about her life and expe-
rience of selfhood. She did not, in *Incidents*, have agency over her own veil:
Child writes, "This peculiar phase of Slavery [i.e., sexual violation] has gen-
erally been kept veiled; but the public ought to be made acquainted with its
monstrous features, and I willingly take the responsibility of presenting them
with the veil withdrawn." Given such a framework of visual revelation, it
makes sense that Jacobs would be both attuned to and wary of the terms of
visual disclosure of some kind of inner truth. Might it be more productive,
Jacobs asks—in her narrative, in her letters—to cultivate and maintain a self-
hood that inhibits revelation, that refuses narratives of transformation,
that exists fully and richly but in terms unavailable to the prying and distort-
ing eyes of enslavers and "sympathetic" whites alike?

Rearranging the Portrait Gallery

Jacobs engaged with portraiture as both material object ("I had never seen
paintings of colored people before") and way of seeing (the veil withdrawn).

Her layered attention to portraiture's various forms of power had a number of different effects. Jacobs calls into question how portraits often consolidate whiteness in the form of family lines and inheritance, leaving Black humanity outside the frame. She questioned the new photographic language of "truth" and "revelation" that was applied to portraiture's representation of selfhood, and explored the role of the aesthetic in constructing notions of inner life. And, finally, she used portraiture as an aesthetic form through which to offer alternative visions of Black history and Black sociality. In this final section, I want to look more closely at two portrait galleries that appear in works of fiction by Black writers in the 1850s. As I demonstrate in chapter 1, mid-nineteenth-century portrait fiction served an important role in sketching new ideas about personhood in literary works by authors such as Nathaniel Hawthorne. It is crucial to also look at fiction by Black writers from this era to understand more fully how portraiture mediated the vexed questions about personhood and inner life within the institutional and social contexts of the slaveholding United States.

Hannah Crafts's *The Bondwoman's Narrative* is possibly, if controversially, the first novel written by an African American woman.[42] It tells the story of Hannah, a young enslaved woman who gets drawn into the drama of the presumedly white woman who enslaves her. Named only "Mistress," this woman is being tormented by a man, Mr. Trappe, who knows that she is a "mulatta" and who has long been "the shadow darkening her life."[43] Though the novel features a rollicking number of Victorian plot contrivances, portraiture is one of the most important hinge figures in the narrative. Mistress's racial identity is revealed by the existence of a portrait of her enslaved mother; the novel draws explicitly on portraiture's power of revelation and consolidation of white authority. Yet the novel also speculates about portraiture's potency in other ways, specifically the art form's ability to awaken the mind and confirm humanity. It's worth thinking through how and why Crafts sets in motion these various nineteenth-century stories about portraiture's varied social and aesthetic powers.

Crafts highlights portraiture's social function in consolidating white authority in the story of Mistress's "true" racial identity. Mistress discovers she is "mulatto" when Mr. Trappe shows her a portrait of a woman who was presumably her mother, an enslaved woman:

"Do you know it?"
"It resembles me," I answered, "though I have never sate [sat] for my likeness to be taken."

"Probably not, but can't you think of some one else whom it resembles."
"The slave [Charlotte] Susan."
"And it was hers, and it is yours, for never did two persons more
 resemble each other" (*Bondwoman's*, 47).

Like the American School of Ethnologists, Trappe offers visual imagery as evidence meant to uphold the ideological project of racism. Trappe asserts that he has "discovered" Mistress's "true" nature, implying the irreducibility of racial identity and analogizing it to something "hidden" deep inside individual people. His perverted form of visual evidence, like chattel slavery itself, draws its power from white portraiture's assertion of familial lines of inheritance. This power has such force that Mistress's vision is obstructed by it. Where she might see in the portrait of her enslaved mother the evidence of sexual violation and white brutality that upheld chattel slavery via the bodies of Black women (and that she is an integral part of) she sees only, instead, her own death-in-life.[44] This exchange between Trappe and Mistress hinges on portraiture's power to reveal, which is here figured as commensurate with its consolidation of white power and authority.[45]

But the novel also contains a profoundly different vision of the power of portraiture. In its first chapter, Hannah is instructed to close the windows in a room that contains all of the family's ancestral portraits. The housekeeper that sends her on this "errand" instructs that she is "not to touch or misplace anything or loiter in the rooms" (*Bondwoman's*, 15). Hannah recounts the "strange legend" related to these portraits, that the original patriarch of the family, Sir Clifford, had "denounced a severe malediction" against any member of the family who removed any of the portraits or refused to have his portrait, along with his wife's, installed in the room. Such a requirement led to the room being lined with "a faithful transcript of [each inheritor's] person and lineaments, side by side with that of his Lady" (*Bondwoman's*, 16). Each inheritor, that is, except her current Master, who had hung his alone, without an accompanying depiction of Mistress.

On these walls we see depicted not just the inheritance of goods and status, but of white privilege, the missing portrait of Mistress indicating that she will be handily excised from such genealogical lines. Crafts's employment of such a gallery of portraits adheres closely to the conventional gothic evocation of the portrait as an oppressive power against which a hero or heroine must react. But as the set piece continues, Crafts dwells not on the oppressive power of these portraits' representation of "truth" but instead on the workings of her own imagination upon them.

But even as I gazed the golden light of sunset penetrating through the open windows in an oblique direction set each rigid feature in a glow. Movements like those of life came over the line of stolid faces as the shadows of a linden played there. The stern old sire with sword and armorial bearings seems moodily to relax his haughty [brow] aspect. The countenance of another, a veteran in the old-time wars, assumes a gracious expression it never wore in life; and another appears to open and shut his lips continually though they emit no sound. (*Bondwoman's*, 17)

She conjures out of these depictions of white privilege, of a system of inheritance and obscured labor, emotional and affective interior lives. As the portrait gallery scene proceeds, it becomes more and more clear that the novel evokes the conventional power of ancestral portraiture for specific ends: to allow Hannah's unique position as an enslaved person *looking* to rework the conventionally Gothic understanding of portraiture as always already surveilling, haunted, and socially oppressive. Rather than an oppositional relationship between Hannah's (alive, energetic) inner life and the (immobile) socially oppressive portrait depictions of the white owning classes, Crafts's novel shows how the portrait's surface invites an imagination of depth that in turn constitutes the viewing subjectivity. In other words, subjectivity does not exist *before* the encounter with the portrait and rise up to meet it—it is significant here that the portrait gallery scene is one of the first scenes in the novel—but that subjectivity itself is sparked, shaped, "crafted," by that encounter.

Though Crafts's focus on the portraits' representations of inner life may seem routine to us now, we must remember that her imaginative reworking of these portraits is fascinatingly on the cusp, just as Hawthorne's were, of making portraits into expressive objects. Her revision of these stern ancestral portraits is akin to Hawthorne's choice to eschew the old portraits from the Peabody and the "business" of portraiture as recounted by William Dunlap in favor of the expressive portrait in his fiction. And, like Hawthorne, Crafts was unsure where to locate the expressive power of the portrait. The reader exits the fictional portrait gallery wondering who the portraits are about. The sitters? The viewer (Hannah)? The (absent) artists? The writer (Hannah Crafts)? The genealogical portraiture that lines the portrait gallery is about family lines and inherited privilege; further, it is about the subjugation of viewing subjects to a particular social order. When Crafts puts the portraits in motion, inviting her literary alter-ego and the reader to read new

expressions into the stern faces, she diverts the unidirectional expression of social discipline and invites the reader to imagine the portrait as expressive of both the sitters' and the viewers' secret interiors.

Crucially, Crafts's reworking of white portraiture not only deauthorizes the form's consolidation of generational power, but also authorizes Hannah's mind. This opening vignette locates the awakening of the enslaved mind in the portrait gallery:

> Though filled with superstitious awe I was in no haste to leave the room; for there surrounded by mysterious associations I seemed suddenly to have grown old, to have entered a new world of thoughts, and feelings, and sentiments. I was not a slave with these pictured memorials of the past. They could not enforce drudgery, or condemn me on account of my color to a life of servitude. As their companion, I could think and speculate. In their presence my mind seemed to run riotous and exult in its freedom as a rational being, and one destined for something higher and better than this world can afford. (*Bondwoman's*, 17–18)

The portraits Hannah gazes upon were not originally meant by their creators to represent their sitters' interior lives; it is only by imagining that these people have interior lives (lives that might be belied by a dimple or an attempt to say something no one can hear) that she can have her own.

While not explicitly marked as particularly strange or aesthetically experimental, the portrait gallery scene that opens *The Bondwoman's Narrative* is further suggestive when considered alongside the strategies being used by mid- to late-nineteenth-century Black performers and entertainers, which Daphne A. Brooks analyzes in her foundational study of the era's popular culture, *Bodies in Dissent*. Brooks argues that a variety of Black political activists, performers, and writers were committed to "interrogat[ing] the ironies of black identity formation. . . . Wedding social estrangement with aesthetic experimentalism and political marginalization with cultural innovation, these resourceful cultural workers envisioned a way to transform the uncertainties of (black) self-knowledge directly into literary and figurative acts of self-affirmation."[46] *The Bondwoman's Narrative* finds its main character doing exactly this work of aesthetic self-transformation. Hannah stays there "as the fire of the sun died out" (*Bondwoman's*, 17), completely absorbed by looking at the portraits. Her imagination of the interior worlds of these others is unmarked by the sort of ambivalence Nathaniel Hawthorne had over the ethics of prying underneath a surface to reveal depths. Violation, for

Crafts, is not located in the act of revelation or exposure, but in the insistence that the viewed or depicted human exists *only* as you see her. Crafts's depiction of the enslaved *looking*, together with the white housekeeper's admonishment of such looking—"as if such an ignorant thing as you are would know any thing about [the portraits]" (*Bondwoman's*, 18)—emphasizes the extent to which psychological depth does not exist prior to its aesthetic depiction and interpretation as such. The housekeeper, to whom the portraits are no more than "wall furniture," is unable to imagine the possibility that the portraits represent anything more than the "purity" of family lines and so cannot see the deep shift that has occurred in Hannah while looking at the portraits. But the portrait gallery was a good place, Hannah Crafts understood, to start.

The Likeness Hung Opposite

Mid-nineteenth-century African American fiction writers did not only employ portraits of whites in their texts to explore genealogy, privilege, and the aesthetic construction of inner life. They also included textual descriptions of portraits of Black people—important historical figures and everyday people alike. The standard nineteenth-century cultural functions of white portraiture—representation of gender, class, and social status (sociality producing), memorializing (history producing), and even generative imaginative aesthetic (subjectivity producing)—took on different meanings within the Black literary tradition. In the analysis that follows, I'll explore Frank J. Webb's novel *The Garies and Their Friends* (1857), which is an important example of how Black writers were exploring the significance of portraiture for Black selfhood, sociality, history, and domesticity.

The Garies is a novel about two families—the Garies, who move from Georgia to Philadelphia so that the white Clarence Garie and the enslaved woman Emily, with whom he has two children (also named Clarence and Emily), can legally marry and set up house, and the Ellises, a middle-class Black family in Philadelphia with whom the Garies have ties and develop a friendship. Both families are torn apart during a calculated race riot planned by the evil Mr. Stevens who aims to kill the elder Clarence Garie in order to lay claim to the family fortune as a Garie descendent—his mother had been disowned by the white Garie family when she married a poor man. Clarence and Emily are killed in the riot, and Mr. Ellis's fingers are cut off, his body mangled after a fall from a roof, his mind forever after addled. The children, save Clarence Garie, go on to thrive in their way—marrying one another and finding

a sort of happiness in Black Philadelphia. The younger Clarence Garie, however, follows the fate that would become common in late-nineteenth-century fiction featuring the "tragic mulatto" figure—he tries to pass for white, but is found out and forcibly separated from his white fiancée by her father. Under the weight of this burden he slowly declines, physically and emotionally, and finally dies, dramatically, on the very day his fiancée Birdie is to visit and make amends.

The first portrait we encounter in *The Garies* is in Mr. Garie's study, situated in the "household of a rich Southern planter."[47] We come upon Garie, who "was seated in a room where there were many things to recall days long since departed. The desk at which he was writing was his father's, and he well remembered the methodical manner in which every drawer was kept; over it hung a full-length portrait of his mother, and it seemed, as he gazed at it, that it was only yesterday that she had taken his little hand in her own, and walked with him down the long avenue of magnolias that were waving their flower-spangled branches in the morning breeze, and loading it with fragrance" (*The Garies*, 97). The portrait of his mother works as both symbol of wealth (full-length portraits are expensive, just as women in wealthy families are expensive), and evocation of a rich past. Here, the past is familial, intimate, and individual (a particular mother and a particular son) *and* social/cultural; the scene participates in the nostalgic myth of Southern abundance with its heavily fragranced air and magnolia branches.

Two chapters later, the scene has changed remarkably, as the Garies have arrived in Philadelphia, characterized as "The New Home" (the title of chapter 11). Garie makes his way to the home of real estate magnate Mr. Walters, who has arranged all the details of the Garies' new house. Seeing the number of Black children in the streets with their bags of books, Garie thinks to himself "This . . . don't much resemble Georgia" (*The Garies*, 120). At Walters's home, readers are given a deep description of its "elegance," including its furniture, rich wallpaper, art, vases, and "charming little bijoux" (*The Garies*, 121).[48] Amidst the clutter of this stylish nineteenth-century room, one item stands out to Mr. Garie: "the likeness of a negro officer which hung opposite" (*The Garies*, 121).

The likeness, we will come to find out, is of Toussaint L'Ouverture. Mr. Walters explains that "I have every reason to believe it to be a correct likeness. It was presented to an American merchant by Toussaint himself." Walters continues, "That . . . looks like a man of intelligence. It is entirely different from any likeness I ever saw of him. The portraits generally represent him as a monkey-faced person, with a handkerchief about his head" (*The*

Garies, 123). One hears an echo here, of Douglass's pointed remarks about the distorted portraits of Black people so common in the popular visual culture of the era. Webb does not only use this portrait to counter the racist popular visual culture of the era, but also to revise the tradition of "great men" portraiture.[49] The portrait's power asserts both the need for "correct likeness[es]" of the Black face and body *and* the importance of a particularly Black history.

This is a crucial point also made by Douglass in "Claims of the Negro." After offering the critique of popular and scientific images of Black people that I discussed above, Douglass reflects, "I think I have never seen a single picture in an American work, designed to give an idea of the mental endowments of the negro." He then goes on to describe a wonderfully alternative portrait gallery. There are no George Washingtons adorning these walls; neither are there "monkey-faced" Toussaint L'Ouvertures. Here Douglass paints for his listeners a gallery hung with likenesses of "A. Crummel, Henry H. Garnet, Sam'l R. Ward, Chas. Lenox Remond, W. J. Wilson, J. W. Pennington, J. I. Gaines, M. R. Delany, J. W. Loguin, J. M. Whitfield, J. C. Holly, and hundreds of others I could mention" ("Claims," 510–12). Douglass's alternative portrait gallery speaks to the continued *importance* of portraiture for Black writers. As we have seen, portraiture was an aesthetic genre so often put to such disciplinary and conservative uses, such as "revealing" blackness/racial "truth" or consolidating (white) inheritance, power, and family "blood" lines. Yet, in Douglass's and Webb's representations of it, portraiture was also an important and necessary genre through which to articulate "mental endowment," "correct likeness," "thoughts, and feelings, and sentiments."

The reader gets a chance to revisit the portrait of Toussaint L'Ouverture again at the end of *The Garies*, when we return to Mr. Walters's home after his marriage to Esther Ellis. We find that "there are several noticeable additions to the furniture of the apartment"—a grand piano, new elegant woodwork, and, importantly, traces of children. Significantly, there is now "opposite to the portrait of Toussaint . . . suspended another picture, which no doubt holds a higher position in the regard of the owner of the mansion than the African warrior aforesaid. It is a likeness of the lady who is sitting at the window—Mrs. Esther Walters, nee Ellis. The brown baby in the picture is the little girl at her side" (*The Garies*, 333).

This domestic portrait of Esther Walters crystallizes, in aesthetic form, many of the vexed issues surrounding cultural representations of the burgeoning Black middle class in the second half of the nineteenth century, and

how these representations often hinged on depictions of Black womanhood and the reproduction of some of the same middle-class familial structures and domestic values that continued to bolster cultural forms of white authority.[50] And yet, in the broader picture, Webb's *The Garies* is a part of the large scale re-vision of the cultural, social, and evolving psychological functions of portraiture in their era. We cannot disregard Webb's clear sense that this portrait of Black mother and child is as radical and powerful as one of Toussaint L'Ouverture. Keeping company together, these images—of powerful and revolutionary Black political manhood and Black female domesticity—assert the significance of portraiture *as* "head work." These portraits serve multiple cultural, social, racial, and individual purposes—they allow for fully emotional domestic familial life, as well as asserting a radical genealogy of revolution and justice.

These portraits are not untroubled, nor are they untroubling. But Black writers' use of portraiture in their texts not only helped to shift the cultural function of portraiture, but also to develop a robust discourse of visuality that offers new perspectives on some of the most fundamental aspects of the visual nineteenth century: the relationship between technology, vision, and "truth"; the significance of the visual in the age of standardized mechanical reproduction; how racial, sexual, and social difference were visualized; and the visual as interface between public and private/domestic.

Another way to say this is that nineteenth-century Black writers' experimentation with, and commentary on, portraiture forms a major contribution not only to the archives of slavery but also to the archives of nineteenth-century visual theory, especially as these theories intersected with developing ideas about selfhood. Nineteenth-century Black writers and artists were often keen visual theorists, and their general absence from historical accounts of nineteenth-century visual culture, as well as from the critical genealogies deployed to explain our own contemporary visual culture, have left us with a dull sense of what vision is, how it works, what it might entail, and how its field of reference has been contracted by its unrelenting theoretical whiteness.[51] For example, one of the most significant scholarly works of visual theory in the late twentieth century—Jonathan Crary's *Techniques of the Observer*—examines how "subjective vision," or the idea that vision is individual, physiological, and subjective rather than objective, developed in the first half of the nineteenth century, but does so without a single reference to writing, thinking, or aesthetic work by any people of color.[52] This is a scandal not only because it passively fails to expand a canon, but because it actively misses the contributions of some of the most insightful

visual theorists of the era—the very texts and works of art most committed to thinking through the complicated relationship between sight, embodiment, subjectivity, surveillance, and social control. Nineteenth-century Black writers' ideas about portraiture are central contributions to the era's modernizing sense of psychology and inner life and how that sense took shape through the visualization of the self, through portraiture's "head work."

Limbs
Postbellum Portraiture and the Mind-Body Problem

The art of Thomas Eakins played a key part in the story of nineteenth-century American portraiture's shifting subjects. Eakins was a wide-ranging artist, working in many different genres and mediums: from landscape to photography to heroic portraiture. At the end of his career, he painted, almost exclusively, moody portraits of sitters lost in thought. The psychological subject matter of Eakins's late portraits is usually taken for granted by contemporary scholars. New and innovative scholarship on Eakins flourished in the 1990s and 2000s, after the discovery of a substantial new archive of materials—the Charles Bregler Collection—related to Eakins's education, artistic process, and the personal and professional sexual scandals that shaped his life and art.[1] But the late portraits have remained stubbornly resistant to critical reassessment. The portraits, critics mostly agree, are masterful achievements; they are moving and finely wrought, and exhibit, in almost every critic's view, "intense psychological study."[2] Unlike the racial, gendered, and professional dynamics of his paintings, the "psychological" is treated as an ahistorically human quality in most analyses of Eakins's portraits, seen as a part of his "realism." What are we missing when we evaluate one of our most canonical American painters in this way?

In this chapter, I will argue that by failing to historicize Eakins's representations of psychology, we miss a significant aspect of how artists and scientists grappled with the mind/body problem in the postbellum era. Across the 1870s, everyone's interest in bodies was changing. Bodies wounded in the Civil War and under the institution of slavery were a feature of everyday life, the fantasy of an "age of science" urged ever more specific knowledge about the anatomical body, and the rise of aesthetic realism insisted on meaningfully accurate representations of the human body. At the same time, psychology as a discipline and science was beginning to cohere and reshape how people would come to understand the mind. Eakins's late portraits depict the mind and body as in embattled relation to one another; this was a departure from his earlier works that explore how they are interanimated. The late portraits are less depictions *of* psychology, than examples of *how* the concept of psychology came to be imagined in new ways. Rather than

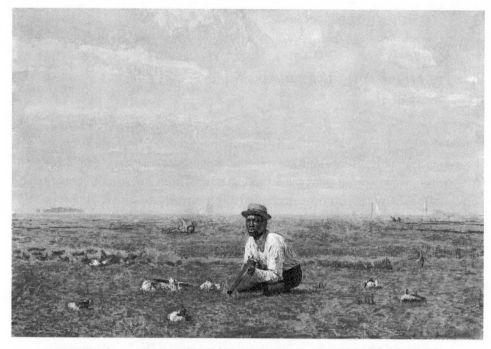

FIGURE 18 Thomas Eakins, *Whistling for Plover*, 1874, transparent watercolor and small touches of opaque watercolor over graphite on cream, moderately thick, moderately textured wove paper, 11 5/16 × 16 11/16 in. (28.7 × 42.4 cm). Brooklyn Museum of Art, Museum Collection Fund, 25.656.

masterfully depicting the psychological, Eakins's work charts its nineteenth-century emergence and evolution.

To make this argument, I trace a new visual genealogy of inner life as it is explored in Eakins's work. Let me open with a brief case study, to which I will return in more depth later, of Eakins's 1874 watercolor titled *Whistling for Plover* (figure 18).

This painting has, to my knowledge, never been interpreted as having anything to say about psychology, selfhood, or subjectivity in general. Neither has it featured in scholarly discussions of Eakins's aesthetic representations of psychology, selfhood, and subjectivity developed across time. That this is so flags an issue with how subjectivity, consciousness, and psychology are often critically framed (for example, I will need to do little to no set up like this in my discussion of Henry James's representations of consciousness in the next chapter). Critically, aesthetically, white people are the figures through which we find out about psychology; Black people, to the

contrary, tell us about history. How did our conversations about psychology become so segregated?

Whistling for Plover helps answer this question. In 1876, Eakins gave the painting to his friend, the prominent physician, neurologist, early psychologist, and prolific writer S. Weir Mitchell.[3] Mitchell is best known today as the originator of the infamous "rest cure" for treatment of neurasthenia, hysteria, and other nervous disorders, and for his neurological research into the phenomenon of "phantom limbs" (he coined the phrase), which he saw regularly when working with amputees at the U.S. Army Hospital for Injuries and Diseases of the Nervous System (Turner's Lane Hospital) in Philadelphia during the Civil War. *Whistling for Plover* is an obscure and rarely examined painting that links these two men—leading figures, respectively, in the science of and aesthetic representation of psychology in the nineteenth century.[4]

The painting, however, has remained frustratingly opaque to critics who have generally approached it only as an isolated hunting subject, a part of Eakins's interest in the "commonplace."[5] It depicts a Black man holding a gun and kneeling in the grass while hunting plover, a type of shorebird, in the tidal marshes outside of Philadelphia. This picture is usually not read within the context of "inwardness" that has shaped most criticism of Eakins's moody psychological portraits (which he produced compulsively after 1887 until his death in 1916). Neither has it been read as particularly meaningful within the context of a Reconstruction-era United States, despite the stunning depiction of a Black man with a gun nearly pointed at the viewer, so oddly drawn as to appear to have had his legs amputated.[6]

But the point here is not the recovery of or restoration of a single work by a canonical artist. Rather, I start with *Whistling for Plover* because it helps open a discussion about the specific texture of postbellum thinking around the mind-body problem, a longstanding philosophical problem that took on new urgency in an era of mass amputation.[7] I argue that *Whistling for Plover* is a part of a complex web of inventive thinking about mind and body in the postbellum United States: it distills the relational quality of that thinking as it passes back and forth between artists and scientists and it evinces the deep anxiety felt nationally over the bodily scars left by the Civil War's racial violence. And, in its marginal critical status, it helps reveal assumptions about Eakins's psychological realism that have become naturalized and invisible—critics who elevate Eakins because of his psychological work cannot see the psychological in this painting because they assume the psychological subject is thought and mind to the exclusion of bodies. These assumptions have

occluded our view of psychological realism's fascination with the body and anxieties around race and gender, its *speculative* (not reflective) approach to the idea of selfhood and psychology.

Whistling for Plover is an overwhelmingly overdetermined aesthetic object (to use psychoanalytic language somewhat anachronistically). This Reconstruction-era painting depicts a kneeling, gun-wielding, whistling Black man, in a setting that in its blankness recalls, as I will show, both psychic space and Civil War battlefield. The painting was presented as a gift to a neurologist who insisted upon the somatic attributes of consciousness, attributes that had been stretched to their limit in a gruesome war fought to free the bodies (if not also the minds) of Black men and women, and which had resulted in mass amputation of limbs and consciousness in its surviving soldiers. How does our genealogy of psychological realism change when anchored in an aesthetic object like this? Where does this painting demand that we become willing to see the psychological?

"Mere Thinking"

To answer these questions, it helps to recount how critics in Eakins's time were crafting ideas of what psychological realism would come to mean. When reviewing the American Watercolor Society's gallery offerings in March of 1882, critic Clarence Cook mentions Thomas Eakins twice. Eakins did not show any paintings at this exhibition, but had done so at the Society's exhibition four years earlier, and Cook had reviewed his showing favorably then. In 1882, Cook brings Eakins up as a bar against which to measure a selection of works presented to the New York City public that winter. Cook first notes that the figures in a painting by an artist named C. G. Bush lack evocative facial expressions. Cook offers, by way of comparison, that "Mr. Eakins has done enough in the way of facial expression to assure us that when he wants it, he knows where to get it, but Mr. Bush has yet his laurels to earn." Cook then continues, praising another painting's "Eakinsish expression": "We hope that Mr. Newell will feel complimented by having his name mated with Mr. Eakins's, for 'tis something to remind one by the skill with which mere thinking is portrayed, without the aid of gesture or attitude, of our best master at that art."[8]

Eakins's reputation was at a high point in the early 1880s. He had been appointed as professor of drawing and painting at the Pennsylvania Academy of the Fine Arts in 1879 and then promoted to director of the Academy in 1882. Though many critics still judged his works harshly, the artist was un-

doubtedly recognized by most as "the first of Philadelphia artists."[9] Cook's comment about Eakins's skill at depicting "mere thinking . . . without the aid of gesture or attitude" is not at all surprising to any viewer today familiar with Eakins's signature late portrait style — men and women either sitting or standing, seemingly lost in thought. Oddly, however, in 1882 — when Cook made his comment — Eakins had not yet developed this style, and though he often depicted people lost in thought, he nearly always did so in a way that *combined* thought and gesture.[10]

Cook's assertion that Eakins's paintings lack gesture is fascinating, then, because it is so wildly wrong. Eakins's paintings say most of what they have to say about thinking through the depiction of gesture. His surgeons wield instruments, his chess players hold their hands to forehead in concentration, his portrait subjects thrust their hands in their pockets and slump their shoulders. Cook's erasure of these gestures from Eakins's aesthetic construction of thought is an important chapter in the history of psychology because the erasure of gesture is at least in part an erasure of the body from that history.[11] Put differently, in Cook's erasure, we see the beginnings of a belief about psychology's disembodiment that is also often held by critics today.

Clarence Cook's comment may not have been so much prescient as it was representative of shifting ideas about what thought actually looks like, since one of the key aesthetic developments of the late nineteenth century was the elevation of thought as subject matter for art. A noted example is the famous reverie Henry James conjures for Isabel Archer in the middle of *The Portrait of a Lady* (1881) (which I will address in the next chapter) or any number of Eakins's late portraits, such as *Portrait of Amelia Van Buren* and *The Thinker* (figures 19 and 20). These works, while certainly gestural, are dependent on the introspective subject's bodily stillness. Such portraits have been described by art historians as "making visible the mind's invisibility"; as capturing a "gaze [that] turns inward . . . in some private, internal world . . . fundamentally inaccessible to sight"; as depicting sitters "wrapped in [their] own thoughts," addressing "the burden of inwardness."[12] None of these descriptions, however, offers an argument about when thought came to look like this, why "inwardness" is posited as a burden, or whether this "mere thinking" really does communicate meaning without the aid of gesture.

One of Eakins's sitters, Helen Monteverde Parker, commented on the experience of having her portrait painted by the artist in 1908 (figure 21). Her comments reveal something about how gesture and the body were deemphasized in modernizing, twentieth-century conceptions of interiority. In 1969, over six decades after sitting for the artist, Parker recalled that "Thomas

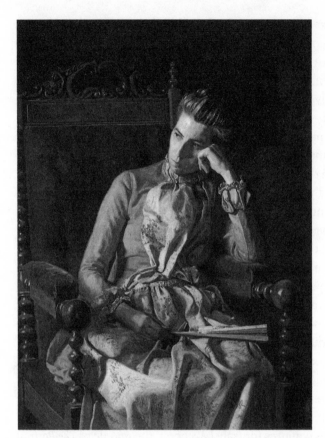

FIGURE 19 Thomas Eakins, *Miss Amelia Van Buren*, ca. 1891, oil on canvas 45 × 32 in. (114.3 × 81.28 cm). The Phillips Collection, Washington, DC. Acquired 1927.

Eakins was not interested in my face—(I have always felt a sense of being decapitated) but he was fascinated by my clavicles and the dress . . . I truly look as if I did not rate that high. I was born in 1885—should have known enough to wear a little intelligent expression."[13] Parker's description of the experience of having Eakins pay more attention to her clavicles than her face is intriguing. She feels that Eakins's attention to her body and dress takes something *away* from the psychological effect of the portrait, the result being that she looks dull rather than introspective, thoughtful, or "deep." And yet she figures this feeling in language that is both strikingly physical and significantly historical. She describes feeling "decapitated," suggesting that the violence this aesthetic depiction does to her sense of selfhood is somatically felt. And she laments failing to present a face that would merit the painter's attention, despite the fact that she was "born in 1885," and "should have known enough" to offer a modern representation of her selfhood in her face,

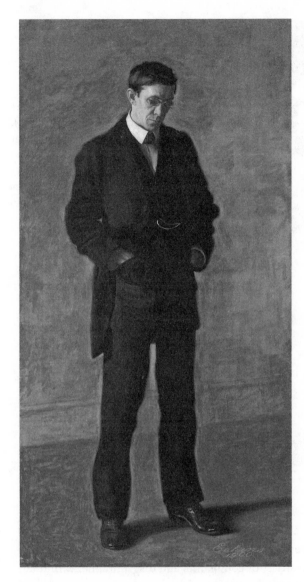

FIGURE 20 Thomas Eakins, *The Thinker: Portrait of Louis N. Kenton*. 1900, oil on canvas, 82 × 42 in. (208.3 × 106.7 cm). John Stewart Kennedy Fund, 1917 (17.172). © The Metropolitan Museum of Art. Image source: Art Resource, NY.

rather than (as was the case in much earlier portraiture) in her wardrobe or posture.

Put into its broader historical and aesthetic context, Parker's comment is unsurprising in its dissatisfaction. Though throughout most of the twenti-eth and twenty-first centuries, the psychological subject matter of Eakins's portraits—the genre in which he primarily worked from the 1880s until his death in 1916—has been taken for granted, Eakins's portraits were not

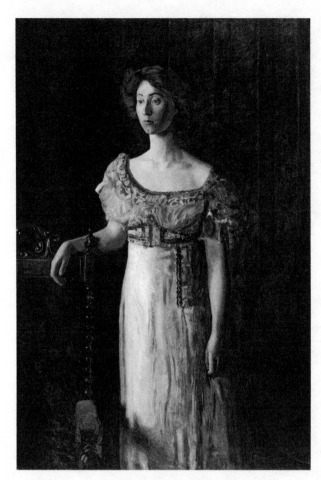

FIGURE 21 Thomas Eakins, *The Old-Fashioned Dress (Portrait of Helen Monteverde Parker)*, ca. 1908, oil on canvas, 60 1/8 × 40 3/16 in. (152.7 × 102.1 cm). Philadelphia Museum of Art, Gift of Mrs. Thomas Eakins and Miss Mary Adeline Williams, 1929-184-29.

popular in his own day, and there are many anecdotes of sitters refusing the portraits Eakins produced compulsively (often without commission or pay), of portraits stuffed into attics, of complaints and disgruntlement. In total, Eakins painted 246 portraits; astoundingly (since portrait painting was still considered a lesser artistic genre that artists took on to pay their bills), only twenty-five of those were commissioned, and of those twenty-five, at least five sitters either refused or only reluctantly paid Eakins for the work. In a large number of the portraits, sitters or those close to them expressed deep displeasure with the way in which they were portrayed. Among those commenters are Mrs. James Mapes Dodge, Frank Linton (of Eleanor Pue), Helen Parker, Mrs. Cryer (of her husband Matthew H. Cryer), Mrs. Montgomery (of mother Mrs. Helen McKnight), Richard Wood (of his brother George

Wood). And for those portraits that sitters did accept, many opted not to display them in their homes, to conveniently "lose" them, or even to destroy them: George Wood (the son of Eakins's physician Horatio Wood) wrote to art historian Lloyd Goodrich, "He painted a portrait of me which was quite 'Eakineeze,' so much so that my family got it lost."[14]

Helen Parker's anecdote about feeling decapitated by Eakins's portrait is a particularly suggestive version of this displeasure: it makes apparent some of the typically invisible histories of nineteenth-century psychology—the struggle to somatically locate the inner self (was it in the spine? In fluids? Humors? The brain?); the debate over the relationship between body and mind; the emphasis on gesture in visibly expressing inner life; the historically situated nature of psychology; and, of course, how portraiture mediates all of these questions. In all of these histories, even Cook's, thinking is in fact never "mere," and psychology never extant without bodily gesture. The critical stripping of gesture and the body from Eakins's depictions of inner-directed subjects—a critical removal (running parallel to the surgical history of amputation) that began in the 1880s and continues today—is part of a larger cultural transition that has redrawn psychology as an ahistorical phenomenon, existing apart from the body's messily raced and gendered existence that is so deeply imbricated in the social and historical worlds through which it moves.

Feeling for Bones

Eakins's fascination with Parker's clavicles was a part of his larger fascination with human anatomy more generally, an attraction evident in almost every one of his works, including his medical subjects, paintings of boxers and other athletes, his Arcadia paintings, and the Naked Series photographs. It also played a large part in his artistic pedagogy and in his dismissal from the Pennsylvania Academy in 1886, when he removed the loincloth of a male model in front of a class including female students. Art historian Henry Adams has called Eakins's teaching emphasis on human anatomy "extraordinary"; the painter required his art students to dissect cadavers, observe the action of muscle tissue stimulated by electrical current, and make plaster casts from body parts of the dead he brought into the classroom.[15] Alan Braddock has noted that in postbellum Philadelphia, the new science of anatomy operated as a "cultural discourse" that, among other things, "distinguish[ed] self from other."[16]

And it is within the context of Eakins's specifically late-nineteenth-century obsession with anatomy, I would argue, rather than in a dehistoricized sense

of selfhood, that critics should understand Eakins's depictions of what we would come to call "inwardness." Accounting for the interplay of body and mind in Eakins's portraiture is important because it restores to our study of artistic representations of interiority the rich context of post-Darwin/ pre-Freud psychological thought—a moment inflected in the United States particularly by a social crisis of the body politic and the (very related) medical reinvestigation of the physiological body.

In a bitter letter to Edward Horner Coates discussing his forced resignation from the Pennsylvania Academy of the Fine Arts in 1886, Eakins protested, "My figures at least are not a bunch of clothes with a head & hands sticking out but more nearly resemble the ~~living body that~~ strong living body's [sic] than most pictures show."[17] As noted, his dismissal famously stemmed from complaints lodged after Eakins undraped a male model's loincloth in front of a class containing female students. This momentous incident arguably shaped the rest of Eakins's life and artistic output, as well as Eakins's reputation to this day. Eakins explained his zeal for representing with anatomical correctness the "strong living body" to a reporter for *Scribner's* in 1879, saying that "to draw the human figure it is necessary to know as much as possible about it, about its structure and its movements, its bones and muscles, how they are made, and how they act."[18] In the midst of painting a portrait of Mrs. James Mapes Dodge in 1896, Eakins reportedly approached his sitter and dug his fingers into her chest. When she exclaimed, "Tom, for heaven's sake, what are you doing?" Eakins supposedly replied, "Feeling for bones."[19]

Eakins's interest in the interrelationship between internal structure and its external casing is of a piece with similar interest in psychological thought from the period, which was devoted to investigating contact points between the physiological and the psychic, and it is worth parsing this academic debate in some depth before returning to its parallel form in Eakins's painting. One of the major controversies in post-Darwin/pre-Freud psychology concerned the extent to which the mind—a still fluid concept—was an effect of somatic workings of the brain. This controversy would shape the way "the mind" was understood by both scientists and laypersons. As the nascent science of psychology developed between 1870 and the end of the century, its theorists and practitioners debated the extent to which consciousness existed outside, despite, or independent of physiology. The theory of automatism, particularly popular with followers of Darwin such as Thomas Huxley, held that consciousness and will were merely effects of the somatic and mechan-

ical workings of the sense organs. In 1874, Huxley declared of animals, or what he called "brutes," that "their volition, if they have any, is an emotion *indicative* of physical changes, not a *cause* of such changes The soul stands related to the body as the bell of a clock to the works, and consciousness answers to the sound which the bell gives out when it is struck." This theory, he continues, "holds equally good of men; and, therefore, . . . all states of consciousness in us, as in [brutes], are immediately caused by molecular changes of the brain-substance We are conscious automata."[20]

But this is a very different account than that developing at the same time in the work of, for instance, William James. James, in a letter written home from Berlin in 1867, hypothesized of the subject of study he and John Dewey would later pioneer in the United States that "perhaps the time has come for Psychology to begin to be a science—some measurements have already been made in the region lying between the physical changes in the nerves and the appearance of consciousness—(in the shape of sense perceptions) and more may come of it."[21] This "region lying between" was not present in Huxley's automata, but it would become crucial to James. In 1884, John Dewey likewise asserted that psychology would now move into a modern age—beyond abstract eighteenth-century metaphysics—by joining together the traditional work of introspection (with its emphasis on the representation of mental states) and physiological investigation of the brain (with its emphasis on the direct recording or observation of the physical reality of mental states). And in 1890, William James countered the automata theory by reaching back to an older tradition and championing introspection.[22] He declared, "introspective observation is what we have to rely on first and foremost and always." He defended the practice of introspection by asserting "the difference between the *feltness* of a feeling, and its perception by a subsequent reflective act." James states, "If to *have* feelings or thoughts in their immediacy were enough, babies in the cradle would be psychologists, and infallible ones. But the psychologist must not only *have* his mental states in their absolute veritableness, he must report them and write about them, name them, classify and compare them and trace their relations to other things."[23]

James's and Dewey's "New Psychology," a term that Dewey coined in an essay of the same name in 1884, tried to make sense of the relationship between what still often seemed like a metaphysical phenomenon—the mind—and concrete findings about the brain offered by laboratory experiments, animal dissections, and cortical stimulation, and analysis of anomalous cases of brain injury. This profoundly unresolved tension between bodies and

minds found expression in Eakins's painting; it was horribly manifest in the wounded bodies of Civil War soldiers; and it became a preoccupation of fiction throughout the postbellum era.[24] And it structured psychological inquiry during the era, as the new discipline grew in tandem with these other human attempts to know the self.

Dismembering the Mind

Henry James wrote in 1914 about the "obscure hurt" that befell him just as the Civil War began, preventing him from enlisting, if not from experiencing what he termed the "huge comprehensive ache" that came of the way the war visited pain upon "one's own poor organism" as well as upon "the enclosing social body, a body rent with a thousand words."[25] Of course, the war rent bodies with more than just words, and as the fighting ended and soldiers began reentering society at large, the gruesome injuries they received entered the public consciousness with a living, breathing immediacy. One might readily see the violence of this new awareness of the human body in Thomas Eakins's famously unflinching depictions of painful surgical scenes from the 1870s and 1880s.

But one might also see Eakins considering "the body" and its relationship to the mind in other of his works from that period, as well. Eakins's hunting pictures are intriguing in their address of the post-Civil War landscape as psychic space within which powerful bodies move. Paintings such as *Whistling for Plover*, *Pushing for Rail* (1874), and *Rail Shooting* (1876), among others, depict armed white and Black men scattered across a permeable, liminal landscape that is both realistic setting and introspective space. *Pushing for Rail* (figure 22), for example, presents pairs of hunters pursuing rail, a breed of small game bird, in the same tidal marshes depicted in *Plover*.

In *Pushing for Rail*, each pair balances in a shallow boat almost hidden by marsh grass, the man in front wielding a rifle, the man behind using a long, wooden pole to steer and keep the boat stable. The scene is muted with a low-key, organic tonality punctuated only by the blood-red shirt of the Black man at its very center. The symbolic potential of the precariously balanced boats in the rail shooting paintings highlights that these images might be read as "about" the aftermath of the Civil War as much as about anything else.

Indeed, one rarely noted aspect of *Whistling for Plover* is how uncannily similar its composition is to a photograph titled "A Harvest of Death" (figures 23 and 24), taken by Matthew Brady's assistant Timothy O'Sullivan and published in Alexander Gardner's *Gardner's Photographic Sketch Book of the War*.[26]

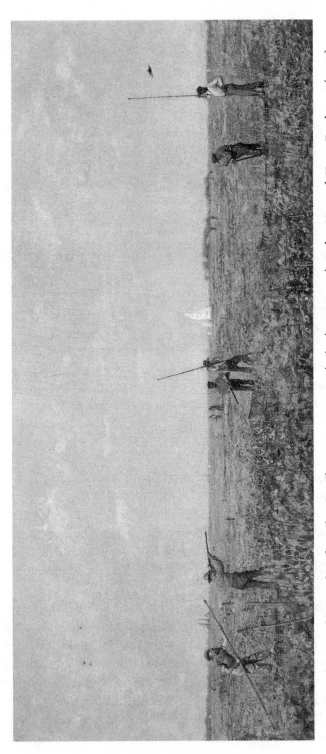

FIGURE 22 Thomas Eakins, *Pushing for Rail*. 1874, oil on canvas, 13 × 30 1/16 in. (33 × 76.4 cm). Arthur Hoppock Hearn Fund, 1916 (16.65). © The Metropolitan Museum of Art. Image source: Art Resource, NY.

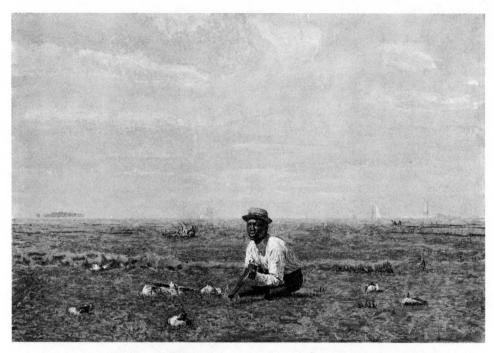

FIGURE 23 Thomas Eakins, *Whistling for Plover*, 1874, transparent watercolor and small touches of opaque watercolor over graphite on cream, moderately thick, moderately textured wove paper, 11 5/16 × 16 11/16 in. (28.7 × 42.4 cm). Brooklyn Museum of Art, Museum Collection Fund, 25.656.

A signature aspect of *Whistling for Plover* is how the dead birds strewn across the front of the picture plane are ominously echoed by the prone human figures lying in the grass behind the central hunter. This image suggests high casualty rates, the dissolving focus in the background emphasizing the banal nature of ever replicating dead bodies. Gardner's photograph works similarly: shock front and center, replaced by a sort of vague numbness as the eye moves further back.

To note this specific compositional echo, or to draw out the deeper connection between Eakins's hunting pictures and the post-Civil War world is, however, not to say that these images are fundamentally different from Eakins's later paintings which retreat inside—both physically and psychically. Because in addition to the themes critics have established as central to Eakins's sporting pictures from the 1870s—manliness, self-discipline, the celebration of everyday life in and around Philadelphia—the hunting pictures begin constructing and proposing interest in what might at first appear to us as the very

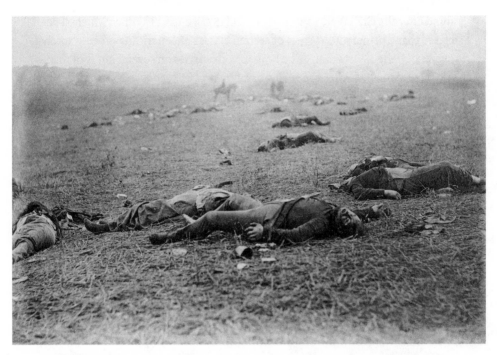

FIGURE 24 Timothy H. O'Sullivan and Alexander Gardner, *A Harvest of Death*, Gettysburg, Pennsylvania, albumen print, negative by T. H. O'Sullivan; positive by A. Gardner, 1863. Library of Congress, LC-DIG-ppmsca-12557, Prints and Photographs Division.

thing they are missing: the introspective subject.[27] The marsh itself—its liquidity, permeability, opacity, and liminality—suggests what James and Dewey were beginning to conceive of as psychic space, "a region lying in between." In *Pushing for Rail* and *Rail Shooting*, the relationships between the men in each boat, one steering, the other acting, might be analogized to ideas about the conscious and unconscious mind emerging at the same time as the paintings.[28]

These new theories of mind were, importantly, shaped by discussions of materialism. S. Weir Mitchell was not only a physician investigating the nervous system's responses to amputation at the height of and in the wake of the Civil War but also an aesthetic theorist of bodily dismemberment and its relation to the psyche. In Mitchell's scientific writings and now largely unread fiction (he wrote fourteen novels, as well as poetry and short stories), one finds, in addition to pernicious sexual, gender, and class stereotypes, a revealing gloss on popular scientific approaches to the relationship between body and

mind after the Civil War. In *Wear and Tear* (1871), a tract in which Mitchell declared that "the nervous system of certain classes of Americans is being sorely overtaxed," he asserts that "[t]he human body carries on several kinds of manufacture, two of which—the evolution of muscular force or motion, and intellection with all moral activities—alone concern us here. We are somewhat apt to antagonize these two sets of functions, and to look upon the latter, or brainlabor, as alone involving the use or abuse of the nervous system. But every blow on the anvil is as distinctly an act of the nerve centres as are the highest mental processes."[29] Mitchell is at pains to emphasize the interrelation of body and mind, arguing that physical labor is as likely to induce mental exhaustion as any excessive activity of intellection. And, he, like other nineteenth-century reformers, espouses a theory of balance and moderation that seems indebted to old-fashioned humoral theories, or eighteenth-century accounts of sensibility, slightly revamped to accommodate modern understanding about the nervous system: "every organ must or ought to have its period of activity and of rest, so as to keep the vital fluid in a proper state to nourish every other part."[30] In 1884 Mitchell published *Fat and Blood*, in which he advocated consumption of dietary fats to counteract fatigue and lethargy resulting from bad blood malnourishing the brain. His scientific writings repeatedly emphasize the connection between body and mind. Significantly, so does much of his fiction. Mitchell's 1866 story, which appeared in the *Atlantic Monthly*, about a quadruple amputee, "The Case of George Dedlow," overtly addresses all these questions: as the eponymous character puts it in this fantastically bizarre story, "I have dictated these pages, not to shock my readers, but to possess them with facts in regard to the relation of the mind to the body."[31]

Eakins's gift of *Whistling for Plover* to Mitchell, eight years after his story's publication, takes on additional significance in this context, because of the radically foreshortened central figure in the painting. Given Eakins's zealousness for the aesthetic representation of correct bodily anatomy, the oddness of the central figure's body in *Whistling for Plover* begs deeper analysis. Eakins has not realistically painted a person whose legs have been amputated; he's done something even a little bit stranger. He has painted a person who at first appears to be curled up, perhaps leaning on his hip, but whose body makes less and less sense under sustained visual attention. His lower legs and feet *should* be visible; there is simply no way for him to be sitting and have them not be. But they aren't visible, and the painting gives no indication to its viewer as to why. This is not an aesthetic flub: Eakins knew how to draw bodies accurately, *realistically*, like almost nobody else working at the time.

This isn't exactly a picture about amputation; it's a picture about bodily decomposition. And insofar as this is true, Eakins's gift of this painting to Mitchell is significant.

S. Weir Mitchell's story is a perfect example of an aesthetic text that used the trope of amputation and bodily decomposition to symbolically explore a number of significant questions about selfhood, subjectivity, and the relationship between the mind and body at a particularly fruitful juncture of early psychological study. In Mitchell's story, the main character's sense of psychological selfhood and experience of consciousness is *lessened* in parallel to the reduction of his body. Speaking in the first person, Dedlow, a Civil War surgeon himself, states, of losing all his limbs as a result of injuries sustained in the war, "Against all chances I recovered to find myself a useless torso, more like some strange larval creature than anything of human shape. Of my anguish and horror of myself I do not speak." The narrator avers that he offers his story not because it contains any new "medical facts" but rather because it has provoked in him a number of "metaphysical discoveries" ("Dedlow," 1). The whole of the narrator's convalescence in the "Stump Hospital" is taken up by a careful and thorough mental notation and examination of his sensations: "I amused myself, at this time, by noting in my mind all that I could learn from other limbless folk, and from myself, as to the peculiar feelings which were noticed in regard to lost members" ("Dedlow," 6).

Despite his willed psychic attention to the sensations communicated to his consciousness via the nervous system (which functions both normally, in registering pain, and abnormally, in detecting feeling in nonexistent limbs), Dedlow notices a curious fact about himself: "I found to my horror that at times I was less conscious of myself, of my own existence, than used to be the case. This sensation was so novel that at first it quite bewildered me" ("Dedlow," 8). He ultimately concludes that his loss of sense of self is because "[a]bout one half of the sensitive surface of my skin was gone, and thus much of relation to the outer world was destroyed Thus one half of me was absent or functionally dead. This set me to thinking how much a man might lose and yet live" ("Dedlow," 8). He then slips into a reverie on this question, in which he determines he could still survive without his spleen, half of his intestines, and a good part of his nervous system. But living and "possess[ing] the sense of individuality in its usual completeness" are two different things altogether, and so Dedlow observes (I would argue this is the "metaphysical discovery" he promised at the outset): "I thus reached

the conclusion that a man is not his brain, or any one part of it, but all of his economy, and that to lose any part must lessen this sense of his own existence" ("Dedlow," 8). "The Case of George Dedlow" doesn't so much as challenge or attempt to discredit introspection, as it refuses to consider the introspective labor of the mind as existing somehow either prior to, or separate from, the somatic body. This story intervenes in postbellum psychological debates about the mind/body problem—this is neither automata theory, nor introspection, but something that tries to bring these strident scientific debates into more nuanced relation to one another.

George Dedlow performs a sort of experiment on himself, seeing how much of his physical body he can sacrifice and still remain a subjectivity in the world; he claims to discover that "man is not his brain," and yet here we are, readers, accepting words put into circulation solely by his brain (the story does not address how he physically gets the words on paper). At the end of the story, Dedlow attends a séance during which his skepticism is rapidly overcome by a deep desire to restore communication with the parts of himself he has lost. With the help of a medium, he initiates contact with something from another realm that identifies itself by rapping out a series of numbers and words. The medium writes down what she hears and gives the scribbling to Dedlow: "United States Army Medical Museum: Nos. 3486, 3487." Dedlow realizes what he is in communication with: "they are MY LEGS—MY LEGS" ("Dedlow," 10). He staggers across the room on limbs that are invisible to him and to the others. He experiences "a strange return of my self-consciousness. I was reindividualized, so to speak" ("Dedlow," 10). But this happiness is short-lived—as discoveries at séances tend to be—and the story ends with Dedlow dryly stating that "It is needless to add that I am not a happy fraction of a man, and that I am eager for the day when I shall rejoin the lost members of my corporeal family in another and a happier world" ("Dedlow," 11).

For Dedlow, the dismemberment of his body is akin to a dismemberment of his mind, his consciousness, and his subjectivity. When Dedlow loses his limbs, he notes that he has less bodily surface area through which to come in contact with the world, an observation that relocates subjectivity from the brain to the surface of the skin. But this deeply personal and individualizing experience matters to more than just Dedlow the man. His legs reside in a governmental museum, his bodily loss catalogued and preserved as a sort of national memory. "How much of my body could I lose and still remain a man," it seems, is a national, not only a personal, question.

Gesture and Limb

Eakins's *Whistling for Plover*, along with many of his other hunting pictures, asks similar questions. That these issues—is the mind metaphysical or somatic?—take shape in Eakins's painting of a Black figure should not come as a surprise. Throughout the nineteenth century, exterior appearance was often coordinated with inner essence in order to maintain racial hierarchies. The faculty psychology that underpinned phrenology—the idea of a compartmentalized mind with each different area of the mind controlling separate psychological, behavioral, and emotional functions—constructed the mind as a hierarchical system of "higher" and "lower" brain functions.[32] Historian of psychology Graham Richards notes that, in the nineteenth century, the "sense that physical form reflected underlying psychological character" imbued scientific discourse of the era with "a powerful racist rhetorical force."[33] Nineteenth-century psychologists such as Gall, Spencer, and G. S. Hall offered various accounts of racial difference in human psychology that nonetheless all offered the same circular logic: the physical qualities associated with nonwhite races (visually) appear as subhuman, thus testifying to an innately inferior subjectivity which is in turn expressed through physical appearance.

While it would not be until the late nineteenth century that racial difference was subjected to New Psychology's focus on reaction times and other "observable" phenomena, physicians throughout the nineteenth century attempted to "objectively" diagnose the Black body as expressive of various psychological states and maladies. In 1851, the physician Samuel A. Cartwright coined the word "Drapetomania" to medically diagnose with a psychological ailment the phenomenon of enslaved people liberating themselves. The fugitive was troublesome to the proslavery defense of slavery as a beneficial social institution; such a diagnosis concluded that fugitives were deviant, psychologically—a deviance which was expressed physically, in their bodies and behavior. When researchers did begin to turn their attention to racial difference in more recognizably "modern" ways, they asserted the inferiority of racialized consciousness through interpretation of somatic characteristics. In 1895, the psychologist Meade Bache's experiment "Reaction time with reference to race" led to the conclusion that "The Negro is, in brief, more of an automaton than the white man is."[34]

The traces of these lines of thinking traverse *Whistling for Plover*. Kneeling in the grass, the central figure in *Whistling for Plover* confronts the viewer

with gun in hand, seemingly ready to explode out of the canvas. And yet, strikingly, the figure also kneels. The gesture of kneeling invokes both Reconstruction-era fears of recently freed African American men and the classic image of Black supplication. The Black man at its center is both powerful and disempowered, a threat warranting constant vigilance but also a figure of gratitude. This particular supplicant might be seen as an echo of Josiah Wedgwood's indelible abolitionist engraving "Am I Not a Man and Brother?" (1787) or of Thomas Ball's *Freedmen's Memorial to Abraham Lincoln* (1876), in which a thankful freed man kneels at the feet of the "great emancipator." The figure's bodily gesture (kneeling) and visual dismemberment both work as metaphorical explorations of the relationship between body and mind akin to the one Mitchell pursues in his short story.

The depiction of the figure's face is similarly suggestive in the context of the racialized fields of nineteenth-century scientific discourse. Hunting plover required one to emit an imitative bird call; the figure's lips are pursed mid-whistle. The surprising and powerful threat of a Black man holding a gun is undercut not only through the figure of amputation, but also the expected visual alignment of the Black body with imitation, musicality, and animality. As the Black writers I discussed in the previous chapter repeatedly noted, nineteenth-century visual typologies of Black embodiment were employed in literature, scientific treatises, institutions, photography, illustrations, and more to establish racist "truths" about human psychology and the racialized nature of consciousness.[35] Racial and racist taxonomies should be understood as fundamental to nearly all nineteenth-century scientific discourses, even when the purported subject under study is not obviously "race."

Caught at the precise moment of intention, the central figure of *Whistling for Plover* encourages its viewer to imagine and perhaps even experience the mind—its will and consciousness—as embodied—in lips, fingers, bent knees. These are questions about how the interior subjectivity of a human comes into contact with the external world; consider again *Pushing for Rail*, each figure holding either a long pole or gun that functions as a sort of prosthetic extending the embodied reach of their will and thinking in important ways. But *Plover*'s strange composition—the figure kneeling and cut down, arrayed in a field of death—is in tension with this extended vision of the integrated body and mind. The bodily fragment of *Whistling for Plover* reminds us of the threat and of the promise of embodiment in the years following the Civil War, years in which the fragmented bodies of soldiers haunted the public consciousness, offering testimony to both the necessity

of wholeness (national, personal) but also to such a wholeness's impossibility. Eakins's exploration of the intersection of the cerebral and the physiological through depictions of Black bodies underscores how the modernizing discourse of psychology was racialized and highlights how the question from Mitchell's story—"what makes a man?"—is fundamentally racially inflected.

Eakins's kneeling man/amputee, and Mitchell's national museum of dismemberment, remove or neutralize the threat of embodiment that we have seen considered in Eakins's depictions of Black hunters—threats of both assault and loss. The museum of limbs may briefly call to mind previous wholeness, but in doing so, it only (and always) leaves its visitors with a melancholy sense of loss and of the alienation of mind from body. Eakins's late portraits of white people switch their attention to this sort of modern alienation, which is expressed through his sitters' radically fractured presence: their minds always seem to be wandering far from their bodies. And yet, the traces of the soma that remain in these depictions are crucial.

Perhaps what Clarence Cook meant, then, when he used the phrase "mere thinking" was that certain bodily gestures—slumping or resting one's head on a hand—were distinct from others—kneeling, dancing, running away, or reacting quickly. That one set connotes psychological thought while the other automatism. Obviously, the classification of gestures along these lines is just one part of the larger story whereby the boundaries between body and mind, Black and white, material and metaphysical are drawn up, strengthened, and then re-presented as natural.[36] In the next section, I will argue that even while Eakins's late portraits memorialize the loss of integration of mind and body, they still bear important traces of that integration. Critical dismissal of the importance of the body in these images—the critical tendency to see in them "mere thinking . . . without the aid of gesture or attitude"— suggests that the retreat of the mind from the body at the turn of the century was a sort of whitewashing of the mind, a way to associate the mind with whiteness, and then put that white mind in a fractured relationship to the body.

Trouble in My Head

Portrait of Amelia Van Buren (c. 1891) is a key image in which we find such traces. Van Buren was Eakins's student and played a key role in the events that ended in his dismissal from the Pennsylvania Academy.[37] After graduating from the Academy, she abandoned painting and became a pictorialist photographer, sharing a studio and household with Eva Lawrence Watson

(later Eva Watson-Schutze) in Atlantic City between 1894 and 1896. Van Buren lived out the rest of her life (she died around 1917) in Tryon, North Carolina, with her companion and physician Juanita Lea. Partly because her house burned down after her death, we have only limited archival information to fill out our understanding of her relationship with Eakins or her own views on her artistic endeavors.[38] During her schooling, Van Buren periodically returned to her hometown of Detroit for treatment for what was probably diagnosed as neurasthenia. She wrote to Susan Macdowell Eakins (with whom she was close, as she lived with Thomas and Susan Eakins for periods of time when in Philadelphia) that "I have at last discovered that the trouble with me is in my head it is exhausted by worry or something or other and I must just have patience until it is rested so provoking to have nothing the matter with you and yet be everlastingly ill."[39]

Van Buren was one of the sitters whom Eakins seems to have aged prematurely. While period photographs show her as having blonde hair and a serious demeanor (figure 25), in Eakins's portrait her hair is gray and her mental state has gone beyond seriousness to what appears to be exhaustion (figure 19). As noted earlier, most of the sitters Eakins painted were dissatisfied with what they seemed to find his overly literal, unflattering portraits. No critic has yet offered a convincing account of why Eakins chose to represent his sitters in this way. Eakins regularly chose to alter his sitters' appearances so that they appeared older, more haggard and worn than they look in contemporary photographs. The question, I would assert, is not one of Eakins altering the "truth" of these photographs, but rather why he seems to have repeatedly located qualities of realness or authenticity in moments of exhausted introspection. Certainly, altering a sitter's appearance in a portrait depiction has been commonplace for centuries, but generally the changes go in the opposite direction: the sitter is more attractive, regal, or otherwise idealized in depiction than in life. One likely reason Eakins did not participate in this particular convention was that he did not have pressing financial need to complete flattering portrait commissions. But then, why did he continue to accept or solicit portrait commissions at all? Such questions go to the heart of the problem of taking the appearance of "psychology" as a given, rather than a form of understanding inner life that was actively under construction at the time.

In her painted portrait, Van Buren looks toward an unpictured light source, which illuminates her head and hands. Her figure is dwarfed by the heavy, ornate, old-fashioned Renaissance Revival chair in which she sits and which Eakins had used in a variety of other portraits. A number of contrasts

FIGURE 25 Thomas Eakins, *Amelia Van Buren*, late 1880s, platinum print, 8 1/4 × 6 5/8 in. (21.0 × 16.9 cm). David Hunter McAlpin Fund, 1943 (43.87.16). © The Metropolitan Museum of Art. Image source: Art Resource, NY.

structure the image; for example, that between her slight figure and the heavy chair. I would like to focus here on two formal contrasts that both result from the image's highlighting of the sitter's head. The first is that between the finely modeled detail of her revealed bone structure and the flat, indistinct shadows blocked out in dull brown behind her. The second is between the detailed modeling of the head and hands against the constricting clothing that swallows up the rest of her body, especially from the waist down.

This second contrast, between the dryly colored, rumpled heavy fabric draping her figure and the almost glistening reality of her flesh, calls to mind S. Weir Mitchell's emphasis on how George Dedlow's "relation to the outer world was destroyed" when he lost "half of the sensitive surface of [his] skin." Amelia Van Buren is smothered by the excessive femininity of her dress, the heavy fabric muffling her contact with the world. The fan that she holds limply seems clearly uninteresting to her as feminine signifier (she does not wield it with any coquetry). And though it protrudes from her pelvis, seemingly phallic in nature, her weak grasp on it communicates not aggressive

power but instead weakness and passivity. As in most of his portraits of women, Eakins represents Van Buren rather androgynously (her features are slightly masculine, she exhibits few female secondary sexual characteristics), an approach that contrasts sharply with the cotton candy pink of her dress (which is painted in an unusually high key).

Her liminality—both masculine and feminine, both monumental and delicate—is emphasized by the dimness in which she sits and upon which her mind cannot cast any illumination. The dull and abstractly blocky shadows behind her are a common feature of Eakins's work; oftentimes the shadows cast by his figures diverge from his image's "realistic" content. The contrast between figure and shadow here suggests that in his late portraits Eakins had little faith that the introspective subject might have a way of communicating what she gleans about herself to the world. If mind is severed from body, it is also severed from world.

The focus in *Amelia Van Buren* on the *contrast* between the body and the mind that it houses perhaps *begins* as a critique of how social expectations, gender roles, and other manifestations of Victorian identity constrict free expression and bodily wholeness. But the way that Eakins frames the finely modeled, heavy head of his sitter against a dull blankness suggests that Eakins's "critique" is, in the Foucauldian sense, an expression of the very values he purports to unseat. Eakins here deepens the contrast between body and mind, introducing the idea of the subject as fractured and disconnected from her own embodied, physical reality. This is a theme that Eakins develops repeatedly in his late portraits; his technical skill at highlighting or directing the viewer's attention to portions of his canvases nearly always emerging from the way in which he contrasts the extremely illusionistic three-dimensionality of faces, heads, and hands against the flatly painted shadows behind them, or against the dull clothes from which they emerge as if trying to escape. In trying to elevate the status of the body in Realism, Eakins has turned it into the very thing minds must try to escape.

This contrast, between the monumentality of his figures' physical presence and the narrative sleight-of-hand that turns the viewer's attention *away* from these monumental bodies and toward something unseen and interior, is again visible in a portrait Eakins completed in 1900 of Louis N. Kenton, who was married to Susan Eakins's sister. The painting was later given the title *The Thinker* (figure 20). Eakins exhibited this painting multiple times between its completion and the end of his life, singling it out as one of his more successful compositions from that time. One might posit that the painting achieves what Eakins had been working toward during the last decade of the

nineteenth century. The painting has subtracted all external markers of personal narrative or social or professional status. Kenton stands in a completely empty room, head bent, brow furrowed, and hands thrust into his pockets. Again we see the contrast between a delicately and articulately rendered thoughtful face and the flat, dull sack of oversized clothing from which it emerges, the contrast again suggesting the *difference* between the mind and the body from which it is cut off or from which it tries to escape. Kathleen Foster notes that "[a]s Kenton's gaze turns inward, his physical presence flattens, suggesting that his body is not important to the work at hand."[40] Eakins seems to have finally perfected the representation of "mere thinking" Clarence Cook asserted he had years earlier.

But such an explanation—Eakins finally "achieving" insight into the true character of modern psychology—no longer works. For, given what we have learned by revisiting a variety of works in which Eakins addresses the intersection between body and mind, we might pose the question of why Eakins's late portraits—every one of them depicting gestures of bodily resignation in their renderings of slumped shoulders, lax stomachs, hands thrust into pockets, gazes averted, heads tilted, eyes tearing—why these portraits are only read as representations of a sort of psychological interiority that is "fundamentally inaccessible to sight."[41] For these figures, in every case, communicate what they have to say about the human interior, through physical gesture. Nearly every analysis of *The Thinker* mentions that Kenton's hands are "thrust" into his pockets; this is because the physicality of his gesture is striking. That bodily motion, like the furrow in his brow, however, is decorporealized, coming only to signify as a function of mind, of his inward turn. The metamorphosis of these gestures into their own absence, their fundamental erasure, ultimately reshaped perception of the psychological interior.

Eakins's progressively subtracted canvases directed viewers' attention to the interiority of his figures, rather than upon their posture, gesture, or accoutrements. This was a new and convincing representation of subjectivity as the century turned. But Thomas Eakins's portraits were not popular in his own day. We might go so far as to say that the people who viewed his portraits during his lifetime did not recognize much value or meaning in the canvases, because people needed to become familiar with this new form of subjectivity, which Eakins was, along with early psychologists and neurologists, at the forefront of exploring. The portraits' rehabilitation began in the 1930s with Lloyd Goodrich's repeated assertions that Eakins was unusually adept at revealing his sitters' true selves. A 1904 review of *The Thinker* illustrates how people needed to learn how to see Eakins's late portraits, and

provides a suggestion of what they would see once they did. Writing of "the very crudity of the realism" of the painting, Charles Caffin goes on to marvel that "the truth of the representation is so extraordinarily convincing, that one loses sight of the ugliness of the picture and becomes fascinated by the revelation of life and character."[42] The ultimate conclusion that Eakins "reveals" rather than "constructs" people's psychological interiority ratified his troubling nonnarrative and inward-turning approach in the late portraits and naturalized the relocation of the human interior to the mind.

But even as narratives of "revelation" began to take hold in discussions of Eakins's late portraits, they could not fully tame the strange connections these works maintain with depictions that seem very unlike their spare, seemingly revelatory vision. Both Amelia Van Buren and the central figure in *Whistling for Plover* are, like George Dedlow, *lessened* insofar as their bodies are cut down or cut off. These visual and textual representations of limb and gesture are a crucial part of postbellum ideas about the mind-body problem. The formal, aesthetic qualities of these works—as seen in the awkward composition of the figure in *Plover*, or in the gestural poses of Van Buren and Kenton—reveal portraiture's significance in sketching the outlines of new forms of subjectivity in the postbellum era.

Artists, scientists, and the general public were all speaking different languages when it came to describing, representing, or consuming ideas about subjectivity. The general public seemed not to understand Eakins's aesthetic representations of inner life; Eakins was clearly interested in the new neurological thinking that Mitchell offered about vital fluids and the holistic organism, yet at the same time he moved inexorably toward ever more atomized aesthetic representations of the mind and body. In a development that would probably surprise many of his portrait sitters, these atomized depictions started to feel *true* and, what's more, ahistorically true. His portraiture's critical reception, especially across the twentieth century, naturalized ideas of inner life as decorporealized. It was not only gesture that was muffled, but rather an entire alternate genealogy of inner life.

And ignoring this genealogy makes it difficult to see how our own ideas about aesthetic depictions of inner life intersect with the history of racism. To see what I mean, we might return to Mitchell's story, which doesn't seem to us as particularly interested in exploring the relationship between race and subjectivity. But his main character's focus on the signal role skin plays in developing a sense of psychological selfhood offers an intriguing and necessarily racialized conception of the mind as somatically dispersed—as present in the fingertips as it is in the head. This sort of somatic mind was fascinat-

ing and threatening to nineteenth-century writers, artists, and thinkers. The sensitivity of one's skin was not only an immediate *marker* of higher brain function, but also a sort of psychology or form of selfhood in and of itself. But such understanding of the skin as neurological puts two very different value systems in play. On the one hand, Dedlow's conclusions locate higher brain functions such as consciousness within the materialism of the body. But on the other, the notion of the skin as supersensitive neurological organ is one of the foundational concepts of nineteenth-century race science — in which nonwhite skin was repeatedly figured as insensate and coarse in contrast to the positively elastic sensitivity of whiteness, and in particular, gendered and sexualized whiteness. As we see in *Portrait of Amelia Van Buren*, as well as in an unsettling portrait of his wife *The Artist's Wife and His Setter Dog* (1884–89) and other of his portraits of white women, Eakins's work often crafts an image of alienated white femininity through the representation of fabric on/and skin. His aesthetic depictions of white women as overly-sensitive, dampened, impressed-upon, were crucial elements of the nineteenth-century fantasy of "scientific" racial differentiation. As Kyla Schuller has put it, "Impressibility came to prominence as a key measure for racially and sexually differentiating the refined, sensitive, and civilized subject who was embedded in time and capable of progress, and in need of protection, from the coarse, rigid, and savage elements of the population suspended in the eternal state of flesh and lingering on as unwanted remnants of prehistory."[43] Eakins's representations of white women being swallowed, and nearly erased, by the fabric that envelops them are fascinating documents that reveal how much of the values underpinning the development of "psychology" stem from the idealization of white womanhood as under threat, increasingly disordered, and in need of protection.[44]

Throughout this chapter, I have tried to undo some of the assumptions of Eakins's scholarship. These assumptions and conventions have, to my mind, produced structures that make it difficult to think about paintings like *Whistling for Plover* and *Portrait of Amelia Van Buren* together. My analysis here is offered in the spirit of loosening the mortar that has sedimented between the varying critical approaches applied to representations of race, gender, and the psychological, in which the minoritized come to be read for traces of history (whether the subject being analyzed is art and writing *by* people of color, or representations *of* people of color), while the dominant continue to be understood as expressions of the ahistorical ideal of "consciousness" (whether the subject being analyzed is art and writing *by* white people or representations *of* white people). In this chapter, I have tried to weave

together both historicist analysis—situating a major American artist in the intellectual and aesthetic contexts of his time—and formalist criticism—highlighting compositional echoes and fissures—in an attempt to prise apart the critical conventions that have fastened around discussions of psychology and inner life. By pursing this line of inquiry, I hope to suggest, further, that our own contemporary critical conventions in analyzing representations of what we deem to be "inner life" were put into place in large part *because of* the aesthetic experimentations of the late-nineteenth century.

The disparate cultural and racialized values related to the mind and body in the postbellum era could not coexist, and nineteenth-century somatic psychologies ultimately gave way to a new sort of metaphysics in the form of psychoanalysis.[45] And yet the vibrancy of these nineteenth-century aesthetic and scientific experiments—the willingness to consider limbs as constitutive of psychological selfhood, the suggestion that consciousness might manifest in movement, the emphasis on gesture and subjectivity, the reclamation of the body as a form of thought—potentially provides suggestive models for the renewed scholarly interest in the somatic in an age of genetic determination. Eakins's late portraits do representationally amputate the body from the mind. And yet, we could treat this less as a revelation of human psychological truth than as a memorial to a particular historical moment in which the bodily fragment came to represent modernity's loss of wholeness and experience of alienation.[46] Modernity's forms of bodiless thinking were never inevitable or revelatory, as we might see in this new genealogy of Eakins's depictions of thought and inner life and his earlier interest in the forms the embodied mind could take.

Mind/Brain
The Physiognomy of Consciousness

When he died in 1916, Thomas Eakins was at work on a portrait of "cerebralist" Dr. Edward Anthony Spitzka (figure 26), who had died three years earlier. Originally a full-length figure of Spitzka holding a brain in his hands, the portrait was not only left unfinished by Eakins, but was also at some point during the twentieth century cut down to its current approximately three-quarter-length size. The image that we are left with now is of a faceless man's torso barely emerging from the murky background of the picture plane.

On March 4, 1906, the *New York Times* published an article on Spitzka, headed "Looking for the 'Face Within the Face' in Man." The article's subheading reads, "Dr. Spitzka, Surrounded by His Collection of Brains, Discusses the Latest Phases of Cerebral Science — No Such Thing as a 'Criminal Brain Type,' He Says" (figure 27). It's a typical turn-of-the-century scene, featuring a white man of science making racist claims while being interviewed in a room full of brains in jars.[1] But one aspect of this interview stands out: Spitzka's continual invocation of "the face" as analogous to the brains he studies. He haltingly and circuitously articulates an idea that he calls "cerebral physiognomy." He notes that this cerebral physiognomy "is difficult to describe in words," and yet keeps trying to do exactly that. The brain, Spitzka avers, can be read like a face; it should be approached visually, with an eye toward deducing what its appearance expresses about the person under scrutiny. From the perspective of our current era of relatively sophisticated brain imaging, Spitzka's claims don't seem particularly shocking. But restored to their moment — the human brain so suddenly available to interpretation — we can see a little more clearly: Hawthorne would have gasped.

Spitzka's faith in visual evidence would have been stymied by Eakins's unfinished portrait. The facelessness of the figure in the portrait was not intended. If he had finished the painting, Eakins, a practicing realist to the end, would have worked up facial features on top of the underpainting of the figure's head. But those features, left undone, instead appear blotted out or smeared. The brushwork on the face is extremely rough, with large and streaky wound-like slashes of fleshy pink. Spitzka's almost fetal, sealed eyelids appear to direct his gaze inward.

If the facelessness is not intended, neither is the absent brain. The story goes that Eakins was having a hard time rendering the brain on canvas and so asked his wife and fellow artist Susan MacDowell Eakins to do so for him. Eakins was a master at faces, but perhaps this confrontation with the "face within the face," the possibility of a cerebral physiognomy that his work had so helped to naturalize, proved too difficult for him. In the previous chapter, I argued that Eakins evolved a style at the end of his career that emphasized the disembodied nature of the mind, the way in which the mind exists separately from, is alienated from the body. Is it possible that trying to paint the brain—a somatic manifestation of the mind—might have occasioned a representational crisis for him?

Eakins's unfinished portrait connotes a particular sort of modernism that Eakins himself would probably have found distasteful, or at least, aesthetically suspect. Many writers and artists in the early twentieth century turned away from the realist commitment to likeness.[2] Using a variety of strategies of *defacement*, these writers and artists often sought to bypass the face's representation of an individual's interior world, instead experimenting with

FIGURE 27 "Looking for 'the Face Within the Face' in Man," *New York Times*, March 4, 1906.

ways to access and represent that interior directly, without mediation. These experiments argued that the interior unity implied by the face was either unrevealing or deceptive. The turn away from the face was in some ways a reaction against the literalism of the realist project "to construct a community of mutual recognition."[3] But, importantly, the turn away from the face involved a turn toward the interior. Leon Edel has called the modernist attempt to represent deep psychology "the inward turning"; Charles Taylor describes it as "the epiphanies of modernism."[4]

Eakins's unfinished portrait of Spitzka reveals how incomplete these accounts of modernism's epiphanic inwardness are without an account of how nineteenth-century portraiture generated the ideas about selfhood and inner life that both became psychology's subject *and also* enabled modernism's

rejection of that psychology/commitment to likeness. The Spitzka portrait unintentionally tells us something true about the genealogy of modernism. It appears at the very moment that many visual artists and fiction writers were moving away from figurative representation in favor of exploration of (in William James's term) the "stream of consciousness." This is a major, historic aesthetic shift. Where was portraiture in it? What speculative modes did writers and artists interested in portraiture use to navigate the tension between differing ideas about consciousness?

To answer these questions, this chapter argues that Henry James's obsessive interest in portrait fiction both mediated conflicting contemporaneous ideas about consciousness (an effect of the soma? Metaphysical? Distributed?) and imagined its own. James's portrait fiction is a key part of tracing the brain's "face," of considering the physiognomy of consciousness. Spitzka, at the time of his death, was developing a criminological "physiognomy of brains"—a positivist assertion that every individual's brain has as unique an appearance as a face, and thus can be tracked and taxonomized. James's portrait fiction navigates this complicated cultural scene, by thematizing the pursuit of interiority (undertaken by criminologists, neurologists, and psychoanalysts alike in this era) upon the portrait surfaces that litter his fiction. Ultimately, I argue that Henry James embraced neither the positivist view of the human-as-automaton, nor the philosophical view of the ahistorical and metaphysical nature of subjectivity, but rather the *aesthetic* view of inner life as continually reinvented by the artistic representations that give it expression.

Arguably, the culmination of the nineteenth-century fascination with portraiture and its visual imagination of inner life is Henry James's *The Portrait of a Lady* (1881). When he wrote the preface to the novel's New York Edition twenty-seven years later, James declared that the novel's subject matter was consciousness, and that this subject matter was, in the 1880s, aesthetically revolutionary. He explains this key structural feature of the novel by describing the thought process by which he arrived at it: "'Place the centre of the subject in the young woman's consciousness,' I said to myself, 'and you will get as interesting and as beautiful a difficulty as you could wish.'"[5]

Here we find James *discovering* in the consciousness of a young woman a new fictional topic. But he communicates this discovery to the reader of his preface via free indirect discourse, a formal device that allows writers and readers the illusion of having immediate access to a character's psychological interior. His use of free indirect discourse to explain how he decided to make Isabel Archer's consciousness the "subject" of the novel underscores

how dependent such consciousness is upon the specific aesthetic forms that express it. Like his brother William James—who described consciousness multiply and metaphorically: as a stream, a spinning top, darkness, the flight and perch of a bird, namelessness, a set of linguistic conjunctions, and so on—Henry's formal reiteration of how consciousness is designed and determined by the manner in which it is represented is significant; consciousness, both Jameses declared repeatedly, requires representation (in language, gesture, art) for us to grasp its existence.

Like Hawthorne (and Eakins), Henry James was fascinated by portraiture. Portraits figure prominently in his earliest stories "The Story of a Masterpiece" (1868) and "A Passionate Pilgrim" (1871), as well as "The Sweetheart of M. Briseux" (1873). As mentioned above, the portrait is obviously the scaffolding of *The Portrait of a Lady* (1881), as well as, more loosely, of two other nonfiction works from the 1880s that complete a portrait triptych from that decade: the critical essays collected in *Partial Portraits* and the travel writings in *Portraits of Places*. James's continuing interest in portraiture is evident also in tales from the last two decades of the nineteenth century; for example, "The Liar" (1888), "The Real Thing" (1892), "Glasses" (1896), "John Delavoy" (1898), "The Special Type" (1900), "The Tone of Time" (1900), and "The Faces" (1900).[6] In his novels, a character's encounter with a portrait often marks a revelatory or memorable moment. Significant instances include Millie Theale in *The Wings of the Dove* (1902) exclaiming of the Bronzino portrait she is said to resemble, "she is dead, dead, dead!" and the picture-gallery debate that occurs in *The Sacred Fount* (1901).[7] James's *tour de force* description of Christopher Newman in chapter 1 of *The American* (1877) offers the portrait as its model, while the delightful Gertrude Wentworth in *The Europeans* (1878) blossoms while having her portrait painted by the callow Felix Young. And, James's final, unfinished novel, *The Sense of the Past* (1917) finds its hero, Ralph Pendrel, stepping into an ancestral portrait and being transported into the past.

In this chapter, I will consider James's career-long fascination with portraiture as not ancillary to or simply coincident with his fiction's development of new and radical "ideas of consciousness" but rather foundational to his ability to imagine new forms of inner life.[8] His portrait fiction, like Eakins's visual art, dramatizes shifting ideas about human psychology at the turn of the century, especially as those ideas found expression in the debates surrounding materialism, physiological psychology, and the "stream" of consciousness. James's late-nineteenth-century fiction, I argue, is surprisingly (surprisingly, that is, insofar as critics rarely note it) attuned to the body as

a cognitive system and consciousness as corporeal (rather than metaphysical). But his portrait fiction also expressed skepticism of portraiture's new "psychological" subject matter—what I will term below the "expressive requirement" of portraiture (the idea that portraiture captures an individual's unique inner life on the canvas). In a selection of portrait fiction written right around 1900, James imagines new and more forms of portraiture: portraits that are not premised on physical resemblance, portraits that have a meta-engagement with the patriarchal functions that characterize many nineteenth-century portraits (marking inheritance and family lines, commemorating weddings), portraits that spring forth from characters' minds. These new aesthetic forms were a part of a larger cultural reimagination of human subjectivity, psychology, and inner life that was taking place at the turn of the century, as the physiological psychologies of the nineteenth century gave way to a return of the metaphysical in the form of psychoanalysis.

Isabel Archer's Body

We cannot fully understand Henry James's portrait fiction without first addressing what critics interested in these works' psychological acumen often find missing: the body. Lacking an analysis of the interface between consciousness and body, we cannot see how James's portrait fiction engaged with portraiture's cultural and social functions, nor can we fully account for how James's fiction helped craft the category of "the psychological" within which it would come to be so often analyzed. To begin, then: Isabel Archer, the subject of one of James's greatest portraits.

In her analysis of the key revisions James makes to *The Portrait of a Lady* in 1908, Nina Baym finds that "[a]t the same time that James gives [Isabel Archer] a rich mental life in 1908, he effaces the original main quality of her character, emotional responsiveness. Her intellectual agility is greatly extended at the expense of her emotional nature." The Isabel of 1908, Baym asserts, "responds with her mind, not her emotions."[9] A suggestive interpretation of the revisions, Baym's argument might be extended in light of recent scholarship in the humanities and neurobiological sciences that suggests we attend more carefully to the ways in which the mind and body are mutually animated.[10] Baym finds that the revised novel suppresses emotion/impulse/body in favor of consciousness/intellect/mind, but does not venture a theory as to why this might be the case.

One possibility is that the nearly thirty years that intercede between the novel's first publication and its revision as a part of the New York Edition proved to be significant years in the development of psychological thought in the United States and Britain. As I argued in chapter 3, during this period, the physiological psychologies of the nineteenth century—from popular fads such as phrenology and mesmerism to the materialist approaches of thinkers such as Herbert Spencer and G. H. Lewes—were becoming supplemented by nonphysiological psychoanalytic modes of inquiry into the inner life. James did not simply incorporate these changing scientific notions about consciousness into *The Portrait of a Lady*. Rather, the novel actively hypothesizes new forms of consciousness and explores the potential and limitations that inhere in both the physiologically embodied mind and the wandering consciousness enabled by the increasingly influential "talking cure."

Nineteenth-century critics who reviewed *The Portrait of a Lady* were interested in the relationship between fictional "psychology" and embodied physiology. Writing in the *Nation* in 1882, W. C. Brownell declared that the novel "is not only outside of the category of the old romance of which 'Tom Jones,' for example, may stand as the type, but also dispenses with the dramatic movement and passionate interest upon which the later novelists, from Thackeray to Thomas Hardy, have relied." Brownell describes *Portrait* as a "dissection" and further, a "professedly scientific work" in which "characters are treated with a microscopy."[11] The review highlights James's unusually intense focus on his characters' minds and consciousness (at the expense of plot ["dramatic movement"] and "romance"). But importantly, as Brownell's references to dissection and microscopy suggest, contemporary readers did not necessarily understand consciousness as disembodied.

In *The Portrait of a Lady*, Isabel Archer's body is figured as a form of thought itself, one which is often put in tension with the intense (and more "traditional") disembodied thinking she does with her mind. The novel, in fact, opens with characters discussing bodies and feelings. Gathered on the quiet lawn of Gardencourt, Ralph Touchett fusses about his father, checking whether he has enjoyed his tea, and wonders whether he is cold.

> The father slowly rubbed his legs.
> "Well, I don't know. I can't tell till I feel."
> "Perhaps some one might feel for you," said the younger man, laughing.
> "Oh, I hope some one will always feel for me! Don't you feel for me, Lord Warburton?"[12]

What does it mean to "feel for" someone? Common usage dictates that to "feel for" someone is to sympathize with that person, to identify one's mind with the other person's, or even to experience romantic feelings toward another. But what if we were to take the Touchetts' teasing a bit more sincerely—as expressing a need for a body through which they might *feel* the world (and here it helps to read the word "feel" literally, as related to bodily touch, rather than metaphorically, as related to sympathy)? Mere pages later, Isabel Archer appears as if conjured by Ralph's suggestion that someone may come along to feel (touch and experience) for his father.

Primed to feel, Isabel Archer is introduced to the reader in creaturely terms. Her arrival is detected not by human perception, but instead is heralded by the bodily emanations of an animal: "[Ralph's] attention was called to her by the conduct of his dog, who had suddenly darted forward, with a little volley of shrill barks" (*Portrait*, 15). Isabel "stooped and caught [the dog] in her hands, holding him face to face while he continued his joyous demonstration." Warburton remarks that he knows this is "the independent young lady" of which they spoke "from the way she handles the dog" (*Portrait*, 15). Isabel is free because her body acts freely; later in the chapter she is described as having a fluid connection between her mind and body: "her head was erect, her eye brilliant, her flexible figure turned itself lightly this way and that, in sympathy with the alertness with which she evidently caught impressions" (*Portrait*, 18).

If Isabel at her most joyful is Isabel *in* her body, Isabel at her most vulnerable is also Isabel in her body. Upon inheriting a vast fortune, Isabel is stunned into stillness: "She doesn't know what to think about the matter at all. It has been as if a big gun were suddenly fired off behind her; she is feeling herself to see if she is hurt," Lydia Touchett ventures (*Portrait*, 223). After coming into the "architectural vastness" of the secret Gilbert Osmond and Madame Merle have kept from her—that Merle is Pansy Osmond's biological mother—Isabel rediscovers the tears that have eluded her since marrying Osmond and cries, of Merle, "Ah, poor creature!" (*Portrait*, 501). And when Caspar Goodwood makes his last plea for her love, "Isabel gave a long murmur, like a creature in pain; it was as if he were pressing something that hurt her" (*Portrait*, 543). During these moments in which she experiences the "dumb misery" (*Portrait*, 306) that so irritates her in Goodwood, Isabel is less fine mind than wounded animal. The novel's emphasis on the creaturely— for example the attention paid to the characterization of the Touchetts' dogs in the early chapters—goes beyond metaphor, detail, or setting. The post-*Origin of Species* world was riveted by newly animalistic characterizations of

human qualities. Charles Darwin's *The Expression of the Emotions in Man and Animals* (1872) attempted to understand the seemingly most human phenomenon of emotion by uncovering the physiological, muscular, and nerve-force origins of the emotions, drawing comparisons between human and animal expression of joy, pain, shame. By failing to appreciate their materialist, animal, instinctual qualities, Darwin asserts, we have conceived of human expression and emotion in far too transcendent and metaphysical of terms.

Isabel has incorporated her era's conflicted ideas about the relationship between the somatic/animal body and disembodied subjectivity. Feeling oppressed by the possibility that Caspar Goodwood might soon show up at Gardencourt to press his case with her once more, Isabel takes a walk around the grounds of the estate, accompanied by Bunchie the terrier. "She entertained herself for some moments with talking to the little terrier [b]ut she was notified for the first time, on this occasion, of the finite character of Bunchie's intellect; hitherto she had been mainly struck with its extent. It seemed to her at last that she would do well to take a book; formerly, when she felt heavy-hearted, she had been able, with the help of some well-chosen volume, to transfer the seat of consciousness to the organ of pure reason" (*Portrait*, 93). Isabel's realization that there is a lack of continuity between her consciousness and the animal's is accompanied by her attempt to will her own human consciousness *into* her mind (presumably from her heavy heart). But her attempt to move from the animal world of heart and body to the human world of mind and consciousness is interrupted by a letter that arrives from Goodwood, which she reads with "such profound attention" that she doesn't notice Lord Warburton suddenly "loom[ing]" over her as she sits on the park bench. Isabel's desire to experience consciousness through "the organ of pure reason" is ironized when she goes on to refuse Warburton on "instinct," making a decision that Ralph urges her to explain in terms of "logic" but which she cannot explain satisfactorily to anyone. As readers, however, we do not need a reasonable or logical explanation because we have access to the narrative articulation of Isabel's *feeling*, which is more than enough explanation: "What she felt was that a territorial, a political, a social magnate had conceived the design of drawing her into the system in which he lived and moved. A certain instinct, not imperious, but persuasive, told her to resist—it murmured to her that virtually she had a system and an orbit of her own" (*Portrait*, 95). Such intense, instinctual feeling is reason enough.

Isabel's desire for "pure reason" is thrown suggestively into relief not only by the role of heart and emotion in this scene, but also by her bodily action

during Warburton's proposal. The first thing she does is get up: "Isabel had got up; she felt a wish, for the moment, that he should not sit down beside her" (*Portrait*, 94). Then she declares that they should walk: "'We will walk about a little then,' said Isabel, who could not divest herself of the sense of an intention on the part of her visitor It had flashed upon her vision once before, and it had given her on that occasion, as we know, a certain alarm" (*Portrait*, 94). It seems in these moments that Isabel's bodily agitation reflects her mental agitation, is somehow an *expression of* a prior metaphysical emotional state.

But this assumed causal relationship between emotions and their bodily expression was being reevaluated in the 1880s by thinkers and psychologists. Three years after the initial installments of *The Portrait of a Lady*, Henry James's brother William published an essay titled "What is an Emotion?" that inverted common understandings of expression. William's essay articulated what would come to be called the James-Lange theory of emotion, which posits that humans don't feel something and then experience bodily change accordingly, they experience a physiological change and *then feel* accordingly.[13] "Common sense says, we lose our fortune, are sorry and weep; we meet a bear, are frightened and run; we are insulted by a rival, are angry and strike [T]his order of sequence is incorrect . . . the bodily manifestations must first be interposed between . . . we feel sorry because we cry, angry because we strike, afraid because we tremble."[14] At the heart of William's theory were the recent discoveries of just how physiologically manifest the emotions are:

> [N]ot even a Darwin has exhaustively enumerated *all* the bodily affections characteristic of any one of the standard emotions. More and more, as physiology advances, we begin to discern how almost infinitely numerous and subtle they must be. The researches of Mosso with the plethysmograph have shown that not only the heart, but the entire circulatory system, forms a sort of sounding-board, which every change of our consciousness, however slight, may make reverberate. Hardly a sensation comes to us without sending waves of alternate constriction and dilatation down the arteries of our arms And the various permutations and combinations of which these organic activities are susceptible, make it abstractly possible that no shade of emotion, however slight, should be without a bodily reverberation as unique, when taken in its totality, as is the mental mood itself.[15]

William James's theory takes a commonsensical notion—*of course* emotion registers bodily, as a flush, or increased heart beat—and turns that notion into a revolutionary idea: the emotion that we experience as one aspect of our inner life is nothing other than the workings of our bodies, our machines. That is to say, there is nothing metaphysical about emotion, it does not exist prior to or apart from the body. Emotion is an *effect of* our most materialist self, not terribly different from sweat on skin on a hot day.[16]

A number of moments in Henry's novel look differently when we return to them with a keener sense of the importance Isabel's body plays, not in "expressing" emotion or thought, but in becoming a form of thought itself. Isabel's body almost involuntarily rises when Lord Warburton appears; the instinctive motion of her body manifests as a sense of alarm. Her impulses murmur and Isabel listens. Even when she is not yet able to translate her own body's language, Isabel cocks an ear. One of the most famous scenes in the novel—Isabel's coming upon Osmond and Madame Merle in the position of "something detected"—is shot through with the language of physiological cerebration. Isabel "stopped short," she "instantly perceived," and "felt it as something new." The thing that strikes Isabel most strongly is the positioning of Osmond's and Merle's bodies: "he was sitting while Madame Merle stood; there was an anomaly in this that arrested her" (*Portrait*, 376). Their violation of social custom takes on an almost ethological dimension with Isabel paused mid-step like an animal that has detected something amiss near the nest. This is not introspective consciousness as we commonly understand it but something more akin to embodied thought.

If the novel puts its finger on those moments when the body *thinks*—makes decisions, generates emotion, comes to conclusions—it is at least equally attuned to how bodies are vulnerable, and often fallibly unreflective. In the preface to the New York Edition of the novel, James celebrates Isabel's midnight vigil—in which her body remains still while "her mind, assailed by visions, was in a state of extraordinary activity" (*Portrait*, 401)—as "obviously the best thing in the book" because "it all goes on without her being approached by another person and without her leaving her chair."[17] This is the familiar Jamesian "ordeal of consciousness," a bodiless and bloodless (though extraordinarily casualty-laden) war. The novel's (and James's) embrace of this type of disembodied thought might be skepticism or discomfort with materialist theories of embodied thought, or it might just be a desire to have more than one option on the table. Because, despite critical attempts to define consciousness in James, consciousness takes *many* forms in this

novel—from the familiar central subjectivity of Isabel Archer in the chair by the fire, to the decentered consciousness that Sharon Cameron argues is James's key innovation (and which he eschews embracing in his preface), to the embodied mind I have been suggesting requires more attention. In fact, the embodied mind only means *in relation to* other ideas regarding what form consciousness might take.

For example, Isabel's body becomes less responsive as the novel progresses. This is not because the novel "decides" to abandon one form of consciousness for another. Rather, Isabel's disembodied experience of subjectivity in the second half of the novel—her vigil, her frustrating devotion to sacrifice and abstract principles of right—is at least in part an effect of her unnarrated pregnancy and the subsequent death of her child, two significant features of Isabel's post-marital life that critics rarely note. Despite her claims that her unhappy marriage "was not physical suffering [s]he could come and go; she had her liberty" (*Portrait*, 396), it is clear that Isabel's body has been affected by her union with Osmond. Many critics have noted the significance of the moment the reader is reintroduced to Isabel three years after her marriage: through Ned Rosier's eyes we see Isabel "framed in a doorway . . . the picture of a gracious lady" (*Portrait*, 396). Swathed in black velvet, Isabel is described in terms that suggest the ebullient and elastic figure of the early chapters is gone: after her marriage, she is "indifferent" and "her light step drew a mass of drapery behind it" (*Portrait*, 424).[18] If Isabel's mind now dwells in "the house of darkness, the house of dumbness, the house of suffocation" (*Portrait*, 395), Isabel's body is likewise muted through fabric, pose, and ornament.

The lengthiest commentary the reader receives about Isabel's loss of a child is through Ralph, who juxtaposes what critics often notice about Isabel (her loss of expressiveness and responsiveness) with what critics rarely notice about Isabel (that she has lost a child): "There was something fixed and mechanical in the serenity painted upon [her face]; this was not an expression, Ralph said—it was a representation. She had lost her child; that was a sorrow, but it was a sorrow she scarcely spoke of; there was more to say about it than she could say to Ralph" (*Portrait*, 362). The juxtaposition suggests that the death of the child has snapped a connection between mind and body; the body no longer manifests thought or emotion, it merely represents calculated states of feeling. Ralph's vision of Isabel critiques the understanding of the "inner" and "outer" as distinct from one another and underscores the conceptual work William James would go on to do on the emotions: a blush or

racing heartbeat is not a representation of an emotion but rather the emotion itself.

Later, in a scene that echoes Ralph's vision of Isabel's "fixed and mechanical" aspect, Isabel looks at Ralph's face as he lies dying: "There was a strange tranquility in his face; it was as still as the lid of a box. With this, he was a mere lattice of bones; when he opened his eyes to greet her, it was as if she were looking into immeasurable space" (*Portrait*, 528). Ralph's body is in the process of dying, it is mere structure, barely able to contain the content of his subjectivity, which is expansive, immeasurable. It is next to this "immeasurable space" that the very finite qualities of the body start to look insufficient. For a creature in pain such as Isabel, who Henrietta describes as "like the stricken deer, seeking the innermost shade" (*Portrait*, 461), such disembodied subjectivity must appear as not just a relief but an aspiration.

Both of these moments feature characters looking intently at another's face, tracing its physiognomy of consciousness. Crucially, the descriptions of Ralph's and Isabel's faces offer the face as not just the content of person (her soul, inner life, emotion) but also its form—a body, flesh, "lattice of bones." In *The Portrait of a Lady*, then, we see James actively working through his era's major questions about bodily emotion and corporeal consciousness: the extent to which the most transcendent aspects of human subjectivity were simply the byproduct of brute animality, and the extent to which consciousness is a manifestation of the body or a refuge from the body. One way to understand *The Portrait of a Lady*, especially in relation to the antipsychological tradition of Jamesian criticism established by Sharon Cameron and Leo Bersani, might be to see in this novel a sort of nineteenth-century naivete, in which the novel not only seems to believe in the existence of individual psychology located deep inside discrete individuals, but also in the capacity of portraiture as an aesthetic form to give expression to inner life. But a closer look at the short portrait fiction that James wrote both before and after *The Portrait of a Lady* suggests that the novel is not so much "antipsychological" as it is actively engaged in the process of defining what "psychological" might come to mean.

Personalism, or the Weapon of Portraiture

James's portrait fiction directly addresses portraiture's developing role in representing something penetrating, intimate, authentic, and deeply true about the inner life of its subject. Sometimes his fiction seems to believe in

this vision of portraiture's expressive function; other times, it exhibits deep suspicion of it. We can see this ambivalence, or nuance, taking shape in an uncharacteristically breathless essay about John Singer Sargent written for *Harper's Magazine* in 1873. James exclaims

> There is no greater work of art than a great portrait—a truth to be
> constantly taken to heart by a painter holding in his hands the weapon
> that Mr. Sargent wields. The gift that he possesses he possesses
> completely—the immediate perception of the end and of the means.
> Putting aside the question of the subject (and to a great portrait a
> common sitter will doubtless not always contribute), the highest result
> is achieved when to this element of quick perception a certain faculty
> of brooding reflection is added. I use this name for want of a better,
> and I mean the quality in the light of which the artist sees deep into his
> subject, undergoes it, absorbs it, discovers in it new things that were
> not on the surface, becomes patient with it, and almost reverent, and,
> in short, enlarges and humanizes the technical problem.[19]

This praise embraces a variety of opposites: James celebrates both immediacy and protracted reflection, finds the sitter or subject of the portrait to be both central and marginal, and understands the portrait as both a painterly expression of truth and an opportunity for technical showmanship. Yet achieving aesthetic greatness in portraiture is no benign process; Sargent may have a "gift," but that gift, James emphasizes, is a "weapon." One sees this weapon at work even in James's secondhand description: he overtly erases the sitter ("a common sitter doubtless will not always contribute") in his celebration of artistic mastery.

Indeed, there is an element of violence in most of James's portrait stories; portraits are regularly slashed or otherwise destroyed at the climax of these narratives.[20] Critics have interpreted these scenes as examples of James's worry over turning people into art.[21] But the weapon of portraiture, I want to suggest, cuts both ways. The portrait in James can serve to flatten and otherwise negatively aestheticize the individual; such a reading only obtains, however, when accompanied by the belief that the depicted person's "real" self exists somewhere inside or behind external appearances. The portrait is just as likely, in James's oeuvre, to question the idea that selfhood and subjectivity exist in such hidden-from-view places.

Take for example, James's early "The Story of a Masterpiece" (1868). This tale recalls Hawthorne's "The Prophetic Pictures" in its account of a wedding

portrait that turns out to be a curse upon a couple's future. In James's story, John Lennox, a wealthy older man, commissions a portrait of his young bride, a beautiful woman of modest means named Marian Everett, to be painted by the up-and-coming portraitist Stephen Baxter. When the couple visit the portrait studio, it is revealed that Baxter and Everett knew one another in Europe some months back, and Baxter had used her as a model for his painting titled "My Last Duchess," after Robert Browning's poem. Baxter insists to Lennox that "My Last Duchess" is *not* a portrait, but rather a figure painting, "an attempt to embody my own private impression of the poem." He goes on, apologizing for any resemblance the figure in the painting bears to Marian Everett: "I'm sorry if the copy betrays the original."[22]

Though Lennox is suspicious of the relationship between his fiancée and the painter, he goes forward with the commission, telling Baxter, "I expect you . . . to make a masterpiece" ("Masterpiece," 190). The resulting portrait disappoints him twice. When he first sees it just before its completion, he is horrified by its "too frank a reality," instructing the painter that one "can be real without being brutal—without attempting, as one may say, to be *actual*" ("Masterpiece," 199), and finally confessing that he is bothered mainly because Baxter has "given poor Miss Everett the look of a professional model" ("Masterpiece," 199). In other words, that this looks more like a figure painting for which a "professional" woman would have been paid to model for than a portrait meant to capture the specific, personal, expressive qualities of an upper-class lady.

After just a few hours more work, Baxter re-presents the portrait to Lennox: "it now impressed him as an original and powerful work, a genuine portrait, the deliberate image of a human face and figure. It was Marian, in very truth, and Marian most patiently measured and observed" ("Masterpiece," 199). Yet still the work fails to satisfy, and indeed works a dark magic upon Lennox's impression of Marian: "It seemed to Lennox that some strangely potent agency had won from his mistress the confession of her inmost soul, and had written it there upon the canvas . . . Marian's person was lightness—her charm was lightness; could it be that her soul was levity too? . . . What else was the meaning of that horrible blankness and deadness that quenched the light in her eyes?" ("Masterpiece," 200–1).

What is the difference between the "brutal" version of the portrait where Marian looks like a professional and the "genuine" version where Marian looks like Marian? The tale ends as Lennox, resolutely the gentleman, resolves to marry Marian, so as not to make her "pay the penalty" for "the

fault was his own" ("Masterpiece," 208). But in a frightening, though familiar, moment, he lets loose his rage, grasps a knife and "thrust[s] it, with barbarous glee, straight into the lovely face of the image. He dragged it downward, and made a long fissure in the living canvas. Then, with half a dozen strokes, he wantonly hacked it across" ("Masterpiece," 208–9). This violent ending does more than enact a sexualized murderous fantasy (though it certainly does that). It raises one final question about the psychologized representation realism depends upon: what happens when one cuts through the surface and finds not a secret or a truth or even a mess of emotional pottage—what happens when one penetrates the surface only to find that there is nothing there?

The story observes Lennox's expectations of Marian's portrait with extreme irony, a narrative point of view I will return to below. But first it might help to understand the context that surrounded this story that is at least in part about the precipitant violence of expressive portraiture. Intriguingly, "The Story of a Masterpiece" appeared in *The Galaxy* in January 1868. In April of that same year, in the same venue, Walt Whitman published an essay titled "Personalism." A follow-up to his essay "Democracy" (which was published in December 1867), "Personalism" offers Whitman's vision of the "towering Selfhood" that will counteract the flattening tendency of democracy. Whitman worries that American culture is tending toward the average, rather than the individual, "rapidly creating a class of supercilious infidels, who believe in nothing" and asks, "Shall a man lose himself in countless masses of adjustments, and be so shaped with reference to this, that, and the other, that the simply good and healthy and brave parts of him are reduced and clipped away, like the bordering of a box in a garden?"[23]

Whitman's concern over the "healthy and brave parts" being "reduced and clipped away like the bordering of a box in a garden" will find an echo in *The Portrait of a Lady*'s later description of the "garden-like quality" of Isabel Archer's "nature" (*Portrait*, 244). But more immediately relevant to this moment in the late 1860s is Whitman's interest in the portrait as a mediating reference point. After making his introductory argument *for* individuality and expression in all its variety, Whitman declares: "Attempting then, however crudely, a model or portrait of Personality . . . we should prepare the canvas well beforehand" ("Personalism," 543) and then offers long Whitmanian lists of types of American selfhood: "in youth, fresh, ardent, emotional, aspiring, full of adventure; at maturity, brave, perceptive, under control, neither too talkative nor too reticent, neither flippant nor somber; of the bodily figure, the movement easy, the complexion showing the best blood, some-

what flushed, breast expanded" ("Personalism," 544). When he weighs in on the varieties of feminine Personalism, which include the young seamstress and "the wife of a mechanic," Whitman concludes, "The foregoing portraits, I admit, are frightfully out of line from these imported models of womanly Personality—the stock feminine characters of the current novelists, or of the foreign court poems (Enids, Guineveres, Princesses, or Ladies of one thing or another), which fill the envying dreams of so many poor girls, and are accepted by our young men, too, as supreme ideals of feminine excellence to be sought after. But I present mine just for a change" ("Personalism," 546).

In "Personalism," Whitman uses portraiture as an extended metaphor through which he can explore the convergence and divergence of type and individual. Whitman remains ambiguous as to whether "the seamstress" he invokes is an individual or a type. James is less ambiguous in "The Story of a Masterpiece." When Stephen Baxter paints Marian Everett as "My Last Duchess" he insists that the result is *not* a portrait; the image has nothing to do with Marian Everett the person. The "My Last Duchess" image offers the woman as an Enid, Guinevere, Princess, or Lady. In other words, as a type. This image of Marian Everett, Baxter insists, is not *Marian Everett*. When it comes to the wedding portrait, John Lennox desires an image of Marian Everett that is *Marian Everett*. What he does not recognize is that Marian Everett only exists as such in relation to systems of social and gender discipline. She, to paraphrase Whitman, has already been pruned, gathered, trimmed, conformed, to arrive at her advantageous match with Lennox.

The tale sets up a difference between the *painting* Stephen Baxter makes of Marian Everett and the *portrait* he makes of her. In the former, Baxter desires to express his own "private impression" of the Robert Browning poem. Marian is not the subject of the painting, but she is, in her capacity as a model, its purchased body (and mind) through which Baxter effects his expression. The difference between the two men is that Lennox does not recognize that the portrait he commissions of Marian will, in fact, be *his* private expression. In other words, Lennox confuses two competing narratives about portraiture: that it commemorate patriarchal lineage and that it express the depicted individual's qualities of mind. The true function of the wedding portrait is to display Marian Everett in a manner becoming her husband, under whose legal identity she is soon to be subsumed.[24] According to both legal and social custom, she is to express her husband. The irony, James points out here, is that her fiancé wants her to express *herself*.

Portraiture and the Promiscuous Plural

If *The Portrait of a Lady* suggests that James considered portraiture an exceptional aesthetic form through which to explore ideas about corporeal consciousness, "The Story of a Masterpiece" (along with Whitman's essay "Personalism") reveals how skeptical his work was of developing notions that a portrait was a window into an individual's soul or inner life. James's later short portrait fiction moves away from the understanding of portraiture as *expressive of* something else (a sitter's inner life, an artist's genius, et cetera) and toward an understanding of portraiture *as* the thing itself, as inner life/psychology/consciousness/genius itself. This aesthetic progression, I have been arguing, was central to how psychology came to be understood as the century turned.

James's early stories like "The Story of a Masterpiece" recognize that one often finds in a portrait—contrary to its conventional guarantee—an expression of interiority that in fact belongs to someone other than the sitter. In two stories written in 1900, James further explores the capacity of the portrait to multiply and distribute psychology, rather than focalize it in singular individuals. In these stories, singular characters are referred to via plural pronouns and portraits and people become literally interchangeable. Ultimately, in James's late stories, portraits not only fail to represent the expressive psychological specificity of one single person, but in fact confound the very ideas (or possibilities) of individualism, expression, and self-contained psychological interiority.

The narrator of "The Special Type" (1900) is a portrait painter who describes himself as "a man habitually ridden by the twin demons of imagination and observation." His characterization as such underscores portraiture's hybrid state as both document of observed reality and expressive imaginative hypothesis.[25] "The Special Type" tells the story of four people: the portrait painter narrator; Alice Dundene, a beautiful model he often uses for subject paintings; Rose Cavenham, an aristocratic woman whose portrait he paints; and Mr. Brivet, a rich American man.[26] Brivet is in the midst of securing a divorce from his wife in America and is carrying on an affair with Rose Cavenham. In order to give his wife the "evidence" she needs to finalize the divorce, he needs to appear to be having an affair, but he does not want to sully the name of the woman he is actually having the affair with. At the portrait painter's studio one day, Brivet is introduced to Alice Dundene, whose beauty and grace make her the perfect foil; she is, as both Brivet and the narrator agree, a "special type." Rose Cavenham goes to America while

Brivet publicly cavorts with Dundene. Once his divorce is finalized, Cavenham returns and commissions a portrait of Brivet which the narrator completes to his own great satisfaction: "It was the very view of him she had desired to possess; it was the dear man in his intimate essence for those who knew him; and for any one who should ever be deprived of him it would be the next best thing to the sound of his voice" ("Type," 302).

Despite his aesthetic triumph in this portrait of Brivet, the narrator has become disgusted with the whole situation. In the end, Alice Dundene comes to him to say that, in exchange for allowing herself to *appear* promiscuous, Mr. Brivet has offered to give her whatever she most desires in the world. What she most desires, it turns out, is a portrait of Brivet, "full-length. I want it for remembrance, and I want it as you will do it. It's the only thing I do want" ("Type," 303). The narrator promises her the portrait he had painted for Rose Cavenham, who is furious, and the tale ends.

Brivet is not the only person to sit for the narrator in this story. Rose Cavenham sits for a portrait by him, while Alice Dundene models for a variety of figure paintings. The story highlights how skill at modeling for figure paintings shows a flexibility and depth of character in a way that sitting for a portrait does not.[27] Alice Dundene enlivens the painter's studio: "There were studies of her yet on the walls; there were others thrust away in corners; others still had gone forth from where she stood and carried to far-away places the reach of her lingering look" ("Type," 303). Contrast this kinetic description of Alice's varied representations with the one Brivet offers of Mrs. Cavenham's portrait. Here Brivet counters the narrator's worry that Rose Cavenham "stands . . . straight in the splash" of the scandal: "'She doesn't!' he interrupted me, with some curtness. 'She stands a thousand miles out of it; she stands on a pinnacle; she stands as she stands in your charming portrait—lovely, lonely, untouched. And so she must remain'" ("Type," 291). Mrs. Cavenham's portrait—her name likely appended to it as title—ensures that her reputation remains unsullied and static, framed and cataloged. Mrs. Dundene's figure paintings—which appropriate both her body and her mind (her "lingering look") but disconnect them from her disciplining name—circulate freely and widely, just as the stories about her do. In the diverging cases of the two women, the ability to *seem* offers the woman up for "spattering" ("Type," 291), while the ability to *be* (self-identical) secures for the woman a "reputation untouched."

The narrator frames the story as one of "sacrifice," and goes so far as to claim that "[i]n the way of service and sacrifice for love I've really known nothing go beyond it" ("Type," 287). Significantly, it is unclear who is making

the sacrifice. The story bears out the narrator's extreme sympathy toward Alice Dundene and ultimate antipathy to the far less superb Rose Cavenham, and so a likely reading might allow that the sacrifice is Alice's, since she sacrificed not only Brivet (in embodied form) but also her reputation. But the opening frame multiplies feminine pronouns to the point that the reader is incapable of deducing whether the "she"s and "her"s refer to Alice, Rose, or, even the absent Mrs. Brivet. Indeed, all three women sacrifice something; importantly, Rose must give up the portrait of Brivet, a sacrifice that in this story is not taken lightly. For if Rose Cavenham's portrait frames her and protects her, and Alice Dundene's modeling puts her name into circulation ("unlimited publicity"), the portrait of Brivet (emphatically "full-length," we are told multiple times), in the end, substitutes for the man himself. Rose ends up with Brivet the man, Alice with Brivet the painting. It is crucial to recognize that the story does not actually articulate which result is the "sacrifice."

Just as Brivet is multiplied via his representation, so is Alice Dundene multiplied by Rose Cavenham's inability to utter Alice's name or even use the singular pronoun to refer to her: "[Mrs. Cavenham] never, to the end of the affair, came any closer to her in speech than by the collective and promiscuous plural pronoun" ("Type," 299). Mrs. Cavenham takes her grammatical side-stepping to the extreme, telling the narrator that Brivet "never saw them alone." The narrator adopts her usage in the narration itself, bemoaning that Cavenham could be so "smugly selfish" since "while she had kept her skirts clear, her name unuttered and her reputation untouched, 'they' had been in it even more than her success required. It was their skirts, their name, and their reputation that, in the proceedings at hand, would bear the brunt" ("Type," 300). This convention is not as far-fetched as it might at first seem, if we take seriously that Alice Dundene is pluralized insofar as she is multiply represented; when one refers to Alice Dundene, one refers not only to Alice Dundene but also to her many representations that circulate around the world. Alice Dundene plus the many paintings in which she appears plus the gossip about her plus the loosening of gender discipline that her visibility effects equals "they."

In the end, both Cavenham and Dundene emphasize that the latter was never alone with Brivet, confirming that the "spatter" upon Alice is rhetorical only. Alice's final request of Brivet's portrait is asked in relation to this insistence. She is so pleased with the image—"It's the whole story. It's life"—that she tells the narrator that "It will be him for me I shall live with it, keep it all to myself, and—do you know what it will do?—it will seem to

make up" ("Type," 304). When asked for what it will make up, she replies, "I never saw him alone." Brivet's portrait will be Brivet, alone, for her (and here again remember, it will be Brivet, in "full length"). It is so real a representation of the man that it will make up for the fact that she never did see him alone.

In a final, brief argument with which the story closes, the narrator explains to Cavenham that Dundene wants the portrait of Brivet and nothing else will do. But in saying so, the narrator employs the "promiscuous plural pronoun" that Rose Cavenham insists on using when she refers to Alice Dundene. The narrator tells Cavenham that, "they want him." Rose Cavenham doesn't understand what he means at first and so he repeats Alice Dundene's words to her: "To live with . . . to make up." Cavenham still doesn't understand, and so he repeats Dundene again, but this time, with a difference, and it is on this line that that tale closes: "Why, you know, they never saw him alone" ("Type," 305). Rose Cavenham's obtuseness here at the end is suggestive; it's unclear whether her own speech patterns, reflected back to her, are what fail to register, or whether she simply cannot find her way into empathy with Alice Dundene's emotional motivations. But these are perhaps not opposed entities; Cavenham meant the "promiscuous plural pronoun" to function cruelly, as a way to shun the woman she wanted to discipline. Her speech patterns *manifest* her lack of empathy. And yet, one feature of linguistic and aesthetic forms is how easily they transform, once put into the world.

The portrait's capacity to multiply and distribute subjectivity is key here. Whereas James makes an initial distinction between the depictions of the women in this story—Rose Cavenham's traditionally-commissioned portrait versus Alice Dundene's figure paintings—that imply that portraiture frames and protects selfhood, the conclusion of the story dissolves this distinction in its treatment of the representation of Brivet. Brivet and the portrait of Brivet are interchangeable, and we end the story with quite an odd couple: a woman who is not singular but plural, proposing to "live with" a portrait of a man rather than the man himself. Despite Rose Cavenham's attempts to arrest their promiscuous movements, once set in motion, the pronouns (words that *stand in for*) and portraits (images that *stand in for*) get loosed from their frames. In this story, consciousness does not reside "in" singular persons, and portraits are not meant to *represent* subjectivity; rather, they function as subjectivity.[28]

James wrote another story in the same year that uses almost the same structure as "The Special Type." In "The Tone of Time," we join another group vying for the privilege of either making or owning a portrait. The narrator,

a male portrait painter, informs his friend Mary J. Tredick, also a portrait painter, of a commission that he thinks she would do well to take. A wealthy woman named Mrs. Bridgenorth wants a portrait of a man to hang over her hearth. At first it seems like she is asking for a portrait of her deceased husband, but it eventually becomes clear that she's asking for a portrait of a man who may never have existed: the portrait is "to represent, to symbolize, as it were, her husband, who's not alive and who perhaps never was" and that it should have "the tone of time," that it should "look old."[29]

Tredick takes this curious commission and completes the painting without using a sitter. When the narrator sees it, he is struck that she has "produced an extraordinary thing" ("Tone," 627) and asks her: "'[Y]ou've arrived at this truth without documents?'" ("Tone," 628). When Mrs. Bridgenorth sees the completed painting she lets out an "extraordinary" cry—"The likeness! The likeness!" ("Tone," 629)—and it becomes clear to the narrator that somehow Mary Tredick has produced a portrait of the very man Mrs. Bridgenorth had in mind.

The baroque romantic complication in this tale is that Tredick has painted an image of a man she had loved long ago, but had lost to another woman whose identity she never knew. The man Tredick loved, it turns out, had left her for Mrs. Bridgenorth. The unnamed man died before he and the woman who would become Mrs. Bridgenorth were ever married. Upon seeing this portrait of the exact man she had in mind, Mrs. Bridgenorth puts two and two together and realizes that Mary Tredick was the woman she had unknowingly competed against for the unnamed man's affections years ago. She knows she must keep her own affair with the man a secret, because if Tredick finds out, she won't let Bridgenorth keep the portrait. Panicking, Bridgenorth convinces the narrator to offer Tredick more money for the portrait; but this strategy backfires and tips Tredick off. Tredick sneaks into the narrator's studio (where the painting temporarily resides) and takes it back, refusing in the end to let Bridgenorth have it. Tredick promises the narrator the portrait when she dies, since he admires the artistry of the picture. Both Tredick and Bridgenorth die, and the last paragraph of the story finds the narrator calling this "an old man's tale. I have inherited the picture, in the deep beauty of which, however, darkness still lurks. No one, strange to say, has ever recognized the model, but everyone asks his name. I don't even know it" ("Tone," 634). The unnamed man at the center of this portrait is a screen memory, an image that represents not a person but, rather, endlessly unfulfilled desire.

The representational economy of portraiture — that certain surface gestures, poses, tones, or atmospheres make visible and perceivable a person's psychological interior — is confounded here. Portraiture here no longer consolidates or marks lineage; indeed, the portrait in "The Tone of Time" is the *anti*-marriage portrait. It commemorates the failure of a marriage to occur. No name passes down to successive generations, only "darkness" and the unfulfilled desire to know whom the image depicts. This last point is crucial because such an unfulfilled desire reveals how the story also confounds the expressive portrait function. The desire to know the subject of the portrait is generated because while the portrait promises to express something about the individual depicted, what the portrait actually expresses is only ever the failure of that promise.

When the narrator in "The Tone of Time" first sees the portrait Mary Tredick paints, he remarks that the man depicted appears "so handsome, in short, that you can scarcely say what he means, and so happy that you can scarcely guess what he feels" ("Tone," 628). The appearance of happiness not only fails to correspond to the sitter's interior emotional state (the idea of the mask and the real, the former covering the latter), but also undoes the psychological chronology of surface and depth (where the former comes after the originality of the latter). The figure's appearance of happiness dismantles a viewer's ability to even hypothesize about "what he feels." This is far different from being able to deduce that a person is "really" sad, even though she looks happy. Of course, in this case, a viewer could not "guess" at the depicted man's interiority, given that the "sitter" for this portrait is not a real person, but rather a memory unknowingly shared by two women. This man springs forth out of their minds. If the problem with Marian Everett's portrait was that there was no depth beneath her surface, the problem with this unnamed man's portrait is that there is no man in the man. The portrait without a subject challenges the very notion of psychological subjectivity that James cataloged in his other fiction.

Trifling with Resemblance

Mrs. Bridgenorth loses her breath over the "likeness" of the portrait Mary Tredick conjures out of memory and heartache. But the bizarre circumstances surrounding the composition of the portrait force the reader to interrogate what exactly "likeness" really is. Visual resemblance? The picturing forth of some sort of essence or truth about the sitter's subjectivity or

consciousness? In the case of "The Tone of Time," the likeness is more clearly between the two women's minds, rather than between the sitter's appearance and his portrait depiction. The motivating question of *The Portrait of a Lady*—what does it mean to *feel for* someone else, to do the corporeal work of emotion, consciousness, and cognition—arises again in slightly different form here: what (and who) does "likeness" adhere together?

James ended his career continuing to consider likeness, portraiture, and distributed consciousness, leaving unfinished at the time of his death a novel about portraits, time travel, and the conundrum of understanding consciousness in historical (rather than ahistorical) terms. James began *The Sense of the Past* in 1900, abandoned it in that same year, and picked it up again in 1914, two years before he died. The convoluted plot of the novel concerns Ralph Pendrel, an American historian of English descent living in 1910, who, while visiting the house he was bequeathed in London, comes face to face with a portrait of an ancestor also named Ralph Pendrel. He goes to tell the U.S. Ambassador in London of this uncanny experience, then returns to the house, steps across the threshold, and finds himself transported to 1820, living the life of the previous Ralph Pendrel (complete with a romantic triangle). James never completed the plot line as sketched out in his notebook entries (dictated in 1914), which bring Ralph Pendrel back to 1910.

The last full scene James wrote before putting the manuscript aside in 1900 has Pendrel come upon the ancestral portrait. As he explores the dimly lit rooms of the house, he notes that the "portraits of men in the house . . . had alike that prime and sufficient property of the old portrait—they had, as Ralph put it to himself, their more or less attaching 'look' to give out. They had in short those painted eyes for the particular purpose of following their friend as he moved."[30] As if to affirm this, Ralph playfully watches the eyes of the ancestral portraits follow his movements. Then he comes upon a portrait—"the single picture in which anything to call art had been appreciably active" (*Sense*, 72)—that presents quite a different face to him. In fact, "this work, prominent in its place over the mantel, depicted a personage who simply appeared to have sought to ignore our friend's appeal by turning away his face" (*Sense*, 72). Ralph is immensely puzzled over why the figure is posed so that he is looking away from the viewer: "Who in the world had ever 'sat'— though in point of fact the model in this case stood—in a position that so trifled with the question of resemblance?" (*Sense*, 73), he wonders. He soon begins to get the impression that the figure in the painting is in fact turning to and fro; that when Ralph is watching him, the figure turns away from him,

but when Ralph is not, the figure faces outwardly. He imagines that "when one wasn't there the figure looked as figures in portraits inveterately do, into the room, and that this miraculous shift, the concealment of feature and identity, took place only when one's step grew near" (*Sense*, 73).

Ralph leaves the room to clear his head. He wanders for a long while but finds himself back at the room that contains the curious portrait. A wind kicks up outside, and he enters, shocked to receive "the amazing impression" that "[s]omebody was in the room more prodigiously still than he had dreamed" (*Sense*, 85). He at first mistakes this impression for the sense that he is looking in a mirror and seeing himself reflected back. Then he realizes and describes what he is really seeing: "The young man above the mantel, the young man brown-haired, pale, erect, with the high-collared dark blue coat, the young man revealed, responsible, conscious, quite shining out of the darkness, presented him the face he had prayed to reward his vigil; but the face—miracle of miracles, yes—confounded him as his own" (*Sense*, 86). What he at first takes for a mirror reflection of himself is, in fact, a portrait depiction of himself.

In his 1914 notes on how he might resume the novel (his notes are reproduced in the edition of *The Sense of the Past* cited in this section), James tries to work out exactly how he would make sense of this portrait exchange. He recognizes that one of the crucial questions he confronts is whether "the portrait *in* the house in 1910, is done from Ralph in 1820 or not, done from Ralph himself, or accounted for, as coming into existence afterwards" (*Sense*, 335). Seemingly a bit lost in his own complex creative process, James states first that the existence of the portrait in the novel is "an excrescence perhaps upon the surface I have already in this rough fashion plotted out," but then immediately corrects himself, claiming such a "remark, however, is nonsense, as nothing is an excrescence that I may interestingly, that I may contributively, work in" (*Sense*, 336). This crisis point is then followed by James's declaration that he now has an "idea I begin to clutch the tip of the tail of" (*Sense*, 336–37). He considers adding a portrait painter character to the story: "the painter-man who gets, doesn't one fancy? into a much straighter and closer 'psychologic' and perceptive and mystified and mixed relation with his remarkable subject" (*Sense*, 337). James continues thinking along these lines until concluding that "I don't want to repeat what I have done at least a couple of times, I seem to remember, and notably in The Liar—the 'discovery,' or the tell-tale representation of an element in the sitter written clear by the artist's projection of it on canvas" (*Sense*, 338). James is dissatisfied with

the fantasy of revelation that portraiture had allowed him to explore in an earlier work of fiction; that he puts the term "psychologic" in quotation marks signals that he's not fully at ease either with this newer portrait function.

For James the "psychologic" mode is "perceptive and mystified and mixed" in distinction from a revelatory mode that posits a simple relation between surface appearance and a reality underneath that must be uncovered. James had become fascinated by the possibility of decentered subjects in his later fiction—more precisely, in individuals whose interiority is not located inside them and then projected upon the world, but rather produced by interaction with that world and the other individuals who populate it.

In James's declaration that he does not want to repeat "the 'discovery'" occasioned by a portrait we not only see the subject of portraiture shifting, but also the subject of psychology shifting as well. Just as portraiture can no longer be "tell-tale," so will psychology—in James's view—no longer try to ferret out the truth about the human interior. By considering the addition of a portrait painter to *The Sense of the Past*, James indicates that he wanted to explore the portrait exchange as a newly psychological interaction in which personhood itself is always the result of a collusion between an artist, subject, and viewer—not located *in* any of these individuals but rather between and among them. But this kind of exchange characterizes the James of 1914, not of 1900. The very possibilities he raises in writing the portrait scene of *The Sense of the Past* emerge as integrally connected to his abandonment of the novel as the century turned. The psychological portrait was still a work in progress. Portraiture, as James notes in the novel, no longer "trifled with the question of resemblance" (*Sense*, 73). But if the form was no longer about likeness, what was it about? This is one question James wasn't prepared to answer in 1900.

James's friend and contemporary William Dean Howells identified the sea change I have traced in this book in a review published in December 1901 titled "A Psychological Counter-Current in Recent Fiction." Positing a sort of dialectical aesthetic tide that pulls this way and that, Howells notes, "A few years ago, when a movement which carried fiction to the highest place in literature was apparently of such onward and upward sweep that there could be no return or descent, there was a counter-current in it which stayed it at last, and pulled it back to that lamentable level where fiction is now sunk, and the word 'novel' is again the synonym of all that is morally false and despicable." He cheers himself, though, with what he sees as a new development: "Quite as surely as romanticism lurked at the heart of realism,

something that we may call 'psychologism' has been present in the romanticism of the last four or five years, and has now begun to evolve itself."[31]

"Psychologism" is an interesting term. The *OED* attributes to it a specialized philosophical definition as "The view or doctrine that a theory of psychology or ideas forms the basis of an account of metaphysics, epistemology, or meaning; (sometimes) *spec.* the explanation or derivation of mathematical or logical laws in terms of psychological facts." The more general definition is "The tendency to explain matters in psychological terms, esp. when they are considered to be better or more properly explained in other ways." By using the word, Howells maintains the possibility that "psychological terms" are not the only ones that matter in writing and reading novels, indicating that in 1901, it was still possible to imagine explanations for human behavior (the subject of novels) or human identity (the subject of visual portraits) in ways other than those of the "psychological."

Throughout his portrait fiction, James exploited a productive tension between psychology as an ahistorical and largely fixed quality of discrete individuals and psychology as a stream ebbing and flowing and subject to continual shifting of direction. Recall his 1913 comment, discussed in my introduction, about the Paul Delaroche painting *The Children of Edward* (1831) in the Louvre: "I had never heard of psychology in art or anywhere else — scarcely anyone then had; but I truly felt the nameless force at play here."[32] James economically points out the historically and aesthetically determined nature of psychology (claiming there was no such term in the 1850s) while leaving the door open for interpretations that allow "the psychological" an extra-historical existence (both he and Delaroche had somehow intuited this socially nonexistent dimension of individual experience). We see this again in the 1901 letter to Sarah Orne Jewett, in which James chides her for writing a historical novel, advising that "the real thing," that is "the representation of the old *consciousness*," is virtually "impossible to do."[33]

James declares that "the real thing" is not the mere setting and plot of a work of fiction, but the consciousness of its characters. James approximates his brother's additive approach in characterizing this consciousness as both metaphysical ("the soul") and physiological ("sense" and "vision"), but he begins and ends his declaration to Jewett attending to the relationship between things ("relics and prints") and minds. James implies that the reason a historical novel cannot present a full consciousness is because consciousness itself is historically situated and determined, enlivened by its intercourse with the things common to its particular world. The historical novel will always fail because it cannot imagine, from its own perspective in the present,

how individuals experienced subjectivity in that previous time. James begins by decoupling the "relics and prints" represented in a novel from its characters' consciousness, but ends up showing how much consciousness is shaped by the world of things it apprehends.

James's response to Jewett reveals the extent to which he believed in consciousness as a "real thing." This "real thing" was no simple quantity in James's fiction or thought, and any statement James makes about consciousness, its realness or imagined nature, its location in the body or in the world, must be weighed against contrary comments he makes elsewhere. Sharon Cameron has noted James created a type of unbounded consciousness in *The Portrait of a Lady*, but then "contested" his own invention in the preface he wrote to the novel two decades later, which attends selectively to the self-contained "autonomy of Isabel Archer's consciousness."[34] This sort of back and forth, this indecisiveness about the governing characteristics of human psychology—was it a volitional force? A receiving vessel? Was it located in the body? The mind? Or in the external world?—was James's own inventive interpretive model, and he used the portrait in his fiction as one of the most enduringly interesting devices with which to ask these questions.

Some thirty years before James fully elaborated portraiture's power to envision consciousness as intersubjective, he wrote a story that uses the aesthetic methods of portraiture to reveal intersubjectivity's surprisingly embodied nature. In one of his earliest stories, "The Sweetheart of M. Briseux" (1873), an unnamed narrator stands in a local museum before a painting titled *Lady in a Yellow Shawl*. The portrait was painted by the acclaimed (and recently deceased) artist M. Briseux, and had been recently purchased by this "typical *musée de province*," described as "cold, musty, unvisited, and enriched chiefly with miniature works by painters whose maturity was not to be powerful."[35] The narrator is quite taken by the portrait, a "precious specimen of Briseux's first manner," and thinks to himself:

> It was little wonder that the picture had made a noise: judges of the more penetrating sort must have felt that it contained that invaluable something which an artist gives but once—the prime outgush of his effort—the flower of his originality. As I continued to look, however, I began to wonder whether it did not contain something better still—the reflection of a countenance very nearly as deep and ardent as the artist's talent. In spite of the expressive repose of the figure the brow and mouth wore a look of smothered agitation, the dark gray

eye almost glittered, and the flash in the cheek burned ominously. Evidently this was the picture of something more than a yellow shawl. To the analytic eye it was the picture of a mind, or at least of a mood. ("Briseux," 234–35)

This visual "picture of a mind" comes to life in the tale's narrative within a narrative. The first few pages are told in the first person by a narrator reporting on his experience of seeing the portrait and then recognizing the woman who sat for it, the titular "Sweetheart." The narrator approaches the woman, sitting quietly on a bench outside the museum, and introduces himself. The woman tells him a story, and the narrator proceeds to provide the rest of the story to the reader in her voice: "I repeat her story literally" ("Briseux," 237). The literary structure of "The Sweetheart of M. Briseux" echoes, in important ways, the visual structure of a framed portrait. James specifically assigns to the portrait the ability to create a "picture of a mind" and then highlights the construction of that mind by moving from the externalized spectatorship of the narrator *inside* the expressive mind of the sitter.[36] But perhaps most fascinatingly, the story stages portraiture's depiction of mind as fundamentally embodied and material. In this short passage alone, we see "mind" described by words that capture the centrality of the flow of blood, organic matter, material urge to the experience of inner life: outgush, flower, ardent, brow, mouth, smothered, glittered, flash.

James wrote about portraits across his entire career. Of course, he was a writer given to returning time and again to the same theme, metaphor, even phrase. But, as we have seen, when nineteenth-century authors wrote about portraiture, they were not just engaging a personal concern but a shared interest in writing about the intersections of surface and depth that were coming to define modern notions of psychological interiority. James's sometimes celebrated, sometimes maligned status as "The Master" stems in large part from critics' interest in his fiction's remarkable psychological acumen. His portrait fiction is clearly important for a study of shifting scientific, literary, and artistic beliefs about interiority in the period. But his portrait fiction also offers a key set of documents related to James's celebrated representations of psychology that have nevertheless not yet been systematically considered as a whole. The scholarship on James's interest in and use of the visual arts in his fiction is vast, as is the scholarship on the centrality of consciousness and psychology in his work. But no critic has offered a sustained analysis of how James's fiction picks up on portraiture's increasingly

common nineteenth-century cultural function as a "picture of a mind," as a new form of *seeing* inner life.

This is perhaps because the scholarship on the visual arts in James's fiction tends to offer materialist analysis, situating James within his time, in relation to visual artists he admired or had contact with, at the intersection of discourses about taste, aestheticism, and turn-of-the-century material culture. Meanwhile, most analyses of representations of consciousness in James's fiction have tended to treat these representations in a contextual vacuum, as artistic insight into an eternal human condition.[37] Portraiture and consciousness, it seems, reside in two different worlds, the first a historically specific one, the latter an aesthetically transcendent one. But in James's fiction, portraiture and consciousness are mutually inflecting forms. That is to say, where the portrait is a historically situated aesthetic object, governed by certain conventions, *so is consciousness*. In James's fiction, human psychology is not an ahistorical given but, rather, part of a "modern apparatus," a new way of understanding the self and its relation to others and the world in which it resides. Consciousness and mind are not a disembodied flow of immaterial subjectivity, but rather an embodied experience, plastic, able to be touched or caressed, a face within a face.

CHAPTER FIVE

Bones

The X-ray and the Inert Body

Some of the most enduring turn-of-the-century innovations in portraiture and portrait representations involved undoing likeness and untying expression from the body. These innovations troubled the link between conventionally legible visual representations of emotion, affect, thought, and consciousness, which had historically been represented as emanating from (or being expressed by) an individual's body. Modernist artists began to produce portraits that did away with a realist or even vocational commitment to likeness. At the same time, the earlier nineteenth-century physiological psychologies—which also understood consciousness and the body to be in intimate relation to one another—were fading in influence. Consciousness and interiority became representationally untethered from the bodies that so much nineteenth-century art, writing, and psychological theory focused on. If consciousness could now float free of the body, what would happen to portraiture's century-long project of envisioning the bodily expression of inner life?

In 1895, a radical new visual technology was invented, and the nineteenth-century portrait's project of imagining inner life came to an end of sorts. Within three months of physicist Wilhelm Conrad Röntgen's discovery of what he called "a new kind of rays" in Wurzburg, Germany, the equipment needed to generate and capture the images produced by the rays was sold out in Philadelphia.[1] The X-ray was, of course, a scientific discovery; here was a new kind of electron never before detected by scientific process. But from the beginning, it was also a visual technology like photography. "X-ray" names both a ray (a newly discovered and observable phenomenon of the physical world) and also the image that can be produced by that ray. As a new kind of image of the human body, the X-ray extends the story of nineteenth-century portraiture in provocative ways. This was a visual technology that initially promised the aesthetically penetrative gaze that so many authors and visual artists pursued across the nineteenth century.

In this brief final chapter, I approach X-ray imagery of the human body as an important coda to the story of portraiture's changing representations of subjectivity and soma. The X-ray quickly became understood as a visual

technology whose gaze—like portraiture's—would be turned upon the human body and interior. The invention of X-ray imagery of the human body, I will argue, was a major aesthetic development, making manifest and somewhat literal much of nineteenth-century art's imaginative drive *inward*. Yet the manifestation of this drive was, in a way, profoundly anticlimactic. Consider the rich and unruly worlds of fictionalized and visualized interiority that we've tracked across nineteenth-century portraiture's imagination of inner life: cognitive spines, plural subjectivity, recursive expression, gesture, subterfuge, and misrecognition. Next to these representational riches, X-ray images of the human interior (and many of the later advances in medical imaging that evolved out of it) fall somewhat flat: restricted tonality with limited detail, the X-ray image was better, in fact, at visually erasing the body whose secrets it was meant to reveal.

Yet while X-ray imaging of the human body seemed to winnow the expansiveness of human consciousness and soma to dull images of unresponsive bone, the discourse around the X-ray was explosive and weird. When it burst into cultural consciousness in 1895, its ultimate meaning and use were far from foreordained. In this final chapter, then, I turn to the first few years of X-ray imaging to explore the riot of terms and metaphors that visualize and describe the changing relationship between body and mind that was featured in nineteenth-century portraiture. Though X-ray images ultimately figured the human body as inert—unchanging, inactive, and subject to penetration— their experimental nature in those early years reveal that the nineteenth-century's ideas about the interanimation of the body, mind, consciousness, and vitality were not fully erased or abandoned.

I approach the X-ray image here as an aesthetic genre; and, in particular, as a genre that exists in provocatively akimbo relationship to the genre history of portraiture. Indeed, some of the first uses to which X-ray imagery were put drew from the long history of portraiture; the human body stilled and observed, to both record objective truth about the human body *and* to speculate about the inside of that body. In particular, like the photographic portrait, the X-ray image of the human body provided a new vantage on the relationship between the external body and its interior life. This new vantage was characterized by epistemological instability. What did the X-ray image depict? What would it be used for, medically, scientifically, culturally? What (and how) would it help us to know? Would these new images of the human body change what it means to be human? These are questions that, as we've seen throughout this book, animated much of portraiture's cultural life throughout the nineteenth century.

X-Ray Vision and the Portrait's Subject

Many historians and theorists of the visual and scientific cultures of the late nineteenth century argue that the X-ray marks the beginning of a distinctly new form of modernity. In her book about "medicine's visual culture," Lisa Cartwright asserts that "the X-ray was a radically new way of viewing and organizing the body."[2] Emerging contemporaneously with the 1895 "birth" of the cinema, the X-ray's optical penetration of the human body—the human interior *finally* revealed to the light of day!—has long been framed by scholars as an innovation, or break from earlier eras that suffered under murkier or less advanced visual knowledge.

Yet, the X-ray was as much a culmination of the nineteenth-century's construction of the human interior as it was a break with the earlier era.[3] In the early years of X-ray technology, scientists were excited by, but unsure what to do with, the new imaging technique. At the same time, consumers were hungry for the spectacle that these new images offered. In its first few years, the X-ray led both "scientific" and "aesthetic/popular" lives. As historian Bettyann Holzman Kevles recounts, "X-ray fever remained throughout all of 1896, during which 49 serious books and 1,044 papers were published, as well as cartoons, verse, and anecdotes galore about the wondrous new rays."[4] But she also highlights how what she calls "X-ray fever" extended beyond scientific and print cultures into the somewhat wilder world of turn-of-the-century spectacle and leisure consumption: "Within weeks X–rays seemed to be everywhere. X-ray Boy's Clubs sprouted in the United States, and X-ray slot machines were installed in Chicago and Lawrence, Kansas, where, for a coin, you could examine the bones in your own hand."[5] The cultures of science and visual entertainment sat side by side, often cross-pollinating one another.

As Kevles puts it, the general populace was initially "astonishingly receptive to th[e] radical shift in perspective" that the X-ray required from its viewers and subjects.[6] Certainly, from one standpoint we might marvel at that receptivity; within the span of just a few months, skin and tissue suddenly went from opaque to transparent. But when we take a broader view that understands X-ray imaging to be *a part of* the nineteenth-century's intense project of visualizing inner life, we see a bit more clearly that the body was likely not at all opaque for the general populace at the turn of the century. Having been invited to imagine depth into the vibrantly imaged surfaces of loved ones, celebrities, and fictional characters that surrounded them, the shift from skin to bone—from images of surface to images of depth—was fun, pleasurable, and exciting, but not necessarily ontologically radical.

X-ray images of the human body were, then, always already shockingly new and hauntingly familiar perspectives. They slotted in snugly into a long history of portrait representations of the human body that had, since 1839, shifted understandings of inner life to something that was buried deep "inside" each person, subject to ferreting out. This was an idea that appealed to modern science, even as it contained aesthetic elements of the gothic world of secrets and death. The X-ray's revelatory function drew on gothic terms and images of bone, skeleton, and viscera that were familiar symbols of death and decay. Even as the X-ray image was lauded as a modern imaging technique that would aid in scientific advancement, public health, and indexical knowledge of the human body, it has always also contained within it gothic fantasies of collapse and rot from the inside—the sense that, if we really began to look, we might find that we are all harboring something destructive inside of us.

The X-ray, that is to say, is a slippery image: science and spectacle, indexical and gothic, banal and revelatory. This slipperiness extended to the debates that scientists, photographers, and amateur X-ray technicians were having over what the X-ray image's primary cultural and scientific functions might be. The questions that animated these debates took shape around three potential uses of the X-ray: diagnosis, therapy, and spectacle. In scientific papers, laboratory experiments, newspaper reporting, and spectacular public events, the X-ray entered turn-of-the-century American culture variously as diagnostic tool used to reveal invisible recesses of the human body; as curative therapy for various pathologies, diseases, and imperfections; and as a new popular aesthetic genre. For example, in 1899, the *Medical Record* asserted in a short article titled "The Therapeutic Uses of the X-Ray," that scientists and physicians needed to move beyond the diagnostic, arguing that "The diagnostic value of the method has been established beyond all right of question. The suggestion was made over a year ago in these columns that the rays might also come to be of decided therapeutic worth. Recent literature contains some references to attempt in this direction, which indicate at least that the use of skiagraphy is not to be restricted to the detection and depiction of injuries to, deformities of, and the presence of foreign bodies in the tissues."[7] Here, the *Medical Record* frames the X-ray's diagnostic function as established, but limited or restricted, and imagines some *other* function for the X-ray that will go beyond simply detecting things in the body to the ability to *change* the body itself. This assertion was even then questionable, however, as reports of serious injuries resulting from bodily exposure to X-rays were already well known. I would argue that the scien-

tific indecision about, or speculation around, the X-ray's diagnostic functions versus its therapeutic potential (even in the face of the technology's obvious bodily violence) was driven by the same epistemological instability of nineteenth-century visions of surface and depth that I have tracked across this book.

The X-ray's ability to both skim across the surface of the human body *and* penetrate its invisible interior were understood at the end of the nineteenth century in explicitly gendered and raced terms. The X-ray, it quickly became apparent, had the ability to change the appearance of one's skin; a variety of race panics followed false media reports of scientists learning how to "turn" black skin white using X-ray therapy. Likewise, the X-ray's penetrative abilities envisioned the body as inert—subject to the will of a controlling gaze.[8] The subject of X-ray imagery was feminized, the body now forcibly opened to a perspective that flushed out the unsanitary secrets harbored within.[9] X-ray vision was an explicitly raced and gendered perspective.

What was the conceptual fallout of X-ray imaging's varying cultural and artistic functions around the turn of the century? Where it was understood as a diagnostic tool: what, exactly, beyond specific disease and malady, was it used to "diagnose"? What were the specific contours of the "imperfections" the X-ray was thought to be able to "heal"? And what sorts of cultural energies fed the machinery of spectacle that both drew in and repulsed crowds of people hungry to see inside? Ultimately, this new visual technology promised revelation but delivered decomposition and destruction.

Skin, Bone, and Hands

The most iconic images produced by X-rays in the late nineteenth century are, of course, of people's bones. Yet, I'd like to begin with the skin. Despite nearly immediate reports of burns that seemed connected with the use of X-rays on the human body, physicians experimenting with the technology were excited and hopeful about its ability to treat skin conditions such as acne and birthmarks.[10] The scientific and medical interest in the therapeutic potential of the X-ray to erase and make *invisible* various markings on the skin exists in fascinating relationship to its (more lasting) ability to make *visible* the previously hidden interior of the human body. The therapeutic capacity of the X-ray did not pan out, as it became clear how violent the technology really was toward the human body, altering living tissue in deadly and irreversible ways.

Yet such a gaze had been imagined long before the X-ray; textual imaginations of the power of photography involved the fantasy that the newly

powerful gaze enabled by technical invention would have bodily and material effects upon the people that wielded and were subjected to those technologies. Nathaniel Hawthorne's 1843 story "The Birthmark" is a representative example of such imaginative work. The scientist/alchemist/magician Aylmer has developed an obsession over a birthmark—in the image of a "crimson hand"—that mars his wife's face. To Aylmer, Georgiana "came so nearly perfect from the hand of Nature that this slightest possible defect, which we hesitate whether to term a defect or a beauty, shocks me, as being the visible mark of earthly imperfection."[11] Aylmer undertakes an experiment to erase the mark.

To distract his wife from the worry and boredom that she experiences while waiting for her husband to concoct the "elixir" that will erase the mark on her face, Aylmer takes her photographic portrait: "he proposed to take her portrait by a scientific process of his own invention. It was to be effected by rays of light striking upon a polished plate of metal. Georgiana assented; but, on looking at the result, was affrighted to find the features of the portrait blurred and indefinable; while the minute figure of a hand appeared where the cheek should have been" ("Birthmark," 771).[12] The camera's revelatory vision both grasps and enacts what Aylmer and Georgiana willfully turn away from: the gradual decomposition of her bodily and facial features happening alongside the gradual recomposition of her body as fully subject to a controlling hand.

The controlling hand is not only the hand of the master (husband, scientist, author, God), but also the hand that ties her "angelic spirit" to her "mortal frame"; once it disappears, Georgiana dies. Georgiana reassures her husband, as she dies, "you have aimed loftily; you have done nobly. Do not repent that with so high and pure a feeling, you have rejected the best the earth could offer" ("Birthmark," 780). Georgiana's commentary on her husband's fantasy of white female perfection (lofty, pure, high) is underwritten by Aylmer's Prospero-like relation to his "dark" laboratory assistant Aminadab. Just before Georgiana wakes to her death, Aylmer exults to Aminadab "'Ah, clod! ah, earthly mass! you have served me well! Matter and spirit—earth and heaven—have both done their part in this! Laugh, thing of the senses!'" ("Birthmark," 779).

Hawthorne's story worries about human attempts, through scientific, aesthetic, and technological innovation, to play God. In its telling, however, it captures the stakes of new visual technologies and how various individuals come to be seen under their visionary gazes. Further, the story shows prescient awareness of the relationship that would develop between body and

sight. Georgiana dies in part as her husband (and she, in passive agreement) pursues a particularly gauzy feminine immateriality.

Here we see the contrast between the gendered fantasy of bodily transparency and the stubborn nature of flesh. The rhetoric that surrounded X-ray technology's ability to make its subject transparent was often explicitly gendered. In 1896, *Life* magazine printed a slight, ironic poem titled "Lines on an X-ray Portrait of a Lady" by Lawrence K. Russel that read:

She is so tall, so slender; and her bones —
Those frail phosphates, those carbonates of lime —
Are well produced by cathode rays sublime,
By oscillations, amperes, and by ohms.
Her dorsal vertebrae are not concealed
By epidermis, but are well revealed.

Around her ribs, those beauteous twenty-four,
Her flesh a halo makes, misty in line,
Her noseless, eyeless face looks into mine,
And I but whisper, "Sweetheart, Je t'adore."
Her white and gleaming teeth at me do laugh.
Ah! lovely, cruel, sweet cathodograph![13]

The most beautiful and poetic women, it turns out, continue, as Edgar Allan Poe asserted in "The Philosophy of Composition" (1846), to be (mostly) dead ones. The woman subject of the X-ray portrait is totally and completely available; not even her skin conceals anything about her. The male gaze is at one with technological visual penetration. And yet, even as the poem tracks a fantasy of complete and total visual access, it formally drives toward the frustration of such access. The poem's volta introduces the irony that even as the skeletal love object promises the male viewer complete control and access, his fantasy is overturned by the eruption of her embodied utterance, here issued by "teeth" (like the hand, another particularly overdetermined body part often envisioned by X-ray imagery). Here is a moment in which the male fantasy of visual access to a woman is closed down by the eruption of her embodied reality back into the illusion of metaphysicality.

Something similar happens in "The Birthmark," where Aylmer misrecognizes what the hand is, and how Georgiana's surface is connected to her depth. He imagines that he can penetrate her interior, and move closer to her true essence. But what he finds is that the deeper he moves *in* to her, the more pronounced the evidence of her past sexuality is upon her surface. The

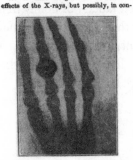

FEBRUARY 14, 1896.] SCIENCE. 231

15. I have sought for interference effects of the X-rays, but possibly, in con-

Fig. 1.—Photograph of the bones in the fingers of a living human hand. The third finger has a ring upon it.

sequence of their small intensity, without result.

16. Researches to investigate whether electrostatic forces act on the X-rays are begun, but not yet concluded.

17. If one asks, what then are these X-rays; since they are not cathode rays, one might suppose, from their power of exciting flourescence and chemical action, them to be due to ultra-violet light. In opposition to this view a weighty set of considerations presents itself. If X-rays be indeed ultra-violet light, then that light must possess the folling properties.

(a) It is not refracted in passing from air into water, carbon bisulphide, aluminium, rock salt, glass or zinc.

(b) It is incapable of regular reflection at the surfaces of the above bodies.

(c) It cannot be polarized by any ordinary polarizing media.

(d) The absorption by various bodies must depend chiefly on their density.

That is to say, these ultra-violet rays must behave quite differently from the visible, infra-red, and hitherto known ultra-violet rays.

These things appear so unlikely that I have sought for another hypothesis.

A kind of relationship between the new rays and light rays appears to exist; at least the formation of shadows, fluorescence, and the production of chemical action point in this direction. Now it has been known for a long time that, besides the transverse vibrations which account for the phenomena of light, it is possible that longitudinal vibrations should exist in the ether, and according to the view of some physicists must exist. It is granted that their existence has not yet been made clear, and their properties are not experimentally demonstrated. Should not the new rays be ascribed to longitudinal waves in the ether?

I must confess that I have in the course of this research made myself more and more familiar with this thought, and venture to put the opinion forward, while I am quite conscious that the hypothesis advanced still requires a more solid foundation. W. C. RÖNTGEN.

RÖNTGEN RAYS.

PROFESSOR RÖNTGEN'S discovery brings to a close a most interesting chapter in the history of electricity; it is the chapter dealing with electric discharges through rarefied gases. Experiments on electric discharges through vacua have for quite a long period now attracted the attention of physicists. Elaborate accounts of these experiments can be found in the transactions of learned societies throughout the last century. A systematic research into the various phenomena accompanying vacuum discharges dates from the time of Faraday. Plücker, Hittorf and Goldstein in Germany, and Spottiswoode and Crookes in England, may be mentioned as the foremost

hand on her cheek marks the touch of other men on her, and even her own touch upon herself. The hand in "The Birthmark" is Aylmer's hand as controlling God/scientist figure: it is his hand that kills her. It is also the haunting hands of touch upon her: her sexual impurity kills her. And, finally, it is also her stubborn flesh, her inability to inhabit a form of femininity that asks her to be essence and not material, and her inability to let go her embodied grasp.[14]

The hand is of central importance to understandings of early X-ray imagery. The human hand was *the* subject of these early images. In fact, the image published as illustration in Röntgen's 1895 scientific paper announcing his discovery—"On a New Kind of Rays"—was accompanied by the photographic image of his wife's radiographed left hand, the ghostly and delicate bones counterweighted by the large wedding ring she wears on her finger (figure 28).

Other theorists have discussed the significance of these images' representation of bone and ornament, their desire to dissolve, representationally,

the skin in pursuit of ever-more authentic depictions of feminine beauty and value.[15] These elements are triangulated, visually, through the appearance of fashionably exhausted skeletal slenderness (see the poem above, as well as the waif figure idealized at the time by high society portrait painters) and the heavy yoke of metal that drapes across this slender fragility, symbolizing possession by a man.

The earliest X-ray images of hands sit in fascinating relationship to Hawthorne's visual imagination. The hand-shaped birthmark in Hawthorne's story marks a version of female subjectivity impossible to gaze *through*. The magical hand that refuses to "let go its grasp"—that refuses to have its own role in touching the world and others erased—is a failure of femininity from which Georgiana must die. These turn-of-the-century images, to the contrary, force the hand to let go by arresting its role in touching the world, by turning it into inert specimen. The X-ray seems to have fulfilled Aylmer's fantasy of feminine transparency and devotion; these women, too, offer visual evidence to having been touched (their wedding rings declare as much) but are now unable to touch back. The vision of the human body as atomized and inert will become, as I'll explore below, one of the central visual innovations offered by X-ray imagery.

X-ray Portraiture, Decomposition, and Diagnosis

X-ray photography was not just an aesthetic that promised metaphysical penetration or insight, it was a technology that enacted this penetration. This penetration was profoundly destabilizing to the surfaces that held cultural and scientific understandings of selfhood together. Importantly, it was not the "diagnostic" approach—the idea that secrets of the body could now be "revealed"—that threatened to decompose the self, but rather the therapeutic one.

Consider the early examples of scientists sacrificing their bodily surfaces to the penetrating power of the X-ray. In response to reports of burns and dermatitis resulting from X-ray exposure, physicist Elihu Thomson undertook an experiment on himself, asking "what part of my body I could best afford to lose, and decided it was the last joint on my left little finger."[16] His language is remarkably resonant of the imagined injuries of S. Weir Mitchell's character George Dedlow (discussed in chapter 3). Recall that as Dedlow loses limb after limb to amputation after injuries suffered on Civil War battlegrounds, he ruminates: "This set me to thinking how much a man might lose and yet live" ("Dedlow," 8). The rhetorical echo between these

statements highlights the contrast between the materiality of the body and immateriality of the "self"—between the unified, lofty sense of "I" and the disparate (and lowly) parts of the body that, frustratingly, seem to compose that "I."

Thomson did not succumb to his experiment; but famously, Thomas Edison's assistant Clarence Dally did. Assigned by Edison to help him experiment with X-rays nearly immediately after Röntgen's paper/announcement was circulated, Dally quickly succumbed, bit by bit, to radiation exposure. First burns, then ulcers, fingers lost, cancer at the wrist, arms amputated, finally restricted to sitting upright in a chair in his last months: Dally's progressive death is a manifestation of the gothic horror of Dedlow's story (which itself was occasioned by the gothic horror of Civil War injuries to limbs). The obituary that appeared in the *New York Times* memorializes his life by basically charting each small piece of his body that he lost (figure 29). Let me quote this remarkable document at length:

> Six months after the first indications appeared the hands began to swell, and Mr. Dally was unable to keep at work continuously, but went to many of the hospitals where the X-ray was being installed and set up the machines and did some work in the laboratory besides. He suffered in this way for two years, when he and his family went West.
>
> Cancer finally developed on the left wrist, and he came East for treatment. An operation was performed, but not successfully.
>
> The disease then steadily spread and Dally was taken to the New York Post-Graduate Hospital, where the affected arm was amputated four inches below the shoulder. For a time an improvement was apparent, but the little finger on the right arm became affected, and on Nov. 20, 1902, this member was taken off at his home.
>
> Three other fingers were removed on June 16, 1903. The development of a spot on the wrist made it necessary to perform another operation on Sept. 7 of the same year. On Nov. 18 the physicians performed another operation where the stump of the little finger remained. Later the right arm was amputated.
>
> A pair of artificial arms was provided for him, but he used them only a week when he was obliged to succumb, the disease having affected his entire system. During the seven years he had been unable to care for himself, and all the time he was West he was obliged to rest his hands in water during the night to allay the terrible burning sensation.[17]

C. M. DALLY DIES A MARTYR TO SCIENCE

Was Burned While Experimenting with X-rays.

WORKED WITH T. A. EDISON

For Seven Years He Constantly Underwent Operations, Finally Losing His Arms.

Special to The New York Times.

EAST ORANGE, Oct. 3.—Clarence M. Dally, electrical engineer, died yesterday at his home 103 Clinton Street North, East Orange, a martyr to science, the beginning of his illness having been due to his experimental work in connection with the Roentgen rays. For seven years he patiently bore terrible suffering and underwent seven operations, which finally culminated in the amputation of both his arms.

During the experimental work on the X-rays Mr. Dally was Thomas A. Edison's chief assistant. Mr. Edison himself was slightly burned with the chemicals, but Mr. Dally, who had almost all of the experimenting to do, was quite badly burned on his hands. He suffered no pain from these burns, but his hands looked as though they had been scalded.

Six monts after the first indications appeared the hands began to swell, and Mr. Dally was unable to keep at work continuously, but went to many of the hospitals where the X-ray was being installed and set up the machines and did some work in the laboratory besides. He suffered in this way for two years, when he and his family went West.

Cancer finally developed on the left wrist, and he came East for treatment. An operation was performed, but not successfully.

The disease then steadily spread and Dally was taken to the New York Post-Graduate Hospital, where the affected arm was amputated four inches below the shoulder. For a time an improvement was apparent, but the little finger on the right arm became affected, and on Nov. 20, 1902, this member was taken off at his home.

Three other fingers were removed on June 16, 1903. The development of a spot on the wrist made it necessary to perform another operation on Sept. 7 of the same year. On Nov. 18 the physicians performed another operation where the stump of the little finger remained. Later the right arm was amputated.

A pair of artificial arms was provided for him, but he used them only a week when he was obliged to succumb, the disease having affected his entire system. During the seven years he had been unable to care for himself, and all the time he was West he was obliged to rest his hands in water during the night to allay the terrible burning sensation.

Mr. Dally was born in Woodbridge, N. J., thirty-nine years ago and served five years in the United States Navy as chief gunner on the Enterprise, but had been connected with Mr. Edison for the past sixteen years. He is survived by his wife and two sons. The funeral services will be held at his home to-morrow night. The burial will be in Woodbridge on Wednesday.

FIGURE 29 "C. M. Dally Dies a Martyr to Science," *New York Times*, October 4, 1904.

This is a strange way to account for a person's life, to so intimately track the decomposition of his material body. On the one hand, the verbal rhetoric of Dally's obituary approximates the developing consensus around the X-ray as an indexical and objective visual technology. Attempting to achieve fidelity in representation, Dally's gruesome obituary offers a realistic depiction of the man dying inch by inch. But yet on the other, its textual condition is so oddly *like* the therapeutic X-ray: roaming across the surface of body and time (naming parts, identifying dates), in its attempt to clarify it instead erases and decomposes. The language names a form of inevitability—cancer "finally" develops in his body—that suggests a sense of modernity and modern "progress" as always already a form of decomposition and devolution. Time moves strangely in this passage, marked by vague assertions such as "after," "then," "finally," "later," until the ultimate reveal in the last paragraph that "seven years" has passed in which Dally was unable to care for himself, slowly losing parts of his body, bit by bit. This most modern of visual technologies brought along with it the sense that we might be sliding backward—toward a world haunted by death, a world that is undoing itself under the name of progress, a world that, in driving inexorably toward visual revelation, would ultimately reveal things about U.S. bodies and selfhood that had previously remained somewhat murky, at least to some viewers.

It is thus not surprising that the X-ray, and its potential to both reveal and take apart human surfaces, produced specific cultural anxieties about race and its manifestation as both visible on the surface, and expressive of deep ("biological," "psychological") truths. The X-ray's threat of erasure and decomposition—its potential to literally break down all of the suspect assertions about human skin, blood, and phenotype that nineteenth-century scientific racism had worked to establish—was registered in the panics that arose around the possibility that X-rays could turn black skin white. In 1904, the X-ray's therapeutic potential came together with its status as visual spectacle as a rash of newspaper, periodical, and scientific journal accounts announced the results of Philadelphia doctor Henry Pancoast's X-ray experiments. Over the course of five months between December 1903 and April 1904, journalists reported this potentially radical new use of the decade-old technology in articles published across the nation with titles such as "X-ray to Turn Black Men White," "Burning Out Birthmarks, Blemishes of the Skin, and Even Turning a Negro White with the Magic Rays of Radium," "Bleaching the Ethiopian," "Can the Ethiopian Change His Skin or the Leopard His Spots?," "All Coons to Look White: College Profs Have Scheme to Solve Race Problem," "Turning Negroes White: With the X-ray Color is Driven

From the Skin," "Will Bleach out the Black." White media and its consumers were in a panic.

The only problem? The reporting was based on scientific conclusions that Pancoast never made (he had experimented with the X-ray's potential to treat keloid scars, but did no explicit experimentation trying to "lighten" skin), and actively tried to "correct" when he became aware of their reports. Pancoast's attempts to clarify his own scientific research didn't really take, and the perception that he was expressly trying to whiten the skin of his Black patients mostly survived across twentieth-century history of science scholarship. In 2006, scholar Carolyn de la Peña offered a fascinating retraction of how she framed Pancoast's experiments in her 2003 book *The Body Electric*. In the later article, titled "Bleaching the Ethiopian," she uses the example of Pancoast to probe the larger question of the intellectual segregation of scholarship on "race" and "technology," trying to come to terms with why scholars have for so long accepted a fiction about Pancoast's science rather than do the more complicated work in examining why the fiction was attractive to its white audience in the first place.[18]

The viral nature of the false narrative about Pancoast's experiments should not be particularly surprising; as de la Peña has written, these newspaper accounts "gave their white readers specific issues to fear: technology that threatened to render black bodies superior, to erase established racial hierarchies, to subvert the social order."[19] The writers and readers who participated in this particular form of race panic seemed to believe that the most worrisome thing about X-ray technology was its possibly radical vision of the fundamentally changeable and transformable aspects of the human body. In this way, this story picks up on a longer tradition (most vibrantly explored in eighteenth-century natural sciences) of understanding race as an environmental effect rather than biological essence.[20] Pancoast had been experimenting with the X-ray's potentially therapeutic use on human skin. The public quickly developed anxiety around this use insofar as it had the potential to upend racist beliefs anchored in the skin as a primary physical marker of racial difference. The X-ray would not prove to be a therapeutic technology; it was too dangerous. But the complicated historical example of Pancoast's research clarifies what was at stake in these turn-of-the-century experiments with the X-ray. When thought of "therapeutically," the X-ray posed a set of ontological problems that worked to destabilize ideas about race, bodies, surface, and depth that so much of nineteenth-century cultural production had worked to establish. The X-ray would come to be a diagnostic tool, offering a far more "stable" vision of the human body than initially

imagined. But X-ray imagery's developing diagnostic function continued to work in bizarre lockstep with these earlier ideas about its therapeutic potential to alter human surfaces.

Selfhood, Diagnosis, and Detection

When used therapeutically, the X-ray was both physiologically and ontologically destabilizing. It destroyed the body that it promised to reveal and introduced (or, more accurately, revisited) the possibility that racial identity was changeable. Importantly, therapeutic uses of X-rays exist outside of a representational frame. They did no representational work—rather simply did, or did not do, their medical work upon the body. As scientists began to abandon the idea that the X-ray could be used for therapeutic functions, they thus reentered the space of visual representation. The history of portraiture across the nineteenth century is in part a story about visual technology's changing depictions of human exteriors, and how these shifts in subject drove new cultural beliefs about the relationship between those exteriors and inner life. The X-ray's diagnostic gaze was an extension of this work.

Scientists at the turn of the century began elaborating the contours of the technology's diagnostic function in detection and depiction. As described in the *Medical Record* in 1899 above, the diagnostic function of the X-ray might consist of "the detection and depiction of injuries to, deformities of, and the presence of foreign bodies in the tissues." This revelatory/diagnostic function of the X-ray was not "arrived at" via accurate science, but rather built up out of a systematic erasure of other versions and understandings of embodiment and selfhood. Specifically, the developing consensus that X-ray technology and imagery would be revelatory, diagnostic, and detective depended on the developing view of the body as *inert*, as well as unchangeable (which is related to, but not the same as, that inertness). Such belief in the inertness of the human body (note the emphasis in "foreign bodies" in that above quote) were in explicit paranoiac relation to fears that X-ray technology and imagery might in fact lead to unstable conceptions of how outer appearance and inner truth are coordinated. The very idea of the X-ray image as diagnosis stabilized the parts (surface, depth, raced and gendered social positions, etc.) that the X-ray as *therapy* had put into dangerous motion.

Was the X-rayed, diagnosable, and newly inert body shocking for late-nineteenth-century viewers? To get a better sense of how these shifting visual representations of the human interior became broadly culturally meaningful, it helps to consider X-ray imagery's popular spectacle function.

Five weeks after Röntgen's discovery was publicized in the United States, William Randolph Hearst telegraphed Thomas Edison, asking him: "WILL YOU AS AN ESPECIAL FAVOR TO THE JOURNAL UNDERTAKE TO MAKE A CATHODOGRAPH OF HUMAN BRAIN."[21] Edison quickly got to work, not only attempting to fashion the machinery that would enable such imaging, but also alerting reporters and journalists about his attempt. Reporters camped out for a month near Edison's laboratories waiting for the scoop on what would have been a major new innovation. Edison did not succeed at this stunt (indeed the ability to image the brain didn't really become available until the 1970s), and the anticipated spectacular breakthrough fizzled out.

But in 1896, Thomas Edison did stage a public spectacle at the annual Electrical Exhibition in New York City to demonstrate the X-ray's penetrating vision to the public. He set up a darkened room, draped in fabric, into which visitors to the exhibition could enter. Each person would have been given a coin to nestle inside a glove worn on their hand. They would be invited to place their hand under a fluoroscope and see through the eyepiece the image not only of their own bones, but also the coin that was now visible through the glove. There are reports of people fleeing the room in which they were able to glimpse their own skeleton (and experience their own seemingly superhuman powers of penetrating vision).[22] Of course Edison's spectacle, and the media reports about it, participate in the vibrant turn-of-the-century showmanship and hucksterism. Yet it makes sense that such an image experience would be overwhelming. Here was a manifestly gothic depiction of death-in-life: even in full, fleshy life, each human contains the image of death inside of her.

Like the skin in the panic surrounding Pancoast's experiments, the hands that Edison turned into a spectacle are meaningful. The human hand is an indexing tool. But under the X-ray, the hand becomes subject to an indexical gaze. What was once active—a metonym for labor and presence—grasping, caressing, pointing, striking—becomes inert. X-ray imaging of the human body offers the hand as important, not as a record of touch or an agent of touch, but rather as an object of sight. As an 1896 special section of *Century Magazine* put it: "And now comes the most startling experiment of all. We hold our hand behind the screen, and, closely observing the luminous surface, perceive within the dim outlines of the flesh the sharp and distinct image of its skeleton. Every bone is perfect, even the cartilaginous spaces between being discernible. It is impossible to describe the feeling of awe that one experiences on actually seeing the image of his own skeleton within the enshrouding flesh."[23] The X-ray portrait image of the hand marks

a shift from touch to sight—the X-ray image certainly reveals one's mortality but above all it reveals one's inertness in the face of the diagnostic gaze.

The writers and readers who participated in the Pancoast-experiment race panic seemed to believe that the most worrisome thing about X-ray technology was its possibly radical vision of the fundamentally changeable and transformable aspects of the human body and inner essence. Attendees at the Electrical Exhibition, to the contrary, perhaps fled the image of their own body now made inert, subject to the force of electrons penetrating their opacity, corporeality, responsive fleshiness.

The compelling spectacularity of X-ray imaging was its ability to reveal to viewers parts of their bodies they had never seen before ("photography of the invisible"). Yet in order to do so, X-ray imagery must visually obliterate and make invisible the vast majority (materially) of that body, as well as the vast majority of that body's material exchange with the world through touch and action. The therapeutic gaze is certainly violent, as we see in the example of Clarence Dally's obituary and the fluorescing paranoia surrounding X-ray technology's potential to undo fantasies of racial difference. The X-ray's diagnostic gaze—which every single one of us continues to experience via our standard cycles of dental or winter-flu-season chest X-rays—perhaps looks more straightforward. After all, what could be more natural than seeing and focusing our interpretive energies inside our own bodies? Yet this diagnostic gaze has a complex scientific and aesthetic genealogy that exposes how the body became figured as inert, and subject to technologies of visual revelation.

Recall, again, the example of Hepzibah's scowl (from Hawthorne's *The House of the Seven Gables*), with which I opened this book. In the mid-nineteenth century, inner emotional and psychological life was often thought to be generated out of touch, sensation, blood flow, circulation, electrical impulse. Importantly, in this example, Hepzibah isn't misinterpreted as being ill-tempered because of her appearance of scowling. Rather, her face's embodied contortion creates the emotion that we still continue to think of as "expressed by" the face (rather than created by the face). Yet, as we saw in chapter 3, the late nineteenth-century's sophisticated forms and languages of talk therapy (posed against the famously barbaric physiological treatment of the disordered interior that ascends in the second half of the nineteenth century) come at a price: the reconfiguration of inner life as existing prior to, and disconnected from, the body.

The X-ray image's momentary flicker—in which the body became suddenly changeable in reaction to its now penetrable surface—was ultimately

dimmed into a more stabilized vision of inert and indexical objectivity. But these two seemingly contrary visualizations of the human body continue to exist in generatively incoherent relation. We continue to believe in the "expressive" function of portraiture—the idea that the visual image of the body conveys an already-formed emotional or psychological reality, and that "depth" is where the "true" self is. And yet, so much of the moral panic associated with "selfie culture" seems to stem from the worry that visual representation of surface imagery of the self is actively harmful to that self.

The early years of X-ray imaging of the body find writers, artists, scientists, and viewers toggling between such generatively different accounts of the process of visual revelation. Once the physiological interior is revealed (despite the partiality of that revelation) inner life becomes something that not only can be visualized but *must* be visualized. Early X-ray technology pursued this project with great cost to those who subjected themselves to the violence of the penetrating gaze. But in the process of trying to reveal the human body as inert (subject to electron force moving *inward*), the X-ray image's projects of erasure and decomposition nonetheless carve out space for a sense of the body as projecting force.

Epilogue
Selfie Nation

This project on nineteenth-century portraiture and selfhood has taken shape during a period I believe will prove significant in the long history of visual representations of the self. Yet the very first glimmers of this project predate my own ability to recognize this contemporary significance. I thought I was pursuing an interesting and under-analyzed aspect of nineteenth-century artistic and popular culture. I had long been drawn to popular and everyday genres (romance novels, for example) that, because of their banality, are often critically dismissed or ignored, and I found in nineteenth-century portraiture exactly that mix of popular everydayness and critical invisibility. I did not immediately recognize the sparks of connection between my historical topic and my twenty-first-century life. As I began work on the earliest versions of what this book would become, I had a clunky Nokia cell phone that I have almost no memory of using and a point-and-shoot digital camera that I used to take pictures of friends and places, when I remembered to bring it along. A few years later I had an iPhone, with a camera on the back that I mostly pointed at my dog. Four more years and I had a phone with a front-facing camera. My subject(s) shifted.

Whether or not I initially recognized the connections between nineteenth-century innovations in visual self-representation and similar innovations shaping my own experience of contemporary selfhood, those connections were there from the moment I began my inquiry. The *Oxford English Dictionary* has traced the coinage of the word "selfie" to 2002, when a young Australian man posted an out-of-focus close-up of stitches in his lower lip to an online forum. The story goes: he got very drunk at a twenty-first birthday party, fell down, punctured his lower lip with his own teeth, got stitches, and then got worried about those stitches. Starting a forum titled "Dissolvable stitches" he asked whether licking his lips often would break his stitches down too early, posted a picture to illustrate his situation and concern, and apologized: "Sorry about the focus, it was a selfie."

I love this story not because it offers such deep contrast to my scholarly project but because it offers so many points of contact. Here we see rapid innovations in visual technology falling into the hands of everyday people

who use these technologies in expected and unexpected ways. These are people who feel lonely and worried, who believe in the power of visual representation to provide evidence and illustration of some fundamental truths of personhood, but who also expect that evidence and illustration to somehow fall short: to be too out of focus, too vain, too filtered, too dumb, too biased. Still, though, the drive inward, the invocation of psychology (he compulsively licks his lips), and a fundamental faith in the expressive, explanatory, and sociable aspects of images of the self.

Now, more than fifteen years later, the word "selfie" has emerged from the random recesses of the internet to cause what I could call an epistemic collapse if I were more given to cultural panic. Somewhere around 2012, I began noticing that people on social media referred wildly, profligately to nearly all photographs that visually represent a real person as "selfies." Portraits, self-portraits, snapshots, posed, candid, celebrity, everyday, individual, group. Engagement photos clearly taken by a professional, highly-filtered Instagram influencers, photo booth snaps, the list goes on. Do a quick keyword search for "selfie" on any social media platform and you'll see how fully the long history of genre definitions and labels—what, aesthetically, counts as a portrait, what a self-portrait, and what a selfie—has collapsed under the sheer force of enthusiastic embrace of the *word* "selfie."

Recently, Arpad Kovacs, a curator at the J. Paul Getty Institute, and writer and theorist Alli Burness, weighed in on this collapse, both offering convincing and elegant sets of genre distinctions to keep in mind when contemplating self-portraits, portraits, or selfies. Kovacs argues that selfies have an "inherently replaceable and even disposable quality," while self-portraits are images that are meant to last, and Burness emphasizes the importance of vernacular art traditions in thinking about the cultural significance of the selfie.[1] Burness argues that it is "perilous" to read selfies as if they are art; in Burness's view they belong more appropriately to the realm of the everyday.

These are, I think, valiant, informed, and convincing attempts to define selfies as a genre. But as prescriptivist work trying to pare down the raucous overflow of contemporary visual representations of selfhood, these genre definitions are unlikely to capture what I've come to think of as the real subject of portraiture's method: the somewhat random, always effervescent, and fundamentally aesthetic *invention of selfhood*. In my Spring 2018 seminar, "Selfies: Selfhood, Literature, and the Visual," my students effortlessly taxonomized the different forms of selfhood they craft through their front-facing cameras. They use selfies to commemorate a memorable event. They take them incessantly but file them away privately, never sharing them. They

avoid taking selfies with white friends because of the racist bias of camera technology itself. They take and post them when lonely, and take and post only when feeling confident and good. They use a selfie of themselves to claim a prom dress on their high school's Facebook group expressly made for such use, or they seek out the dopamine rush from the "likes" they get on a selfie while remaining critically cognizant of the flaws in such a desire. They simultaneously believe in their own and others' selfie images as authentic expressions of deep selfhood and as constructed and false expressions. They resolve such apparent incoherence by clearly articulating that selfie imagery is authentic precisely *because* it is honest about how visual representations of selfhood have become interchangeable with selfhood itself.

The story I have told across this book is one that laid the groundwork for this radical and fascinating collapse between imaging the self and the constitution of that self as deep, readable, and psychological. And as I argued in the introduction, the more abundant critical conversation to have about the cultural work performed by portraiture is one focused on method and process, rather than portraiture's discrete genres or media. Portraiture became, in the nineteenth century, the most readily available method through which to imagine new ideas about selfhood: to what extent it was somatic or metaphysical; what expression meant; whether the self and its consciousness existed prior to (or distinctly from) its somatic manifestation; how the portrait's role as a "revealing" aesthetic document was recognized as potentially violent by Black writers; how images of the self might ultimately untie the experience of subjectivity from individual bodies. The portrait's subject, as we have seen throughout the nineteenth century, was not the representation of, or illustration of, or capture of—but rather, the active production of the possibilities of selfhood.

Notes

Introduction

1. Wharton, *The House of Mirth*, 138.
2. Wharton, *The House of Mirth*, 142.
3. Wharton, *The House of Mirth*, 143.
4. Wharton, *The House of Mirth*, 142.
5. Root, *The Camera and the Pencil*, 143.
6. Shawn Michelle Smith elucidates how the nineteenth-century invention of photography destabilized vision in *At the Edge of Sight*. Building on Smith's argument, I assert that a major effect of photography's destabilizing potential was how it put into play/tension/motion the invisible or unseen aspects of human inner life: souls, personalities, expressions, consciousness, emotion. My approach has also been shaped by much of the most recent scholarship on nineteenth-century photography, which has taken, Dana Luciano notes, an especial interest in the relationship between historical innovations in visual technologies and their effect on the sensory/embodied experiences of subjectivity. For more, see Luciano's review essay "Touching Seeing."
7. See Brilliant, *Portraiture*.
8. Michel Foucault underlines this point when he opens *The Order of Things* with an extended reading of Diego Velasquez's self-portrait/court portrait *Las Meninas* (1656). Foucault asserts that Velasquez's complicated portrait—in which he offers an image of himself painting a portrait of King Philip IV and his wife Mariana, rather than just a straightforward portrait of the royal couple—is significant in its rupture of the relationship between representation and reality, insofar as in this image "representation undertakes to represent itself" (p. 16) rather than provide a transparent window onto a discrete subject.
9. Poe, "Ligeia," 656. See also Hartley, *Physiognomy and the Meaning of Expression in Nineteenth-Century Culture*.
10. Southworth, "An Address to the National Photographic Association of the United States" (1871), 320; Fern, "Taking Portraits" (1860); Fuguet, "Portraiture as Art" (1901), 81.
11. I draw the insight about the shift "from soul to mind" from historian of science Edward S. Reed's book *From Soul to Mind*, which is an excellent narrative history of the development of psychological thought in the nineteenth century in the United States, Britain, Scotland, and Germany.
12. James, *A Small Boy and Others* (1913), 194.
13. See for example, Gershon, *The Second Brain*, and Mayer, *The Mind-Gut Connection*.
14. Walt Whitman, "A Visit to Plumbe's Gallery."
15. For more on this language, see Murison, *The Politics of Anxiety in Nineteenth-Century American Literature*, and Ellis, *Antebellum Posthuman*.
16. Trilling, *The Opposing Self*, 1.

17. See Pfister's and Schnog's *Inventing the Psychological* on the value of historicizing psychology. On "interiority" see Stern, *The Plight of Feeling*; Gillian Brown, *Domestic Individualism*; Pfister, *The Production of Personal Life*; Castiglia, *Interior States*. Recent scholarly work on nineteenth-century Black aesthetics and personhood has complicated and deepened these accounts of the relationship between artistic form and the representation of inner experience. See, in particular, Young, *Embodying Black Experience*; Quashie, *The Sovereignty of Quiet*; Bynum, "Phillis Wheatley on Friendship;" and Freeburg, *Black Aesthetics and the Interior Life*.

18. *ProQuest American Periodicals Series Online, 1740–1900*, http://www.proquest.com/en-US/catalogs/databases/detail/aps.shtml/ (accessed March 13, 2013). What makes these statistics even more striking is the fact that the period between 1800 and 1860 is generally considered "the golden age of American periodicals." The *APS* database catalogs over 900 titles from this period. Yet, even given the smaller number of periodicals (118) cataloged between 1880 and 1900, we see this continuing keyword explosion.

19. For more on how the term "pseudoscience" obstructs more than it reveals, see Britt Rusert, *Fugitive Science*, especially pp. 6–8.

20. On the physiological psychologies of the nineteenth century, see Bourne Taylor and Shuttleworth. On Sigmund Freud's navigation of the territory between the physiological and psychoanalytic see his "An Autobiographical Study" (1925) and "Project for a Scientific Psychology" (1895), both usefully excerpted in Gay's *The Freud Reader*.

21. Damasio, *Descartes' Error*, 250.

22. Murison, 3.

23. Smith, *American Archives*, 4.

24. Browne, *Dark Matters*, 9. See in particular, chapters 1 and 2 for the eighteenth- and nineteenth-century visual cultures of enslavement that laid the groundwork for contemporary surveillance culture. Browne uses the term "lantern laws" to describe "ordinances 'For Regulating Negroes and Slaves in the Night Time' in New York City that compelled black, mixed-race, and indigenous slaves to carry small lamps, if in the streets after dark and unescorted by a white person" (25). For more on the "visual underpinnings of slavery" in the eighteenth century see Cobb, chapter 1, "'A Peculiarly 'Ocular' Institution'" in *Picture Freedom*.

25. Womack, "Visuality, Surveillance, and the Afterlife of Slavery," 192.

26. Cobb, *Picture Freedom*, 26, 13.

27. Banta, *Imaging American Women*.

28. See Dinius, "The Long History of the Selfie;" Syme, "SELFIE: The Revolutionary Potential of Your Own Face, in Seven Chapters;" McFadden, "Teaching the Camera to See My Skin."

29. Kyla Schuller explores how nineteenth-century thinkers were obsessed with the idea of how individuals accrete "layers" of impressions in her discussion of what she calls the "racial palimpsest" in *The Biopolitics of Feeling*.

30. Benjamin, "The Work of Art in the Age of Mechanical Reproduction," 219.

31. Benjamin, "Short History," 200, 205, 206.

32. Benjamin, "Short History," 210, 211.

33. Benjamin, "Short History," 210.

Chapter One

1. Hawthorne, *The House of the Seven Gables*, 9. Hereafter cited in the text as *Seven Gables*.

2. See Chapter 2 in Rifkin, *Settler Common Sense* for an analysis of how the deed in *The House of the Seven Gables* works according to a settler colonial logic that takes Native dispossession as a given.

3. This belief in the power of photography to reveal was bolstered by a more general anxiety, in the era, over false appearances. For more on the nineteenth-century obsession with sincerity as a reaction against sinister forms of false appearances see Halttunen, *Confidence Men and Painted Women*.

4. Hepzibah's scowl is an interesting precursor to the James-Lange theory of emotion, which William James and Carl Lange theorized independently from one another in the 1880s. The oft-cited example James gives pertains to seeing a bear and feeling afraid. The James-Lange theory holds that a person does not see a bear, fear it, and then run away. A person runs away and thus fears the bear. Likewise, one does not smile because one is happy. One feels happy because one smiles. Hepzibah's scowl works on exactly this principle: Hepzibah does not feel grumpy and scowl to express that interior state. She scowls (because, being near-sighted, she just does) and then brings her self-conception in line with her "expression." I discuss this theory, and especially James's articulation of it in his 1884 essay "What is an Emotion?" in chapter 4.

5. Hawthorne employed portraits in his writing throughout his career, from "The Prophetic Pictures" of 1837 to *Our Old Home* of 1863. I should explain here that while I acknowledge the extent to which Hawthorne was influenced by and employed the new language of photography in his fiction, I find that his repeated invocation of the changing representational labor performed by visual portraiture—*in its multiple media*—encompasses and goes beyond his more local interest in photography. For more on photography's influence on Hawthorne's fiction see Davidson; Trachtenberg; Susan S. Williams; and Megan Rowley Williams.

6. Nancy Armstrong opens her book *How Novels Think* with this portrait and this anecdote, claming that *Master Bunbury* is fascinating for a study of the history of the novel because it captures in the boy's expression his response to narrative. In so doing, she argues, the painting "invites the viewer to speculate on the interior life" of the boy and raises "the psychological question of what would produce such an expression on the child's face" (p. 2).

7. The word "psychology" has been in use in English since the seventeenth century. Its strict etymological definition of "science of the soul" caused problems for thinkers from the Enlightenment through the end of the nineteenth century. Immanuel Kant famously declared that "psychology" was not a science (what we today would consider a "hard" science) because one could not subject the soul to empirical scientific experiments. See *Metaphysical Foundation of Natural Sciences* (1786). The early-to-mid-nineteenth century saw some creative attempts on the part of thinkers to develop a true science of the soul. But it was only once scientists abandoned the pursuit of the

ontological implications of psychological inquiry that psychology was able to gain ground as an academic and scientific discipline.

8. Richard Brilliant expresses this succinctly: "Portraits reflect social realities" (*Portraiture*, 11). Though Brilliant goes on to qualify this claim, rightly asserting that a "social reality" is by no means a static thing, his engaging study of the genre generally emphasizes the importance of performance and self-fashioning in *reflecting* changes in social conceptions about identity and the individual rather than focusing on the way in which portraiture helped *invent* concepts like identity and the individual. Remarkably, this 1991 study was, as avowed by the jacket copy, "the first general and theoretical study devoted entirely to portraiture."

9. Here I am thinking of Ian Watt's influential study linking the rise of the novel to the rise of middle-class individualism; Nancy Armstrong's revision of Watt's terms that places female-authored domestic fiction at the center of this rise and asserts that the rise of middle-class individualism, rather than an engine driving the novel, was actually invented by the novel itself; and Cathy Davidson's variegated study of the importance of nation-building and genre to late-eighteenth- and early-nineteenth-century American novels. See Watt, *The Rise of the Novel*; Armstrong, *Desire and Domestic Fiction*; and Davidson, *Revolution and the Word*.

10. See Susan S. Williams and Shawn Michelle Smith, *American Archives*.

11. For more on eighteenth-century commentary on Reynolds see Hayes, "The Theory and Practice of British Eighteenth-Century Portraiture." This essay is especially helpful in elaborating that although Reynolds attempted to freshen the convention-laden business of portraiture by introducing more quotidian and personalized elements into his work, his "new" style could only anachronistically be referred to as interested in the psychological interiority of his sitters.

12. Many critics' readings of *Master Bunbury* focus on the mind-based, psychological experience the boy is having by imagining or visualizing in his mind the story Reynolds is telling him. But the boy's interiority is equally as readable in the blush on his cheeks, though such an interiority would seem to be a function of the boy's character, morality, or code of deportment rather than his mind. For more on the history of the blush in relation to literature, see O'Farrell, *Telling Complexions*.

13. Whytt's conclusions violated the key Cartesian theory that the mind is the "seat of the soul," that only humans have minds, and thus only humans have souls. On Robert Whytt and the cerebralist rebuttal, see Reed, *From Soul to Mind* (5–8, 61–62). In describing the professionalization of the discipline, Reed notes that "as late as the 1860s there were several institutional avenues that the 'new' psychology might have taken: it might have become allied with medicine, physiology, or even science journalism. Instead, it became an academic and laboratory-oriented discipline with an affiliated clinical wing and in fact became one of the forces against which modern philosophy defined itself as an academic and logic-oriented discipline" (p. 13). This idea of multiple avenues is central to my attempt to account for the development of the psychological aesthetic between 1839 and 1900.

14. For more on Lotze, see Woodward, *Hermann Lotze*.

15. This argument is shaped by Foucault's claim in *The Order of Things* that "the historical emergence of each one of the human sciences was occasioned by a prob-

lem, a requirement, an obstacle of a theoretical of practical order" (p. 345), as well as the larger argument of *The Order of Things* that what is acceptable as scientific discourse changes over time and place.

16. Boring, "The Psychology of Controversy," 98.

17. For background on the relationship of Common Sense philosophy to the burgeoning discourse of psychology in mid-nineteenth-century America, see Martin, *The Instructed Vision*; Fay, *American Psychology Before William James*; and Alkana, *The Social Self*, especially pp. 1–55. Common Sense psychology held that individuals were capable of observing the workings of their own minds and that these observations of consciousness would reveal principles and truths that exist independently from individual experience. One might think of this theory as a sort of "self-evident interiority" in relation to the important Scottish influence upon Revolutionary ideals of self-evident and transparent natural language. By the 1840s, though, application of this theory of self-evidence to the workings of the human mind was clearly problematic, given the by then acknowledged nontransparency of character.

18. Brownson, "Schmucker's Psychology," 352.

19. Brownson, "Schmucker's Psychology," 355.

20. Brownson, "Schmucker's Psychology," 361.

21. "Psychology, or a View of the Human Soul," 356.

22. Reid, *An Inquiry into the Human Mind on the Principles of Common Sense*, 16.

23. "Psychology, or a View of the Human Soul," 358.

24. Woodall, *Portraiture: Facing the Subject*, 7. For more on the history of physiognomy and phrenology in relation to American culture, see Jaros, "Circulating Character: Physiognomics, Personhood, and Politics in the Early Republic"; Colbert, *A Measure of Perfection*; and Stern, *Heads and Headlines*. For more on physiognomy and British culture, see Hartley, *Physiognomy and the Meaning of Expression in Nineteenth-Century Culture*.

25. See Young, *Mind, Brain and Adaptation in the Nineteenth Century*: "[N]o one before Gall argued for the dependence of the mind on the brain in such detail, specifically disproving the role of other organs, specifically including all the intellectual and moral propensities, and demonstrating countless instances of the parallelism between variations in the brain and variations in mental and behavioural phenomena" (p. 20).

26. Orvell notes that mid-nineteenth-century United States popular culture was awash in contradictions like this one, and argues that before the Civil War, audiences were remarkably capable of embracing what he terms a "culture of imitation," accepting phenomena such as phrenology or photographic technology as both true *and* artificially constructed cultural forms. See "Introduction" and "Whitman's Transformed Eye" in *The Real Thing*, xv–32.

27. J. B. Dods, *Electrical Psychology* (1850). For standard cynical histories of the role of "pseudoscience" in nineteenth-century American history, see David Armstrong and Elizabeth Armstrong, *The Great American Medicine Show*, and Thomas Hardy Leahy and Grace Evans Leahy, *Psychology's Occult Doubles*. For a good general history of phrenology that attempts to place the movement in a more general cultural context, see Cooter, *The Culture of Popular Science*. For more on Dods, and for an excellent cultural history of mesmerism in the United States, see Emily Ogden, *Credulity*.

28. Barnhill, Brown, and Gordon argue that "the nineteenth century experienced one of the greatest visual revolutions in history," and describe "the vast effusion of graphic materials confronting the nineteenth-century American" as including "an ever-increasing range of illustrated periodicals; the blossoming of the political cartoon; individual decorative, portrait, comic, and genre prints; trade cards; greeting cards; sheet music covers; theater and campaign posters; and overbearing billboards." See "Introduction: Seeing a Different Visual World."

29. For more on the studio portrait photography and the rise of celebrity culture in the mid-nineteenth century, see McCandless, "The Portrait Studio and the Celebrity."

30. For an incisive account of the complex array of stances Melville took regarding having a daguerreotype portrait of himself made and engraved, see chapter 3 in Dinius, *The Camera and the Press*. While there are important differences between engravings made from daguerreotype portraits and those made from paintings, my focus here is on what Hawthorne's comments show us he expected from portraiture in any medium: large format oil, miniature, sketch, or photographic.

31. Melville, *Correspondence*, 180.

32. Quoted in Gollin, *Portraits of Nathaniel Hawthorne*, 34.

33. See my article "'The Inner Brand'" for more on the poet's comments about portraiture.

34. For a checklist of known portraits of Nathaniel Hawthorne, see Gollin, *Portraits of Nathaniel Hawthorne*. On Southworth and Hawes, see Romer and Wallis, eds., *Young America: The Daguerreotypes of Southworth and Hawes*.

35. Barthes, *Camera Lucida*, 87.

36. For more on the complicated social function of eighteenth-century portrait galleries, see Lukasik, "The Face of the Public." On Brady and Duyckinck, see Panzer, *Matthew Brady and the Image of History*, 55–70. On author portraiture and its relationship to teaching readers how to see and imagine literary characters and culture in the early republic, see Megan Walsh, *The Portrait and the Book*.

37. Gollin, *Portraits of Nathaniel Hawthorne*, 29–38.

38. Hawthorne, *The American Notebooks*, 491. Hereafter cited in the text as *AN*.

39. Quoted in Gollin, *Portraits of Nathaniel Hawthorne*, 23–24.

40. Lathrop, "Biographical Sketch of Nathaniel Hawthorne," 558–59.

41. For a related, though usefully different, mid-nineteenth-century aesthetic experiment in representing the relationship between character/self and its material form see the 1836 novel *Sheppard Lee* by Robert Montgomery Bird and Leila Mansouri's reading of it in "Sheppard Lee and the Properties of the Novel in America." Mansouri argues that the novel's representation of metempsychosis—or the transmigration of the soul into different bodies—critiqued the possibility of Americans being able to form any lasting attachment to their land.

42. Hawthorne goes into detail describing a selection of seventeenth- and eighteenth-century portraits he saw during a visit to the Essex Historical Society in the same year he composed the portrait story "The Prophetic Pictures" (1837). See *The American Notebooks*, 154. I will return to his descriptions of these portraits below.

43. Lovell, *Art in a Season of Revolution*, 145.

44. "Nathaniel Hawthorne," 336–37.

45. Hawthorne, *The Blithedale Romance*, 84.

46. "American Authorship, No. III: Nathaniel Hawthorne," 154.

47. Tuckerman, "Nathaniel Hawthorne," *Southern Literary Messenger*, 344. Hereafter cited in the text as "NH."

48. Harris, *The Artist in American Society*, 7.

49. Hawthorne, "Prophetic Pictures,"178. Hereafter cited in the text as "PP."

50. Hawthorne checked Dunlap's book out of the Salem Athenaeum on March 9 and May 21 of 1836 (Gollin, *Prophetic Pictures*, 17) and Hawthorne included a note upon publication of the story in *The Token* that reads: "This story was suggested by an anecdote of Stuart related in Dunlap's History of the Arts of Design—a most entertaining book to the general reader and a deeply interesting one, we should think, to the artist."

51. Dunlap, *The History of the Rise and Progress of the Arts of Design*, 187.

52. Dunlap, *The History of the Rise and Progress of the Arts of Design*, 189–90.

53. In another context, however, this story does reveal something: the gendered violence of marriage, and all of the sexual, emotional secrets and shame that its contractual structure fails to cover over. See, here, Justine Murison, "Uneasy A."

54. Hawthorne, "Edward Randolph's Portrait," 258. Hereafter cited in the text as "ER."

55. For more on contemporary conservation practices, see the website for the Lunder Conservation Center, part of the Smithsonian Donald W. Reynolds Center for American Art and Portraiture. The description of work performed by the Center's paintings conservators emphasizes the importance of hewing as closely as possible to the "original" appearance of a painting: "In this studio conservators restore the surface of paintings to a condition that most closely resembles an earlier unaltered or undamaged state. The two most common procedures that take place here are cleaning and inpainting. During cleaning, conservators carefully remove layers of accumulated grime; darkened varnish; and old, discolored retouching from the surface of paintings. To restore areas of lost paint, conservators fill the areas of loss with gesso, and inpaint them to match surrounding areas of original paint. They use easily reversible materials and take great care not to cover any of the original paint that had been applied by the artist." Lunder Conservation Center, http://americanart.si.edu/lunder /index.cfm.

56. Quoted in Keck, "Some Picture Cleaning Controversies: Past and Present," 75. This article details how in mid-1840s to 1850s England, a controversy raged over the newly appointed Keeper of the National Gallery Charles Eastlake R.A.'s decision to institute a policy of picture cleaning beginning in 1846, a process which commenters felt "flayed" the paintings subject to it. S. Rees Jones clarifies how such a policy of "cleaning" diverged from standard restoration practices of the early-nineteenth century: "[W]ork on the surface of paintings was largely done by artists until the middle of the nineteenth century; they were guilty of freely overpainting and 'improving' rather than of overcleaning; darkened varnish is often found under the repaint; and it was considered preferable to repaint an entire sky than to risk overcleaning." "Science and the Art of Picture Cleaning," 62.

57. Richard Redgrave and Samuel Redgrave, *A Century of British Painters* (1866), 4.

58. Hawthorne, "The Old Manse," 3–27. Hereafter cited in the text as "Manse."

59. Lovell, *Art in a Season of Revolution*, 8–9.

60. See Goddu, *Gothic America*; Berlant, *The Anatomy of National Fantasy*; Lora Romera, *Home Fronts*; and Richard Brodhead, *The School of Hawthorne*.

61. See Williams and Trachtenberg.

Chapter Two

1. Melville, "Benito Cereno," 116.

2. Shari Goldberg has argued that this ending to the novella "figures the complexity of writing about the silences of an obscured past, insisting on a revision of the terms of authorship that have been predominantly used to approach the suffering that neither fictional nor official archives capture on record." "*Benito Cereno*'s Mute Testimony," 1.

3. Many scholars have established how visual surveillance and racist visual imagery secured political and aesthetic power for whites under the institution of slavery. Less often explored, however, has been how Black writers invoked the visual in their texts, as both a recognition of the power of white surveillance *and* also a potentially powerful expression of Black subjectivity and agency. Hortense Spillers notes, in "Mama's Baby, Papa's Maybe," that "The narratives by African peoples and their descendants . . . suggest, in their rare occurrence, that the visual shock waves touched off when African and European 'met' reverberated on both sides of the encounter." Spillers goes on to quote Olaudah Equiano's incredible multi-page passage dwelling on the visually manifest cruelty of the first Europeans he encounters, describing "these white men with horrible looks, red faces, and long hair" (p. 69). There are many such passages across eighteenth- and nineteenth-century Black writing and art. In addition to the texts considered in this chapter, see also Boyrereau Brinch, *The Blind African Slave* (1810), the many merchant-class oil portraits of white sitters painted by Black artist Joshua Johnson in the late-eighteenth and early-nineteenth centuries, William Wells Brown's *Clotel* (1853), and more.

4. Babo's presence in both the "fictional" and "official" accounts of the revolt Melville presents to the reader (the "official" account marked by the deposition documents that "explain" the mysterious events of the story just read) is highly mediated. The reader only comes to know him through the eyes of various white characters and Babo only speaks and embodies forms of mediated language as he performs the role of the enslaved he once was but no longer is.

5. Stewart, "Mrs. Stewart's Essays."

6. Douglass, *My Bondage and My Freedom*, 52.

7. Douglass, *My Bondage and My Freedom*, 22.

8. Peter F. Walker emphasizes Douglass's excision of his mother's femaleness in likening her to the Egyptian ruler and finds his choice of this image, which does not use pigment or even shading to represent the "race" of its subject, to be indicative of Douglass's self-identification as "mulatto." Waldo Martin Jr. sees Douglass's choice of this image as the author's attempt to rewrite his ancestral past and propose a common human future that rests upon the transcendence of race and gender. Michael

Chaney provocatively intervenes in these accounts to suggest that Douglass's reference to the image signifies on the popularizing antebellum discourses of ethnography and sentimentalism, and in so doing observes, "the black look conceives of blackness differently than the colonial gaze practiced by white ethnographers" (p. 406). See Walker, *Moral Choices*; Martin, *The Mind of Frederick Douglass*; Chaney, "Picturing the Mother, Claiming Egypt."

9. Frederick Douglass's sophisticated use and understanding of visual rhetoric has been energetically taken up by scholars in recent years. See, in particular: Dinius, *The Camera and the Press*, especially chapter 6; Maurice O. Wallace and Shawn Michelle Smith, *Pictures and Progress*, especially chapters 1 and 2; and John Stauffer, Zoe Trodd, and Celeste-Marie Bernier, *Picturing Frederick Douglass*.

10. I take the phrase "ways of seeing" from John Berger, who writes, "We never look at just one thing; we are always looking at the relation between things and ourselves. Our vision is continually active, continually moving, continually holding things in a circle around itself, constituting what is present to us as we are. Soon after we can see, we are aware that we can also be seen. The eye of the other combines with our own eye to make it fully credible that we are part of the visible world" (p. 9).

11. See Menand, "Morton, Agassiz, and the Origins of Scientific Racism in the United States"; and Nelson, *National Manhood*, 102–34. For a rich discussion of how nineteenth-century literary writers drew from and resisted mid-century ethnology, see Samuel Otter, *Melville's Anatomies*, especially chapter 3, "Getting Inside Heads in *Moby-Dick*."

12. Morton, *Crania Americana*, 5–6, 54, 81.

13. "Morton's Crania Americana," 173. This reviewer quotes from Morton's own smug claims about the attention to detail evidenced by his volume. The repeated emphasis by Morton and his reviewers on the labor that went into the volume is ironic given that Morton, because he was in poor health, did not do his own field research and instead simply measured the skulls that colleagues sent to him.

14. Nott and Gliddon, *Types of Mankind*, 50.

15. Douglass, "The Claims of the Negro Ethnologically Considered," 290. Hereafter cited in text as "Claims."

16. For a sensitive analysis of the "sting" of looking at images of Black suffering between 1834 and 2005, see Courtney Baker, *Humane Insight*.

17. The digital archive *Freedom on the Move* catalogs thousands of these advertisements: https://freedomonthemove.org.

18. Wood, *Blind Memory*, 87. Hereafter cited in the text as *BM*.

19. Wood perhaps overstates the humanizing quality of the texts of fugitive notices. They could often be numbingly repetitive. Ironically, this was never clearer than in the abolitionist citation of the notices, a citation that undid the particularizing narrative energy of stories of individual escape by compulsively reprinting the notices, emphasizing their repetitive quality.

20. Douglass, "Oh Liberty! What Deeds Are Done in Thy Name!"

21. On the antislavery movement's savvy use of the visual, see Teresa Goddu, "Anti-Slavery's Panoramic Perspective," and Mary Niall Mitchell's *Raising Freedom's Child*, especially pages 1–11.

22. Harriet Jacobs, *Incidents in the Life of a Slave Girl*, 97. Hereafter cited in the text as *Incidents*. For a psychoanalytic analysis of Jacobs's revision of Norcom's details, see Stern, "Live Burial and Its Discontents," 62–82.

23. According to the *Oxford English Dictionary*, 2nd edition, "habit" is defined as first, "fashion or mode of apparel, dress"; second as "external deportment, constitution, or appearance"; and third as "mental constitution, disposition, custom." I thank Katy Chiles for pushing me to think more deeply about the word "habit."

24. This is a dynamic that continued into the twentieth century, as Black creators crafted aesthetic representations of their world for themselves. Koritha Mitchell puts it this way, writing about turn-of-the-century lynching dramas: "In order to survive this era still believing that they were a race of decent people who did not deserve to be butchered, African Americans had to be cultural critics who read their surroundings dynamically. Many also became culture producers, providing art that both reflected and encouraged the community's ability to view national tendencies critically. Lynching drama is one manifestation of black cultural criticism, and it reflects African Americans' understanding that the most powerful messages of their time were multivalent. Their realities were shaped by communication that involved language but was never limited to it" (23).

25. The 1861 speech is reprinted in Stauffer, Trodd, Bernier, *Picturing Frederick Douglass*, pp. 126–41. As they note, Douglass titled the speech "Lecture on Pictures," but the speech was advertised in the press as "Pictures and Progress."

26. See Gates Jr., "The Trope of a New Negro and the Reconstruction of the Image of the Black," and Benston, "Facing Tradition."

27. Otter, "Philadelphia Experiments," 103.

28. In *The Undercommons*, Fred Moten and Stefano Harney describe the centrality of misrecognition to the long arc of the Black radical tradition: "Consider the following statement: 'There's nothing wrong with blackness': What if this were the primitive axiom of a new black studies underived from the psycho-politico-pathology of populations and its corollary theorisation of the state or of state racism; an axiom derived, as all such axioms are, from the "runaway tongues" and eloquent vulgarities encrypted in works and days that turn out to be of the native or the slave only insofar as the fugitive is misrecognized, and in bare lives that turn out to be bare only insofar as no attention is paid to them, only insofar as such lives persist under the sign and weight of a closed question?" (pp. 47–48).

29. For more on contemporary racist forms of visual surveillance, see Simone Browne, *Dark Matters*, (2015) and Womack, "Visuality, Surveillance, and the Afterlife of Slavery" (2017).

30. See Andrews, "Slave Narratives: Chronological List of Autobiographies," *Documenting the American South*, University of North Carolina Library, https://docsouth.unc.edu/neh/chronautobio.html.

31. Janet Neary elegantly unpacks the complicated visual work performed by slave narratives from the eighteenth century to the present in *Fugitive Testimony* (2016).

32. Susan Williams has argued that the excessive number of stories featuring magical daguerreotype portraits appearing in antebellum periodicals—in which the un-

ruly illusory nature of the daguerreotype is generally tamed via its place inside a sentimental marriage plot—is evidence of this tension between the truthful and deceptive qualities of the medium. See Williams, *Confounding Images*, especially chapter 2.

33. Andrews notes that "[r]are was the autobiographer who did not apologize for his lack of facility with words and his inability to portray what he experienced in or how he felt about slavery. Other blacks lamented the inadequacy of language itself to represent the horrors of slavery or the depth of their feelings as they reflected on their suffering" (*To Tell a Free Story*, 9).

34. Williams, *Confounding Images*, 35.

35. For a reading of another aspect of the relationship between slave narratives and portraiture, see Casmier-Paz, "Slave Narratives and the Rhetoric of Author Portraiture": "The [frontispiece] portraits function ideologically to resolve contradictory social relations and to assert the author's understanding, acceptance, and utilization of dominant codes and institutional standards" (p. 98). For more on the function and effects of authenticating documents of traditional slave narratives see Sekora, "Black Message/White Envelope." Joycelyn K. Moody has offered a fascinating close reading of three eighteenth-century portrait frontispiece of Black women authors, exploring "the power dynamics and aesthetic negotiations at work between artist and sitter" in these images. See "Tactical Lines in Three Black Women's Visual Portraits, 1773–1849."

36. Harriet Jacobs to Amy Post, Cornwall, January 11 [1854]. Quoted in Jean Fagan Yellin, *Harriet Jacobs: A Life*, 128.

37. Richard Willis, "Intolerance of Colored Persons in New York."

38. Beers, *Nathaniel Parker Willis*, 171.

39. Jacobs's mocking reference to "portriature" can be understood in two ways. Broadly, it indicates a familiarity with what Shirley Samuels calls a mid-century "aesthetics of sentiment appear[ing] in advice books, statues, photographs, pamphlets, lyric poems, fashion advertisements, and novels" (p. 6), which portrays values of sympathy, affect, and feminine propriety. It may also be understood narrowly as a reference to the remarkably vibrant periodical life of the portrait, where sentimental short stories repeatedly used portraits as plot devices. See Williams, *Confounding Images*, 66–95.

40. Irving, "Rip Van Winkle," 52.

41. Bill Brown provides as an example of this confusion in a 1777 advertisement for a public auction, which listed for sale: "A valuable iron chest, with a handy young negro girl, about 13 years old. Also, a neat riding Chair" (p. 179).

42. For more on the discovery and authentication of this text, see Henry Louis Gates Jr.'s introduction to the novel.

43. Crafts, *The Bondwoman's Narrative*, 34. Hereafter cited in the text as *Bondwoman's*. The novel has a complicated Victorian gothic plot involving a bloodstained cave, the untimely dramatic death by aneurysm of Mistress, a wagon accident, face powder that turns a white woman's face black, and Hannah's ultimate self-liberation and move North.

44. For more on "the iconography of the mulatta" as it develops in the early twentieth century see Cherene Sherrard-Johnson, *Portraits of the New Negro Woman*.

45. Castiglia also explores this portrait's consolidation of white power and authority in "I found a life of freedom all my fancy had pictured it to be."

46. Brooks, *Bodies in Dissent*.

47. Webb, *The Garies and their Friends*, 1. Hereafter cited in the text as *The Garies*.

48. Samuel Otter offers a reading of the cluttered surfaces of *The Garies*—with its detailed descriptions of food, banquets, furnishings, household items, and other myriad material details—within the context of the still-life painting tradition. Otter notes that the still-life tradition allows Webb to depict "the inanimate objects—spilling over their boundaries, revealing their interiors, tempting viewers—seem to be alive" (p. 733) and that such a literary technique is "influenced by the distinctive experience of African Americans in Philadelphia, on the border between freedom and slavery" (p. 745).

49. Christopher Lukasik addresses the tradition of "great man" portraiture in the Revolutionary and Early Republic eras, as an example of how the face was used to represent "abstract ideals of civic virtue" (*Discerning Character*, 19). For more on portrait representations of Black revolutionaries in the United States in the nineteenth and early twentieth centuries, see Powell, "Cinque: Antislavery Portraiture and Patronage in Jacksonian America" and Thompson, "Preoccupied with Haiti: The Dream of Diaspora in African American Art, 1915–1942."

50. Anna Mae Duane has argued that *The Garies* "cannily deploys sentimentalism's emphasis on the family to privilege the strength and resilience of black women" and thus offers a "new domestic model that establishes black motherhood as the generative force of families capable of meeting the challenges of citizenship in a racist country" (p. 202). Yet this domestic model was not without its problems. In *Photography on the Color Line*, Shawn Michelle Smith has drawn out how, at the turn of the century, the Black "elite" was often figured through Black womanhood as a visual symbolic. Smith offers a fascinating reading of what she calls the "piano portrait" that was included in W.E.B. DuBois's *Georgia Negro Exhibit*—a collection of photographic albums that traveled to the 1900 Paris Exposition. This portrait depicts a well-dressed young woman and older man at a piano in what at first appears to be a well-furnished upper-class nineteenth-century parlor, but which upon closer inspection is revealed to be a photograph—of girl, man, and piano—that has been masked, cut out, and then pasted atop a painting of an ornate room. The highly mediated formal elements of this depiction of the Black "elite," Smith argues, not only reveal how vexed such a desired class identity was, but also "points to the gender relations that focus DuBois's vision of an elite African American patriarchy." Smith argues that the figure of female Black domesticity—accomplished in housewifery and the domestic arts— "suggests that an African American patriarchy establishes itself by keeping African American women firmly fixed within its sights" (p. 112). I assert that a fuller understanding of the significance of portrait traditions helps us understand such contradictory positionings of, for example, the domestic in Black culture in the second half of the nineteenth century. Webb's interest in the role that *both* "great man" and "domestic" portraiture might play in African American culture is significant. See also, Jasmine Cobb's theorization of "the parlor" in *Picturing Freedom*, which I discussed in the Introduction.

51. I've written on this phenomenon also in "Making Good Use of Our Eyes." See also Radiclani Clytus, "Visualizing in Black Print."

52. Jonathan Crary, *Techniques of the Observer*.

Chapter Three

1. In 1985, the Pennsylvania Academy of Fine Arts acquired the Bregler Collection from the widow of Eakins's former student. The collection consists of 1,600 items — oil sketches, drawings, glass-plate negatives, journals, letters, and memorabilia — that shed new light, especially, on the famous "loincloth scandal" that led to Eakins's dismissal from the Pennsylvania Academy. Before this acquisition, most scholarship on Eakins lauded his works as a particularly American vision of the heroic nature of everyday, commonplace life. See Goodrich, *Thomas Eakins: His Life and Work* (1933), and Elizabeth Johns, *Thomas Eakins: The Heroism of Modern Life* (1984). Post-Bregler Eakins scholarship reexamined this emphasis on heroism. See Foster, *Writing about Eakins* (1990), and *Thomas Eakins Rediscovered* (1998); Jennifer Doyle, "Sex, Scandal, and Thomas Eakins's *The Gross Clinic*" (1999); Martin A. Berger, *Man Made* (2000); Michael Leja, *Looking Askance* (2004); Henry Adams, *Eakins Revealed* (2005); Sidney Kirkpatrick, *The Revenge of Thomas Eakins* (2006); Amy Werbel, *Thomas Eakins: Art, Medicine, and Sexuality in Nineteenth-Century Philadelphia* (2007); Alan Braddock, *Thomas Eakins and the Cultures of Modernity* (2009).

2. Lubin, "Projecting an Image," 512.

3. For more on the relationship between Eakins and Mitchell, and how their individual ideas about medicine and the body sat next to one another, see Lifton.

4. *Whistling for Plover* is a reprise of an image Eakins first produced in oil (and sent to his former teacher Jean-Léon Gérôme for help in selling in Paris; this painting is now lost) and then again as a small oil-sketch that depicts the kneeling hunter as white (the sketch is now in the private collection of Mr. and Mrs. Andrew Wyeth). The painting, however, ultimately ended up in a Philadelphia secondhand shop after Mitchell's son sold it around the turn of the century. As a fragile watercolor, it is not today often exhibited, but it is also rarely addressed in Eakins scholarship. It was not reproduced in the rather comprehensive catalog that accompanied the 2001 Philadelphia Museum of Art Eakins exhibition, and though it appeared on the cover of the catalog for one of the first museum exhibitions to address representations of African Americans in American painting (*The Portrayal of the Negro in American Painting* [1964]), it is not addressed in more recent studies of fine art representations of African Americans such as Guy C. McElroy's *Facing History: The Black Image in American Art, 1710–1940*. In the last twenty-odd years, art historian Alan C. Braddock's excellent essay "Eakins, Race, and Ethnographic Ambivalence" (1998) is the only sustained attempt to analyze this painting in depth.

5. On Eakins and the commonplace, see Johns. The exhibition wall label from *Whistling for Plover*'s last exhibition at the Brooklyn Museum asserts that the painting concerns "daily life of his family and friends in Philadelphia." "Masters of Color and Light: Homer, Sargent, and the American Watercolor Movement," May 8–August 23, 1998, Brooklyn Museum of Art.

6. The model for this painting is identified by art historian Ellwood Parry as a local resident named William Robinson (*The Image of the Indian and the Black Man in American Art*, 150–52). Braddock also notes how the figure appears to have had his legs amputated in "Displacing Orientalism."

7. Lisa Long's *Rehabilitating Bodies: Health, History, and the American Civil War* (2004) explores the "ontological crises" that were engendered by large-scale amputation and bodily mutilation during and after the Civil War. For more on the role of the nascent art of medical photography in visually recording the mutilated body, see Shauna Devine, *Learning from the Wounded* (2014), and Stanley Burns, M.D., *Shooting Soldiers: Civil War Medical Photography by R. B. Bontecou* (2011). For more on the post-bellum cultural ramifications of mass amputation, see Brian Miller, *Empty Sleeves* (2015).

8. Cook, "The Art Gallery," 73, 74.

9. "Art in Philadelphia," 2.

10. Here I am thinking about the gesturing surgeon in *The Gross Clinic* (1875), the oarsmen in *The Biglin Brothers Turning the Stake-Boat* (1873) and other rowing pictures from the decade, the torsion of the main figure in *Home Scene* (c. 1871), and the various gestured signals of deep thought made by the three figures in *The Chess Players* (1876).

11. For more on gesture as "movements that produce, reproduce, and potentially interrupt embodied structures of power," see Reckson, "Gesture."

12. Lubin, "Modern Psychological Selfhood in the Art of Thomas Eakins," 149; Foster, "Portraits of Teachers and Thinkers," 313; Nochlin, "Issues of Gender in Cassatt and Eakins," 307.

13. Helen Parker Evans to Sylvan Schendler, September 29, 1969, quoted in Goodrich, *Thomas Eakins*, vol. 2, 242.

14. Quoted in Adams, *Eakins Revealed*, 410.

15. Adams, *Eakins Revealed*, 268.

16. Braddock, "'Jeff College Boys,'" 355.

17. Thomas Eakins to Edward Coates, n.d., c. March 10, 1886. Quoted in Foster, *Writing About Eakins*, 216.

18. Brownell, "The Art Schools of Philadelphia," 745.

19. Dodge reportedly told this anecdote to Lloyd Goodrich. Quoted in Adams, *Eakins Revealed*, 399.

20. Huxley, "On the Hypothesis that Animals are Automata, and its History" (1874). Quoted in William James, *The Principles of Psychology*, vol. 1, 131.

21. James, *The Correspondence of William James*, vol. 4, 226.

22. I address the 1840s debates about introspection that characterized much of early psychology in chapter 2.

23. James, *Principles*, vol. 1, 189.

24. From works that directly address wounded Civil War bodies, like Louisa May Alcott's *Hospital Sketches* (1863) or Walt Whitman's "The Wound Dresser" (1867), to works concerned with spiritualism such as Elizabeth Stuart Phelps's *The Gates* series (1868–87), to Oliver Wendell Holmes's "psychiatric" novels *Elsie Venner* (1861) and *A Moral Antipathy* (1885), to works exploring naturalist notions of bodily/mental degen-

eration like Edith Wharton's *Summer* (1917), to the "nervous" literature of the era like Gilman's "The Yellow Wallpaper" (1892) and Kate Chopin's *The Awakening* (1900).

25. Henry James, *Notes of a Son and Brother*, 298, 297.

26. For more on *Gardner's Sketch Book*, see Lee and Young, *On Gardner's Photographic Sketch Book of the War*.

27. Foster's *Thomas Eakins Rediscovered* usefully shifted the critical conversation about Eakins's sporting subjects away from the narrative of American heroism by noting what she termed the "elegiac air" of the shadowy and flickering light in his rowing paintings. Ray Carney's "When Mind Is a Verb" offers a provocative analysis of the relationship between mind and body in paintings like *Pushing for Rail*: "the challenging relation of intention to execution in these situations is precisely what attracted Eakins to them" (p. 387).

28. In *Specters of Democracy*, Ivy Wilson pursues another provocative direction in his analysis of the appearance of Black figures in nineteenth-century genre painting, these figures' placement in representational space, and "the social logic of spatial forms" (p. 104). Wilson asserts that "By analyzing the spatial forms in works by [William Sidney] Mount, [Richard Caton] Woodville, [Eastman] Johnson, Winslow Homer, and others, I argue that the compositional logic of American genre painting strategically organized zones in terms of centers and margins in various settings, such as parlors, barns, and post offices, as a means to illustrate the forms of democratic belonging in the United States" (p. 105).

29. Mitchell, *Wear and Tear, or Hints for the Overworked*, 11.

30. Mitchell, *Wear and Tear*, 22.

31. S. Weir Mitchell, "The Case of George Dedlow," 1–11. Hereafter cited in the text as "Dedlow." This is the first fictional depiction of phantom limb, which Mitchell was researching while working at the U.S. Army Hospital in Philadelphia; he published a textbook entitled *Gunshot Wounds and Other Injuries of Nerves* in 1864 based on the material he collected there. The story itself also bears some resemblance to Edgar Allan Poe's "The Man that Was Used Up" (1839), which tells of a war hero whose body, a snooping narrator discovers, is composed mainly of prostheses. This earlier tale is often read as a satire (of military heroism and masculinity) or rumination on technology and race relations. "The Case of George Dedlow" has featured in some of the most insightful recent literary critical explorations of the relationship between mind and body in the nineteenth century, including Murison's *The Politics of Anxiety*, which discusses the story's role in mediating tensions between postbellum neurologists (seeking the status of "science" for their study) and mesmerism, evangelism, and spiritualism.

32. In making the argument that nineteenth-century American literature and American culture even more generally was deeply structured by faulty psychology in *The Ivory Leg in the Ebony Cabinet*, Thomas Cooley asserts that "racialism was everywhere in the nineteenth century *because* it was inherent in the nineteenth-century conception of the mind" (p. xxiv, my emphasis). Phrenology is also intriguing as an early form of brain imaging, given its interest in visually charting the different functions of various areas of the brain.

33. Richards, *"Race," Racism, and Psychology*, 15.

34. Quoted in Richards, 32. See Richards, 32–40, for descriptions of the empirical research into racial difference of the 1890s, including experiments on racial differences regarding reflexes and memory.

35. See, among many others, George M. Frederickson, *The Black Image in the White Mind* (1971); Stephan J. Gould, *The Mismeasure of Man* (1981); Sander Gilman, "Black Bodies, White Bodies" (1985); Deborah McDowell, "Racism in Art" (1991); William H. Tucker, *The Science and Politics of Racial Research* (1994); Shawn Michelle Smith, *American Archives* (1999), Leigh Raiford, *Imprisoned in a Luminous Glare* (2011); Ivy Wilson, *Specters of Democracy* (2011); Simone Browne, *Dark Matters* (2015).

36. The late-nineteenth-century attempts to psychologize racialized personhood via discourse of body/mind and material/metaphysical can usefully be seen in the context of the long history of settler colonialism and plantation labor. In *Ariel's Ecology* (2013), Monique Allewaert describes how "the body as a disorganizing, fundamentally diversifying entity" was a "key anxiety of Anglo-Europeans writing in and about the American colonies" (p. 2) in the seventeenth and eighteenth centuries. "The tropics," Allewaert argues, "produced a different materialist tradition in which the body (animal or vegetable) is invaded, rendered in parts, and otherwise deranged." This tradition, she continues, "did not signal the end of personhood but rather the origin of a minoritarian and anti-colonial mode of personhood that was largely developed by Afro-Americans" (p. 3).

37. Frank Stephens, Eakins's brother-in-law and spearhead of the attempt to have the artist dismissed from the Academy, named Van Buren specifically, saying that she had posed naked, and that Eakins had revealed himself to her. In a letter to Edward Horner Coates, Eakins defends himself against Stephens's accusations, and describes Van Buren at length. He calls Van Buren a "very capable person," speaks highly of her artistic skill, and then relates the following story: "Once in the dissecting room [Van Buren] asked me the explanation of a movement of the pelvis in relation to the axis of movement of the whole body, so I told her to come around with me to my own studio where I was shortly going. There stripping myself, I gave her the explanation as I could not have done by words only. There was not the slightest embarrassment or cause for embarrassment on her part or on mine." The letter goes on to detail that she "has been quite an invalid at home." Thomas Eakins to Edward Horner Coates, September 12, 1886. Quoted in Foster, *Writing about Thomas Eakins*, 238–39.

38. In a letter dated June 7, 1900, to the photographer Francis Benjamin Johnston (who was at that time organizing an exhibition of photographs made by women to show at the Universal Exposition in Paris in July 1900), Van Buren explains that she used to have "such scorn for photographers" but that after "a few years of trying to run a gallery on a compromise between cheap commercial work and that based on some knowledge of modeling and composition" she had a "revolt from this and determined to use photography solely as a medium through which to express artistic ideas. I am more interested in portraits than anything else and it certainly sounds conceited to say that I hope to make portraits to stand with Sargeant and Watts and the other masters." Amelia Van Buren to Francis Benjamin Johnston, transcribed letter in the Curatorial Research File, The Phillips Collection. I thank Karen Schneider, Head Librarian at The Phillips Collection, for assistance in consulting these archival materials.

39. Amelia Van Buren to Susan Macdowell Eakins, May 14, 1886. Curatorial Research File, The Phillips Collection.

40. Foster, "Portraits of Teachers and Thinkers," 313.

41. Lubin, "Modern Psychological Selfhood," 149.

42. Caffin, "Some American Portrait Painters," 34.

43. Schuller, *The Biopolitics of Feeling*, 8.

44. Many feminist critics in the 1970s, 1980s, and 1990s highlighted exactly this idea, but rarely included an analysis of how feminine neuroses (hysteria, nervousness, frigidity, neurasthenia, etc.) was framed as a racialized quality in the nineteenth century. See Barbara Ehrenreich and Dierdre English, *Complaints and Disorders* (1973); Carroll Smith Rosenberg, "The Hysterical Woman" (1972); Elaine Showalter, *The Female Malady* (1985); Sander Gilman, et. al., *Hysteria Beyond Freud* (1993). Laura Briggs' "The Race of Hysteria" (2000) was a signal essay that asserted a connection between representations of white women's nervousness and ideas about race, noting that "hysteria as a symptom of 'overcivilization' did two simultaneous kinds of cultural work in response to crises of 'modernity': stabilizing the meaning of 'racial' difference while providing a (reactionary) response to the changing roles of women and meanings of gender" (p. 249).

45. It is important to note, however, that the somatic body *was* a foundational category of inquiry for Freudian psychoanalysis, and that, as Elizabeth Wilson has put it, "the psychological tenets of psychoanalysis are indebted to somatic symptomology—that the psyche is always already of the body" (p. 1). And yet, as Wilson has also noted, the broader cultural significance of psychoanalysis was won in large part by championing its theoretical and conceptual sophistication over and against the biological reductionism of the earlier somatic materialisms of nineteenth-century psychologies.

46. This idea is explored in Nochlin, *The Body in Pieces*.

Chapter Four

1. Spitzka's thinking is an extension of the "American School's" racism (considered in chapter two); only now the object of inquiry is the brain rather than the skull.

2. See, for example, Paul Klee's *A New Face* (1932); Pablo Picasso's *Portrait of Daniel-Henry Kahnweiler* (1910); or Man Ray's photograph *Gertrude Stein Sitting in front of Picasso's Portrait of Her* (1922).

3. Kaplan, *The Social Construction of American Realism*, 43.

4. Edel, "The Inward Turning"; Taylor, *The Sources of the Self*, 456.

5. James, *The Portrait of a Lady* (New York Edition, 1908), xv.

6. "The Faces" was retitled "The Two Faces" when James revised it for inclusion in the collection titled *The Better Sort* (1903). Throughout this chapter, I will generally use the texts of the tales as they first appeared in periodical publications, only occasionally referring to revisions he made when collecting the tales into volumes. This decision is not occasioned by any sense of "original" intention, but rather by my primary interest in historicizing the types of psychology and consciousness James explored and created in his portrait fiction prior to the turn of the century.

7. James, *The Wings of the Dove*, 359.

8. Sharon Cameron has (influentially) argued that Jamesian "ideas of consciousness" are unique insofar as he decouples consciousness from discrete individuals. In addition to Cameron, a number of literary critics (most notably, Leo Bersani and Christopher Lane) have emphasized the extent to which James (surprisingly, given his longstanding reputation as the most "psychological" of novelists) resisted and critiqued what has been termed "depth psychology," or the idea that an individual's real self, his or her real psychology, is hidden deep inside. In these accounts, depth psychology is considered to be a historically situated, Victorian type of "psychology," which James eschews in favor of representations of "consciousness" that presumably transcend historical context. But such accounts of the difference between "psychology" (static and located inside discrete individuals) and "consciousness" (wandering, decoupled from notions of individual subjectivity) in his work perhaps overstate the extent to which James's fiction pits these differing categories against one another, given that neither of those terms had settled or agreed-upon meanings for either nascent psychologists or fiction writers of the era. I will thus use the terms "psychology" and "consciousness" somewhat interchangeably here, for that is how Henry James and his brother William James (who uses the phrase "the stream of consciousness" to such effect in his major work *The Principles of Psychology*) used the terms. See Cameron, *Thinking in Henry James*; Bersani, "The Jamesian Lie"; Lane, "Jamesian Inscrutability."

9. Baym, "Revision and Thematic Change," 185, 187. Except where quoting from James's 1908 preface to the revised New York edition, I use the 1881 version of the novel in my analysis because I am interested in the points of contact between it and nineteenth-century psychological discourse. This is, in part, an attempt to undo the "discovery" narrative that often attends James's revisions, which asserts that James's late work offers an altogether more complicated and interesting (contemporary critics often call it "anti-psychological") account of consciousness than his earlier work.

10. See, for example, Damasio; Fisher; Lakoff and Johnson.

11. Brownell, "James's *Portrait of a Lady*," 102–3.

12. James, *The Portrait of a Lady* (Signet), 8. Hereafter cited in the text as *Portrait*.

13. I discuss how Hawthorne and other mid-century writers anticipated this theory in chapter 2.

14. William James, "What is an Emotion?" 190.

15. William James, "What Is an Emotion?" 191–92.

16. The point here is not that Henry James enacted William James's psychological theories in *The Portrait of a Lady* (indeed, that would be impossible in this case as the elder James's work on emotion postdates *Portrait*) but that we have not fully appreciated the novelist's interest in the embodied mind that preoccupied other thinkers of the time period as well.

17. James, preface, *The Portrait of a Lady*, 15.

18. On the emotional significance of the black velvet and the other dresses Isabel is described as wearing see Hughes, *Henry James and the Art of Dress*.

19. James, "John S. Sargent," 227–28.

20. Ironically, John Singer Sargent's portrait of Henry James himself would receive such treatment in real life in 1914, when Mary Wood visited the Royal Academy Exhibition and attacked it with a meat chopper. She explained that "if they only gave women the vote, this would never have happened." For more on this incident see Thomas J. Otten, "Slashing Henry James (On Painting and Political Economy Circa 1900)," and *A Superficial Reading of Henry James*.

21. See, for example, Freedman's reading of Gilbert Osmond in *Professions of Taste*, 146–66.

22. James, "The Story of a Masterpiece," 186. Hereafter cited in the text as "Masterpiece."

23. Whitman, "Personalism," 542. Hereafter cited in the text as "Personalism."

24. James was quite interested in the metaphorical/symbolic ramifications of the material reality of coverture, and he gave the subject a full-length treatment in *The Spoils of Poynton* (1896).

25. James, "The Special Type," 294. Hereafter cited in the text as "Type."

26. In this story, both Rose and Alice are referred to, respectively, as "Mrs. Cavenham" and "Mrs. Dundene." It is not clear whether either, or both, are widowed or have husbands who are alive. The fact that they are both "Mrs." highlights the question of *aesthetic* circulation. Since neither is a young woman on the marriage market, the story's interest in sullied reputation mainly concerns how aesthetic representations of these women circulate.

27. This is a theme James also memorably took up in his well-known short story "The Real Thing" (1892), in which a young Cockney model is much better at modeling for a painting of an aristocratic woman than a real aristocratic woman is.

28. The "promiscuous plural" pronouns of "The Special Type" are fascinating to consider in light of recent work in the field of transgender studies. See, in particular, Emma Heaney's chapter "A Triumphant Plural" in *The New Woman* (2017).

29. James, "The Tone of Time," 624. Hereafter cited in the text as "Tone."

30. James, *The Sense of the Past*, 70–71. Hereafter cited in the text as *Sense*.

31. Howells, "A Psychological Counter-Current in Recent Fiction," 872.

32. James, *A Small Boy and Others*, 194.

33. Henry James to Sarah Orne Jewett, October 5, 1901, in Philip Horne, ed., *Henry James: A Life in Letters*, 360.

34. Cameron, *Thinking in Henry James*, 55, 63.

35. James, "The Sweetheart of M. Briseux," 233. Hereafter cited in the text as "Briseux."

36. Crucially, the move "inside" the Sweetheart's mind is an illusion controlled and mediated by the male narrator's framing, a gendered phenomenon that evokes eighteenth-century ideas about the feminine passivity of the image in contrast to the masculine agency of the word.

37. On James and the visual arts, see Winner, *Henry James and the Visual Arts*; Tintner, *The Museum World of Henry James* and *Henry James and the Lust of the Eyes*; Freedman, *Professions of Taste*; and Torgovnick, *Visual Arts, Pictorialism, and the Novel*. On James and consciousness, see Cameron, *Thinking in Henry James*; Marshall, *Turn of the*

Mind; and Lodge's suggestive "Consciousness and the Novel." A notable recent example that attempts to place Henry James's compulsively metaphorical forms of consciousness in relation to the metaphors used by nineteenth-century psychology is Kress, *The Figure of Consciousness*.

Chapter Five

1. Röntgen, "On a New Kind of Rays."
2. Cartwright, *Screening the Body*, 121.
3. As I've pointed out elsewhere, histories of science and technology often offer suggestive readings of the moments in which artists and writers take advantage of or explore scientific innovations in their works of art, while rarely acknowledging the extent to which artists and writers play key roles in imagining those technologies into being. Bettyann Holzman Kevles's engaging history of X-ray technology and medical imaging in the twentieth century, *Naked to the Bone*, concludes with a chapter on twentieth-century art, and the assertion that "Artists will likely continue to extrapolate and elaborate on the remarkable technologies already available" (p. 302). Such emphasis occludes the central role art and literature play in material scientific and technological innovation.
4. Kevles, *Naked to the Bone*, 23.
5. Kevles, *Naked to the Bone*, 25.
6. Kevles, *Naked to the Bone*, 16.
7. "The Therapeutic Uses of the X-Ray," 573.
8. Mel Chen explores how representations of various forms of matter as inert or lively, inanimate or animate, undergird the historical and contemporary biopolitical visions of what forms of life are socially valued, what forms of life *matter*.
9. Cartwright's chapter "Women and the Public Culture of Radiography" traces how these gendered understandings of the vision enabled by X-ray photography are taken up later in the twentieth century, especially through public health campaigns aimed at eradicating tuberculosis.
10. The canonical histories of X-ray technology are Kevles, Glasser, and Ruth and Edward Brecher.
11. Hawthorne, "The Birthmark," 765. Hereafter cited in the text as "Birthmark."
12. By setting this story, which was written after the invention of photography, at some romantically vague earlier time before the invention of photography, Hawthorne effectively evokes the mid-nineteenth-century sense of photography as both science and magic.
13. Russel, quoted in Glasser, 42.
14. Thanks to Kyla Schuller, who helped me deepen this analysis of how the palimpsest of touch upon Georgiana works in the story.
15. See Cartwright, and Stanley Reiser: "New York women of fashion had X-rays taken of their hands covered with jewelry, to illustrate that 'beauty is of the bone and not altogether of the flesh,'" *Medicine and the Reign of Technology*, 61.
16. Quoted in Percy Brown, *American Martyrs to Science*, 10–12.
17. "C. M. Dally Dies a Martyr to Science," *New York Times*, October 4, 1904.

18. See de la Peña, "Bleaching the Ethiopian."

19. de la Peña, "Bleaching the Ethiopian," 51.

20. See Katy Chiles, *Transformable Race*.

21. Ruth and Edward Brecher, *The Rays*, 33.

22. Kevles, 36–38.

23. Martin, Wood, Thomson, Thompson, McLennan, Morton, and Edison, "Photographing the Unseen: A Symposium on the Roentgen Rays," 124.

Epilogue

1. Annelisa Stephan, "What's the Difference Between a Selfie and a Self-Portrait?"

Bibliography

Adams, Henry. *Eakins Revealed: The Secret Life of an American Artist*. New York: Oxford University Press, 2005.

Alkana, Joseph. *The Social Self: Hawthorne, Howells, William James and Nineteenth-Century Psychology*. Lexington: University Press of Kentucky, 1997.

Allewaert, Monique. *Ariel's Ecology: Plantations, Personhood, and Colonialism in the American Tropics*. Minneapolis: University of Minnesota Press, 2013.

Andrews, William L. "Slave Narratives: Chronological List of Autobiographies." *Documenting the American South*. University of North Carolina Library. http://docsouth.unc.edu/neh/chronautobio.html (accessed June 19, 2006).

———. *To Tell a Free Story: The First Century of Afro-American Autobiography, 1760–1865*. Urbana: University of Illinois Press, 1986.

"American Authorship, No. III: Nathaniel Hawthorne." *Littell's Living Age*. 16 July 1853, 154.

Armstrong, David, and Elizabeth Armstrong. *The Great American Medicine Show: Being an Illustrated History of Hucksters, Healers, Health Evangelists, and Heroes from Plymouth Rock to the Present*. New York: Prentice Hall, 1991.

Armstrong, Nancy. *Desire and Domestic Fiction: A Political History of the Novel*. New York: Oxford University Press, 1987.

———. *How Novels Think: The Limits of British Individualism from 1719–1900*. New York: Columbia University Press, 2006.

"Art in Philadelphia. An Exhibition of Paintings by American Artists at the Pennsylvania Academy of Fine Arts." *New York World*, 21 November 1881, 2.

Baker, Courtney. *Humane Insight: Looking at Images of African American Suffering and Death*. Urbana, IL: University of Illinois Press, 2015.

Banta, Martha. *Imaging American Women: Ideas and Ideals in Cultural History*. New York: Columbia University Press, 1987.

Barnhill, Georgia, Joshua Brown, and Ian Gordon. "Introduction: Seeing a Different Visual World." *Common-Place* 7, no. 3 (April 2007). http://www.common-place .org/vol-07/no-03/intro (accessed 8 August 2007).

Barthes, Roland. *Camera Lucida*. Translated by Richard Howard. New York: Farrar, Straus and Giroux, 1981.

Baym, Nina. "Revision and Thematic Change in *The Portrait of a Lady*." *Modern Fiction Studies* 22, no. 2 (1976): 183–200.

Beers, Henry A. *Nathaniel Parker Willis*. Boston: Houghton, Mifflin, 1885.

Benjamin, Walter. "A Short History of Photography." 1931. In *Classic Essays on Photography*, edited by Alan Trachtenberg. New Haven, CT: Leete's Islands Books, 1980.

———. "The Work of Art in the Age of Mechanical Reproduction." 1935. In *Illuminations: Essays and Reflections*, edited by Hannah Arendt. New York: Schocken Books, 1968.

Benston, Kimberly W. "Facing Tradition: Revisionary Scenes in African American Literature." *PMLA* 105, no. 1 (January 1990): 98–109.

Berger, John. *Ways of Seeing*. London and New York: Penguin Books, 1972.

Berger, Martin A. *Man Made: Thomas Eakins and the Construction of Gilded Age Manhood*. Berkeley: University of California Press, 2000.

Berlant, Lauren. *The Anatomy of National Fantasy: Hawthorne, Utopia, and Everyday Life*. Chicago: University of Chicago Press, 1991.

Bersani, Leo. "The Jamesian Lie." In *A Future for Astyanax: Character and Desire in Literature*. Boston: Little Brown, 1976.

Blackwood, Sarah. "'Making Good Use of Our Eyes': Nineteenth-Century African Americans Write Visual Culture." *MELUS: Multiethnic Literature of the United States* 39.2 (Summer 2014): 1–24.

———. "'The Inner Brand': Emily Dickinson, Portraiture, and the Narrative of Liberal Interiority." *The Emily Dickinson Journal* 14, no. 2 (Fall 2005): 48–59.

Boring, E. G. "The Psychology of Controversy." *Psychological Review* 36 (March 1929): 97–121.

Bourne-Taylor, Jenny, and Sally Shuttleworth, eds. *Embodied Selves: An Anthology of Psychological Texts 1830–1890*. Oxford: Clarendon Press, 1998.

Braddock, Alan. "Displacing Orientalism: Thomas Eakins and Ethnographic Modernity." PhD diss., University of Delaware, 2002.

———. "Eakins, Race, and Ethnographic Ambivalence." *Winterthur Portfolio* 33 (Summer–Fall 1998): 135–62.

———. "'Jeff College Boys': Thomas Eakins, Dr. Forbes, and Anatomical Fraternity in Postbellum Philadelphia." *American Quarterly* 57, no. 2 (June 2005): 355–83.

———. *Thomas Eakins and the Cultures of Modernity*. Berkeley: University of California Press, 2009.

Brecher, Ruth, and Edward Brecher. *The Rays: A History of Radiology in the United States and Canada*. Baltimore: Williams and Wilkins, 1969.

Briggs, Laura. "The Race of Hysteria: 'Overcivilization' and the 'Savage' Woman in Late Nineteenth-Century Obstetrics and Gynecology." *American Quarterly* 52.2 (June 2000): 246–73.

Brilliant, Richard. *Portraiture*. London: Reaktion Books, 1991.

Brinch, Boyrereau. *The Blind African Slave, or Memoirs of Boyrereau Brinch, Nicknamed Jeffrey Brace*. Madison: University of Wisconsin Press, 2005.

Brodhead, Richard. *The School of Hawthorne*. New York: Oxford University Press, 1990.

Brooks, Daphne. *Bodies in Dissent: Spectacular Performances of Race and Freedom, 1850–1910*. Durham, NC: Duke University Press, 2006.

Brown, Bill. "Reification, Reanimation, and the American Uncanny." *Critical Inquiry* 32, no. 2 (Winter 2006): 175–207.

Brown, Gillian. *Domestic Individualism: Imagining Self in Nineteenth-Century America*. Berkeley: University of California Press, 1992.

Brown, Percy. *American Martyrs to Science Through the Roentgen Rays*. Springfield, IL: C. C. Thomas, 1936.

Browne, Simone. *Dark Matters: On the Surveillance of Blackness*. Durham, NC: Duke University Press, 2015.

Brown, William Wells. *Clotel, or The President's Daughter*. New York: Penguin, 2003.

Brownell, William. "The Art Schools of Philadelphia." *Scribner's Monthly*, September 1879, 737–51.

———. "James's *Portrait of a Lady*." Reprinted in Kevin J. Hayes, ed., *Henry James: The Contemporary Reviews* (Cambridge: Cambridge University Press, 1996): 145–48.

Brownson, O. A. "Schmucker's Psychology." *The United States Magazine and Democratic Review*, October 1842: 352–74. *ProQuest American Periodicals*. Northwestern University, Evanston, IL. http://www.proquest.com.turing.library.northwestern .edu/(accessed 28 April 2009).

Burns, Stanley, MD. *Shooting Soldiers: Civil War Medical Photography by Reed B. Bontecou*. New York: Burns Archive Press, 2011.

Bynum, Tara. "Phillis Wheatley on Friendship." *Legacy* 31.1 (2014): 42–51.

"C. M. Dally Dies a Martyr to Science." *New York Times*, 4 October 1904.

Caffin, Charles H. "Some American Portrait Painters." *The Critic* 44, no. 1 (January 1904).

Cameron, Sharon. *Thinking in Henry James*. Chicago: University of Chicago Press, 1989.

Carney, Ray. "When Mind is a Verb: Thomas Eakins and the Work of Doing." In *The Revival of Pragmatism: New Essays on Social Thought, Law, and Culture*, edited by Morris Dickstein, 377–403. Durham, NC: Duke University Press, 1998.

Casmier-Paz, Lynn A. "Slave Narratives and the Rhetoric of Author Portraiture." *New Literary History* 34, no. 1 (Spring 2003): 91–116.

Castiglia, Christopher. "Abolition's Racial Interiors and the Making of White Civic Depth." *American Literary History* 14, no. 1 (Spring 2001): 32–59.

———. "'I found a life of freedom all my fancy had pictured it to be': Hannah Crafts's Visual Speculation and the Inner Life of Slavery." In *In Search of Hannah Crafts: Critical Essays on* The Bondwoman's Narrative, edited by Henry Louis Gates, Jr., and Hollis Robbins, 231–75. New York: Basic Books, 2004.

———. *Interior States: Institutional Consciousness and the Inner Life of Democracy in the Antebellum United States*. Durham, NC: Duke University Press, 2008.

Chaney, Michael. "Picturing the Mother, Claiming Egypt: *My Bondage and My Freedom* as Auto(bio)ethnography." *African American Review* 35, no. 3 (Autumn 2001): 391–408.

Chen, Mel. *Animacies: Biopolitics, Racial Mattering, and Queer Affect*. Durham, NC: Duke University Press, 2012.

Chiles, Katy. *Transformable Race: Surprising Metamorphoses in the Literature of Early America*. New York: Oxford University Press, 2014.

Clytus, Radiclani. "Visualizing in Black Print: The Brooklyn Correspondence of William J. Wilson aka 'Ethiop'." *J19: The Journal of Nineteenth-Century Americanists* 6.1 (Spring 2018): 29–66.

Cobb, Jasmine. *Picture Freedom: Remaking Black Visuality in the Early Nineteenth Century*. New York: New York University Press, 2015.

Colbert, Charles. *A Measure of Perfection: Phrenology and the Fine Arts in America*. Chapel Hill: University of North Carolina Press, 1997.

Cook, Clarence. "The Art Gallery: The Water-Color Society's Exhibition." *The Art Amateur: A Monthly Journal Devoted to Art in the Household* 6, no. 4 (March 1882): 72. *ProQuest American Periodicals*. Northwestern University, Evanston, IL. http://www .proquest.com.turing.library.northwestern.edu/ (accessed 28 April 2009).

Cooley, Thomas. *The Ivory Leg in the Ebony Cabinet: Madness, Race, and Gender in Victorian America*. Amherst: University of Massachusetts Press, 2001.

Cooter, Roger. *The Culture of Popular Science: Phrenology and the Organization of Consent in Nineteenth-Century Britain*. New York: Cambridge University Press, 1984.

Crafts, Hannah. *The Bondwoman's Narrative*. Edited by Henry Louis Gates Jr. New York: Warner Books, 2002.

Crary, Jonathan *Techniques of the Observer: On Vision and Modernity in the Nineteenth Century*. Cambridge, MA: MIT Press, 1990.

Damasio, Antonio. *Descartes' Error: Emotion, Reason, and the Human Brain*. New York: Penguin, 1994.

Davidson, Cathy. *Revolution and the Word: The Rise of the Novel in America*. New York: Oxford University Press, 1986.

de la Peña, Carolyn Thomas. "Bleaching the Ethiopians: Desegregating Race and Technology Through Early X-ray Experiments." *Technology and Culture* 47.1 (January 2006): 27–55.

———. *The Body Electric: How Strange Machines Built the Modern American*. New York: New York University Press, 2003.

Devine, Shauna. *Learning from the Wounded: The Civil War and the Rise of American Medical Science*. Chapel Hill: University of North Carolina Press, 2014.

Dinius, Marcy. "The Long History of the 'Selfie'." *J19: The Journal of Nineteenth-Century Americanists* 3.2 (Fall 2015): 455–451.

———. *The Camera and the Press: American Visual and Print Culture in the Age of the Daguerreotype*. Philadelphia: University of Pennsylvania Press, 2012.

Dods, J.B. *Electrical Psychology*. New York: Fowler & Wells, 1850.

Douglass, Frederick. "The Claims of the Negro Ethnologically Considered, an Address Delivered in Hudson, Ohio, On 12 July1854." In *The Frederick Douglass Papers*. Vol. 2, edited by John W. Blassingame, 497–525. New York: International Publishers, 1950.

———. *My Bondage and My Freedom*. Edited by William L. Andrews. Urbana: University of Illinois Press, 1987.

———. "Oh Liberty! What Deeds Are Done in Thy Name!" *The North Star*, 22 February 1850.

———. "Pictures and Progress: An Address Delivered in Boston, Massachusetts, On 3 December 1861." In *The Frederick Douglass Papers*. Vol. 3, edited by John W. Blassingame, 452–73. New York: International Publishers, 1950.

Doyle, Jennifer. "Sex, Scandal, and Thomas Eakins's *The Gross Clinic*." *Representations* 68 (Autumn 1999): 1–33.

Duane, Anna Mae. "Remaking Black Motherhood in Frank J. Webb's *The Garies and their Friends*." *African American Review* 38, no. 2 (Summer 2004): 201–12.

Dunlap, William. *The History of the Rise and Progress of the Arts of Design in the United States*. 2 vols. New York: George P. Scott, 1834.

Edel, Leon. "The Inward Turning." In *The Modern Psychological Novel*. New York: Grosset and Dunlap, 1964.

Ehrenreich, Barbara and Deirdre English. *Complaints and Disorders: The Sexual Politics of Sickness*. New York: Feminist Press, 1971.

Ellis, Cristin. *Antebellum Posthuman: Race and Materiality in the Mid-Nineteenth Century*. New York: Fordham University Press, 2018.

Fay, Jay Wharton. *American Psychology Before William James*. New Brunswick, NJ: Rutgers University Press, 1939.

Fern, Fanny. "Taking Portraits." *New York Ledger*, 22 September 1860.

Foster, Kathleen. "Portraits of Teachers and Thinkers." In *Thomas Eakins*, edited by Darrel Sewell. Philadelphia: Philadelphia Museum of Art, 2001.

———. *Thomas Eakins Rediscovered: Charles Bregler's Thomas Eakins Collection at the Pennsylvania Academy of the Fine Arts*. New Haven, CT: Yale University Press, 1997.

———. *Writing About Eakins: The Manuscripts in Charles Bregler's Thomas Eakins Collection*. Philadelphia: University of Pennsylvania Press, 1989.

Foucault, Michel. *The Order of Things: An Archeology of the Human Sciences*. 1966. Reprint. New York: Vintage Books, 1994.

Frederickson, George M. *The Black Image in the White Mind: The Debate on Afro-American Character and Destiny, 1817–1914*. Middletown, CT: Wesleyan University Press, 1987.

Freeburg, Christopher. *Black Aesthetics and the Interior Life*. Charlottesville, VA, 2017.

Freedman, Jonathan. *Professions of Taste: Henry James, British Aestheticism, and Commodity Culture*. Stanford, CA: Stanford University Press, 1990.

Fuguet, Dallett. "Portraiture as Art." *Camera Notes* 5, no. 2 (October 1901): 3, 80–82.

Gates, Jr., Henry Louis. "The Trope of a New Negro and the Reconstruction of the Image of the Black." *Representations* 24 (Autumn 1988): 129–55.

Gates, Jr., Henry Louis, and Hollis Robbins, eds. *In Search of Hannah Crafts: Critical Essays on* The Bondwoman's Narrative. New York: Basic Books, 2004.

Gay, Peter. *The Freud Reader*. New York: W. W. Norton and Company, 1989.

Gershon, Michael, MD. *The Second Brain: A Groundbreaking New Understanding of Nervous Disorders of the Stomach and Intestines*. New York: Harper Perennial, 1999.

Gilman, Sander. "Black Bodies, White Bodies: Toward an Iconography of Female Sexuality in Late-Nineteenth-Century Art, Medicine, and Literature." *Critical Inquiry* 12, no. 1 (Fall 1985): 204–42.

Gilman, Sander, Helen King, Roy Porter, G.S. Rousseau, and Elaine Showalter. *Hysteria Beyond Freud*. Berkeley, CA: University of California Press, 1993.

Glasser, Otto. *Wilhelm Conrad Roentgen and the Early History of the Roentgen Rays*. London: National Library of Medicine, 1933.

Goddu, Teresa. "Anti-Slavery's Panoramic Perspective." *MELUS: Multiethnic Literature of the U.S.* 39, no. 2 (Summer 2014): 12–41.

———. *Gothic America: Narrative, History, and Nation*. New York: Columbia University Press, 1997.

Goldberg, Shari. "*Benito Cereno*'s Mute Testimony: On the Politics of Reading Melville's Silences." *Arizona Quarterly* 65, no. 2 (Summer 2009): 1–26.

Gollin, Rita. *Portraits of Nathaniel Hawthorne: An Iconography*. DeKalb: Northern Illinois University Press, 1983.

———. *Prophetic Pictures: Nathaniel Hawthorne's Knowledge and Uses of the Visual Arts*. New York: Greenwood Press, 1991.

Goodrich, Lloyd. *Thomas Eakins*. 2 vols. Cambridge, MA: Harvard University Press, 1982.

———. *Thomas Eakins, His Life and Work*. New York: Whitney Museum of American Art, 1933.

Gould, Stephan J. *The Mismeasure of Man*. New York: W. W. Norton and Company, 1981.

Halttunen, Karen. *Confidence Men and Painted Women: A Study of Middle-Class Culture in America, 1830–1870*. New Haven, CT: Yale University Press, 1982.

Harris, Neil. *The Artist in American Society: The Formative Years, 1790–1860*. New York: George Braziller, 1966.

Hartley, Lucy. *Physiognomy and the Meaning of Expression in Nineteenth-Century Culture*. Cambridge: Cambridge University Press, 2001.

Hawthorne, Nathaniel. *The American Notebooks*. Vol. 8 of *The Centenary Edition of the Works of Nathaniel Hawthorne*, edited by William Charvat et al. Columbus: Ohio State University Press, 1972.

———. "The Birthmark." In *Tales and Sketches*. New York: Library of America, 1982.

———. *The Blithedale Romance*. Vol. 3 of *The Centenary Edition of the Works of Nathaniel Hawthorne*, edited by William Charvat et al. Columbus: Ohio State University Press, 1972.

———"Edward Randolph's Portrait." In *Twice-Told Tales*. Vol. 9 of *The Centenary Edition of the Works of Nathaniel Hawthorne*, edited by William Charvat et al. Columbus: Ohio State University Press, 1974.

———. *The House of the Seven Gables*. Vol. 2 of *The Centenary Edition of the Works of Nathaniel Hawthorne*, edited by William Charvat et al. Columbus: Ohio State University Press, 1965.

———. "The Old Manse." In *Mosses from an Old Manse*. 1846. New York: Modern Library Classics, 2003.

———"The Prophetic Pictures." In *Twice-Told Tales*. Vol. 9 of *The Centenary Edition of the Works of Nathaniel Hawthorne*, edited by William Charvat et al. Columbus: Ohio State University Press, 1974.

———*The Scarlet Letter*. New York: Vintage Books, 1990.

Hayes, John. "The Theory and Practice of British Eighteenth-Century Portraiture." In *The Portrait in Eighteenth-Century America*, edited by Ellen Miles, 19–32. Newark: University of Delaware Press, 1993.

Heaney, Emma. *The New Woman: Literary Modernism, Queer Theory, and the Trans Feminine Allegory*. Evanston, IL: Northwestern University Press, 2017.

Horne, Philip J. *Henry James: A Life in Letters*. New York: Penguin Classics. 2001.

Howells, William Dean. "A Psychological Counter-Current in Recent Fiction." *North American Review* 173, no. 6 (December 1901): 872–88.

Huerta, Monica. "What's Mine: Involuntary Expressions, Modern Personality, and the Right to Privacy." *J19: The Journal of Nineteenth-Century Americanists* 4, no. 2 (Fall 2016): 359–89.

Irving, Washington. "Rip Van Winkle." *The Sketch-Book*. New York: Signet Classics, 1961.

Jacobs, Harriet. *Incidents in the Life of a Slave Girl, Written by Herself*. Edited by Jean Fagan Yellin. Cambridge, MA: Harvard University Press, 2000.

James, Henry. "The Faces." *Harper's Bazaar*, 15 December 1900, 2084–2093. *ProQuest American Periodicals*. Northwestern University, Evanston, IL. http://www.proquest.com.turing.library.northwestern.edu/ (accessed April 28, 2009).

———. *Hawthorne*. Ithaca, New York: Cornell University Press, 1997.

———. "John S. Sargent." In *The Painter's Eye: Notes and Essays on the Pictorial Arts*, edited by John L. Sweeney, 227–28. Madison: University of Wisconsin Press, 1989.

———. *Notes of a Son and Brother*. New York: Charles Scribner and Sons, 1914.

———. "A Passionate Pilgrim." In *The Tales of Henry James*. Vol. 2, edited by Maqbool Aziz, 102–26. Oxford: Clarendon Press, 1978.

———. *The Portrait of a Lady* (1881). New York: Signet Classics, 1995.

———. *The Portrait of a Lady* (1908). New York: W. W. Norton, 1995.

———. *The Sense of the Past*. Elibron Classics facsimile reprint. N.p.: Adamant Media, 2003.

———. *A Small Boy and Others*. In *Autobiography*, edited by F. W. Dupee. New York: Criterion Books, 1956.

———. "The Special Type." In *Complete Stories, 1898–1910*. New York: Library of America, 1996.

———. "The Story of a Masterpiece." In *The Tales of Henry James*. Vol. 1, edited by Maqbool Aziz, 180–209. Oxford: Clarendon Press, 1973.

———. "The Sweetheart of M. Briseux." In *The Tales of Henry James*. Vol. 2, edited by Maqbool Aziz, 233–58. Oxford: Clarendon Press, 1978.

———. "The Tone of Time," *Scribner's Magazine* 28, November 1900: 624–34.

———. "The Two Faces." In *Complete Tales*, edited by Leon Edel, 239–55. London: R. Hart-Davis, 1964.

———. *What Maisie Knew*. In *Novels, 1896–1899*. New York, Library of America, 2003.

———. *The Wings of the Dove*. In *Novels, 1901–1902*. New York: Library of America, 2006.

James, William. *The Correspondence of William James*. Vol. 4, edited by Ignas K. Skrupskelis and Elizabeth M. Berkeley. Charlottesville: University of Virginia Press, 1995.

———. *The Principles of Psychology*. 2 vols. New York: Dover Publications, 1950.

———. "What is an Emotion?" *Mind* 9:34 (April 1884): 188–205.

Jaros, Peter. "Circulating Character: Physiognomics, Personhood, and Politics in the Early Republic." PhD diss., Northwestern University, 2009.

Johns, Elizabeth. *Thomas Eakins, the Heroism of Modern Life*. Princeton, NJ: Princeton University Press, 1984.

Jones, S. Rees. "Science and the Art of Picture Cleaning." *Burlington Magazine* 104 (February 1962): 60–62.

Kant, Immanuel. *Metaphysical Foundation of Natural Sciences* (1786). Cambridge, MA: Cambridge University Press, 2004.

Kaplan, Amy. *The Social Construction of American Realism*. Chicago: University of Chicago Press, 1992.

Keck, Sheldon. "Some Picture Cleaning Controversies: Past and Present." *Journal of the American Institute for Conservation* 23, no. 2 (1984): 73–87.

Kevles, Bettyann Holtzmann. *Naked to the Bone: Medical Imaging in the Twentieth Century*. New York: Basic Books, 1998.

Kirkpatrick, Sidney. *The Revenge of Thomas Eakins*. New Haven, CT: Yale University Press, 2006.

Kress, Jill M. *The Figure of Consciousness: William James, Henry James, and Edith Wharton*. New York: Routledge, 2002.

Lakoff, George, and Mark Johnson. *Philosophy in the Flesh: The Embodied Mind and Its Challenge to Western Thought*. New York: Basic Books, 1999.

Lane, Christopher. "Jamesian Inscrutability." *Henry James Review* 20, no. 3 (Fall 1999): 244–54.

Lathrop, George Parsons. "Biographical Sketch of Nathaniel Hawthorne." In *Tales, Sketches, and Other Papers*. Vol. 12, *Complete Works of Nathaniel Hawthorne*, edited by George P. Lathrop. Boston: Houghton Mifflin, 1883.

Leahy, Thomas Hardy, and Grace Evans Leahy. *Psychology's Occult Doubles: Psychology and the Problem of Pseudoscience*. Chicago: Nelson-Hall, 1983.

Lee, Anthony, and Elizabeth Young. *On Gardner's Photographic Sketch Book of the War*. Berkeley: University of California Press, 2008.

Leja, Michael. *Looking Askance: Skepticism and American Art from Eakins to Duchamp*. Berkeley: University of California Press, 2007.

Lifton, Norma. "Thomas Eakins and S. Weir Mitchell: Images and Cures in the Late Nineteenth Century." In *Psychoanalytic Perspectives on Art*, edited by Mary Mathews Gedo. Hillsdale, NJ: The Analytic Press, 1987.

Lodge, David. "Consciousness and the Novel." In *Consciousness and the Novel: Connected Essays*. Cambridge, MA: Harvard University Press, 2004.

Long, Lisa. *Rehabilitating Bodies: Health, History, and the American Civil War*. Philadelphia: University of Pennsylvania Press, 2004.

Lovell, Margaretta. *Art in a Season of Revolution: Patrons, Artisans, and Painters in Early America*. Philadelphia: University of Pennsylvania Press, 2005.

Lubin, David. "Modern Psychological Selfhood in the Art of Thomas Eakins." In *Inventing the Psychological: Toward a Cultural History of Emotional Life in America*, edited by Joel Pfister and Nancy Schnog. New Haven, CT: Yale University Press, 1997.

———. "Projecting an Image: The Contested Cultural Identity of Thomas Eakins." *The Art Bulletin* 84, no. 3 (September 2002): 510–22.

Luciano, Dana. "Touching Seeing." *American Literary History* 28, no. 1 (January 2016): 140–50.

Lukasik, Christopher. *Discerning Characters: The Culture of Appearance in Early America*. Philadelphia: University of Pennsylvania Press, 2011.

————."The Face of the Public." *Early American Literature* 39, no. 3 (2004): 413–64.

Lutz, Tom. *American Nervousness, 1903: An Anecdotal History*. Ithaca, NY: Cornell University Press, 1991.

Mansouri, Leila. "*Sheppard Lee* and the Properties of the Novel in America." *American Literary Realism* 49.1 (2016): 49–64.

Marshall, Adre. *The Turn of the Mind: Constituting Consciousness in Henry James*. Madison, NJ: Farleigh Dickinson University Press, 1998.

Martin, Terence. *The Instructed Vision: Scottish Common Sense Philosophy and the Origins of American Fiction*. Bloomington: Indiana University Press, 1961.

Martin, Jr., Waldo. *The Mind of Frederick Douglass*. Chapel Hill: University of North Carolina Press, 1984.

Mayer, Emeran, MD. *The Mind-Gut Connection: How the Hidden Conversation Within Our Bodies Impacts Our Mood, Our Choices, and Our Overall Health*. New York: Harper Wave, 2016.

McCandless, Barbara. "The Portrait Studio and the Celebrity." In *Photography in the Nineteenth Century*, edited by Martha Sandweiss. Fort Worth, TX: Amon Carter Museum, 1991.

McDowell, Deborah. "Racism in Art." *Virginia Quarterly Review* 67.2 (Spring 1991).

McElroy, Guy C. *Facing History: The Black Image in American Art, 1710–1940*. New York: Chronicle Books, 1991.

McFadden, Syreeta. "Teaching the Camera to See My Skin." *Buzzfeed*, April 2, 2014. Reference URL: https://www.buzzfeednews.com/article/syreetamcfadden /teaching-the-camera-to-see-my-skin (Accessed May 7, 2019).

McLennan, William James Morton, and Thomas Edison. "Photographing the Unseen: A Symposium on the Roentgen Rays." *The Century Magazine*, May 1896, 120–30.

Melville, Herman. "Benito Cereno." 1855. In *The Piazza Tales*. Edited by Harrison Hayford, et al. Evanston, IL: Northwestern University Press, 1987.

————. *Correspondence*. Edited by Lynn Horth. Evanston, IL and Chicago: Northwestern University Press and The Newberry Library, 1993.

Menand, Louis. "Morton, Agassiz, and the Origins of Scientific Racism in the United States." *The Journal of Blacks in Higher Education* 34 (Winter 2001–2002): 110–13.

Miller, Brian. *Empty Sleeves: Amputation in the Civil War South*. Athens, GA: University of Georgia Press, 2015.

Mitchell, Koritha. *Living with Lynching: African American Lynching Plays, Peformance, and Citizenship, 1890–1930*. Urbana, IL: University of Illinois Press, 2012.

Mitchell, Mary Niall. *Raising Freedom's Child: Black Children and Visions of the Future After Slavery*. New York: New York University Press, 2010.

Mitchell, S. Weir. "The Case of George Dedlow." *Atlantic Monthly*, July 1866, 1–11.

————. *Wear and Tear, or Hints for the Overworked*. 1871. Edited by Michael S. Kimmel. Walnut Creek, CA: AltaMira Press, 2004.

Moody, Joycelyn K. "Tactical Lines in Three Black Women's Visual Portraits, 1773–1849. *a/b: Auto/Biography Studies* 30.1 (2015): 67–98.

Morton, Samuel George. *Crania Americana, or, A Comparative View of the Skulls of Various Aboriginal Nations of North and South America. To Which Is Prefixed an Essay on the Variety of the Human Species*. Philadelphia: J. Pennington, 1839.

"Morton's Crania Americana." *North American Review* 51 (July 1840): 173–87.

Moten, Fred, and Stefano Harney. *The Undercommons: Fugitive Planning and Black Study*. London: Minor Compositions, 2013.

Mulvey, Laura. "Visual Pleasure and Narrative Cinema." *Screen* 16, no. 3 (Autumn 1975): 6–18.

Murison, Justine. "Uneasy A." *Avidly*, September 19, 2014. Reference URL: http:// avidly.lareviewofbooks.org/2014/09/19/uneasy-a/ (Accessed May 6, 2019).

———.*The Politics of Anxiety in Nineteenth-Century American Literature*. New York: Cambridge University Press, 2011.

"Nathaniel Hawthorne." *Arcturus: A Journal of Books and Opinion* 1 (May 1841): 336–37.

Neary, Janet. *Fugitive Testimony: On the Visual Logic of Slave Narratives*. New York: Fordham University Press, 2016.

Nochlin, Linda. "Issues of Gender in Cassatt and Eakins." In *Nineteenth Century Art: A Critical History*, edited by Stephen Eisenman. New York: Thames and Hudson, 1994.

———. *The Body in Pieces: The Fragment as a Metaphor of Modernity*. New York: Thames and Hudson, 1994.

Nott, Josiah, and George Gliddon. *Types of Mankind*. Philadelphia: Lippincott, Grambo and Company, 1854.

O'Farrell, Mary Ann. *Telling Complexions: The Nineteenth-Century English Novel and the Blush*. Durham, NC: Duke University Press, 1997.

Ogden, Emily. *Credulity: A Cultural History of U.S. Mesmerism*. Chicago: University of Chicago Press, 2018.

Orvell, Miles. *The Real Thing: Imitation and Authenticity in American Culture, 1880–1940*. Chapel Hill: University of North Carolina Press, 1989.

Otten, Thomas J. *A Superficial Reading of Henry James: Preoccupations with the Material World*. Columbus: Ohio State University Press, 2006.

———. "Slashing Henry James (On Painting and Political Economy Circa 1900). *Yale Journal of Criticism* 13, no. 2 (2000): 293–320.

Otter, Samuel. "Philadelphia Experiments." *American Literary History* 16, no. 1 (Spring 2004): 103–16.

———. "Frank Webb's Still Life: Rethinking Literature and Politics through *The Garies and Their Friends. American Literary History* 20, no. 4 (Fall 2008): 728–52.

———. *Melville's Anatomies*. Berkeley: University of California Press, 1999.

Oxford Dictionaries, "Oxford Dictionaries Word of the Year 2013." *Oxford Dictionaries Press Release*. 19 November 2013. http://blog.oxforddictionaries.com/press -releases/oxford-dictionaries-word-of-the-year-2013/

Panzer, Mary. *Matthew Brady and the Image of History*. Washington, DC: Smithsonian Institution Press, 1997.

Parry, Ellwood. *The Image of the Indian and the Black Man in American Art, 1590–1900*. New York: George Braziller, 1974.

Pfister, Joel. *The Production of Personal Life: Class, Gender, and the Psychological in Hawthorne's Fiction*. Stanford, CA: Stanford University Press, 1991.

Pfister, Joel, and Nancy Schnog, eds. *Inventing the Psychological: Toward a Cultural History of Emotional Life in America*. New Haven, CT: Yale University Press, 1997.

Poe, Edgar Allan. "Ligeia." 1838. In *Complete Tales and Poems*. New York: Random House, 1975.

———."The Oval Portrait." 1842. In *Complete Tales and Poems*. New York: Random House, 1975.

Powell, Richard A. "Cinqué: Antislavery Portraiture and Patronage in Jacksonian America." *American Art* 11 (Fall 1997): 48–73.

"Psychology, or a View of the Human Soul." *Baltimore Literary and Religious Magazine* 7, no. 8 (August 1841): 348–58. *ProQuest American Periodicals*. Northwestern University, Evanston, IL. http://www.proquest.com.turing.library.northwestern.edu/ (accessed 28 April 2009).

Quashie, Kevin. *The Sovereignty of Quiet: Beyond Resistance in Black Culture*. New Brunswick, NJ, 2012.

Raiford, Leigh. *Imprisoned in a Luminous Glare: Photography and the African American Freedom Struggle*. Chapel Hill: University of North Carolina Press, 2011.

Reckson, Lindsay. "Gesture." In *Keywords for American Cultural Studies*. Edited by Bruce Burgett and Glenn Hendler. New York: New York University Press, 2014.

Redgrave, Richard, and Samuel Redgrave. *A Century of British Painters*. London: Smith, Elder & Co., 1866.

Reed, Edward. *From Soul to Mind: The Emergence of Psychology from Erasmus Darwin to William James*. New Haven, CT: Yale University Press, 1997.

Reid, Thomas. *An Inquiry into the Human Mind on the Principles of Common Sense*. 1764. Edited by Derek R. Brookes. Edinburgh: Edinburgh University Press, 1997.

Reiser, Stanley J. *Medicine and the Reign of Technology*. New York: Cambridge University Press, 1981.

van Rensselaer, Mariana Griswold. "The Philadelphia Exhibition.—II." *The American Architect and Building News* 8, no. 261 (December 25, 1880).

Richards, Graham. *Race, Racism, and Psychology: Towards a Reflexive History*. 2nd ed. New York: Routledge, 2012.

Rifkin, Mark. *Settler Common Sense: Queerness and Everyday Colonialism in the American Renaissance*. Minneapolis: University of Minnesota Press, 2014.

Romer, Grant B., and Brian Wallis, eds. *Young America: The Daguerreotypes of Southworth and Hawes*. New York: International Center of Photography, 2005.

Romero, Lora. *Homefronts: Domesticity and Its Critics in the Antebellum United States*. Durham, NC: Duke University Press, 1997.

Röntgen, W. C. "On a New Kind of Rays." *Science* 3, no. 59 (February 14, 1896): 225–27.

Root, Marcus Aurelius. *The Camera and the Pencil*. Philadelphia: Lippincott & Co., 1864.

Rusert, Britt. *Fugitive Science: Empiricism and Freedom in Early African American Culture*. New York: New York University Press, 2017.

Russel, Lawrence K. "Lines on an X-ray Portrait of a Lady." *Life*. March 12, 1896.

Samuels, Shirley, ed. *The Culture of Sentiment: Race, Gender, and Sentimentality in Nineteenth-Century America*. New York: Oxford University Press, 1992.

Schuller, Kyla. *The Biopolitics of Feeling: Race, Sex, and Science in the Nineteenth Century*. Durham, NC: Duke University Press, 2017.

Sekora, John. "Black Message/White Envelope: Genre, Authenticity, and Authority in the Antebellum Slave Narrative." *Callaloo* 32 (Summer 1987): 482–515.

Sherrard-Johnson, Cherene. *Portraits of the New Negro Woman: Visual and Literary Culture in the Harlem Renaissance*. New Brunswick, NJ: Rutgers University Press, 2007.

Showalter, Elaine. *The Female Malady: Women, Madness, and English Culture, 1890–1980*. New York: Penguin Books, 1987.

Smith, Shawn Michelle. *American Archives: Gender, Race, and Class in Visual Culture*. Princeton, NJ: Princeton University Press, 1999.

———. *Photography on the Color Line: W. E. B. DuBois, Race, and Visual Culture*. Durham, NC: Duke University Press, 2004.

———. *At the Edge of Sight: Photography and the Unseen*. Durham, NC: Duke University Press, 2013.

Smith-Rosenberg, Carroll. "The Hysterical Woman: Sex Roles and Role Conflict in 19th-Century America." *Social Research* 39.4 (Winter 1972): 652–78.

Southworth, Albert. "An Address to the National Photographic Association of the United States." *The Philadelphia Photographer* 8 (October 1871).

Spillers, Hortense. "Mama's Baby, Papa's Maybe: An American Grammar Book." *Diacritics* 17, no. 2 (Summer 1987): 64–81.

Stauffer, John, Zoe Trodd, Celeste-Marie Bernier, Henry Louis Gates Jr. and Kenneth B. Morris Jr. *Picturing Frederick Douglass: An Illustrated Biography of the Nineteenth Century's Most Photographed Man*. New York: Liveright, 2015.

Stephan, Annelisa. "What's the Difference Between a Selfie and a Self-Portrait?" *The Iris: Behind the Scenes at the Getty*. January 21, 2015. Reference URL: http://blogs .getty.edu/iris/whats-the-difference-between-a-selfie-and-a-self-portrait/ (Accessed June 5, 2018).

Stern, Julia. "Live Burial and Its Discontents." In *Symbolic Loss: The Ambiguity of Mourning and Memory at Century's End*, edited by Peter Homans. Charlottesville: University Press of Virginia, 2000.

———. *The Plight of Feeling: Sympathy and Dissent in the Early American Novel*. Chicago: University of Chicago Press, 1997.

Stern, Madeleine. *Heads and Headlines: The Phrenological Fowlers*. Norman: University of Oklahoma Press, 1971.

Stewart, Maria. "Mrs. Steward's Essays." *The Liberator* (January 7, 1832). In *"We Must Be Up and Doing": A Reader in Early African American Feminisms*. Edited by Teresa C. Zackodnik (New York: Broadview Press, 2010).

Syme, Rachel. "SELFIE: The Revolutionary Power of Your Own Face, in Seven Chapters." *Matter*, November 19, 2015. Reference URL: https://medium.com /matter/selfie-fe945dcba6b0 (Accessed May 7, 2019)

Taylor, Charles. *The Sources of the Self*. Cambridge: Cambridge University Press, 1992.

"The Therapeutic Uses of the X-Ray," *Medical Record* 55 no. 16 (April 22, 1899): 573.

Thompson, Krista. "Preoccupied with Haiti: The Dream of Diaspora in African American Art, 1915–1942." *American Art* 21.3 (Fall 2007): 75–97.

Thrailkill, Jane. *Affecting Fictions: Mind, Body, and Emotion in American Literary Realism*. Cambridge: Harvard University Press, 2007.

Tintner, Adeline. *Henry James and the Lust of the Eyes: Thirteen Artists in His Work*. Baton Rouge, LA: Louisiana State University Press, 1993.

———.*The Museum World of Henry James*. Ann Arbor, MI: UMI Research Press, 1986.

Torgovnick, Mariana. *The Visual Arts, Pictorialism, and the Novel: James, Lawrence, and Woolf*. Princeton, NJ: Princeton University Press, 2014.

Trachtenberg, Alan. *Reading American Photographs: Images as History, Matthew Brady to Walker Evans*. New York: Hill and Wang, 1989.

———. "Seeing and Believing: Hawthorne's Reflection on the Daguerreotype in *The House of the Seven Gables*." *American Literary History* 9, no. 3 (Autumn, 1997): 460–81.

Trilling, Lionel. *The Opposing Self: Nine Essays in Criticism*. New York: Harcourt Brace Jovanovich, 1978.

Tucker, William. *The Science and Politics of Racial Research*. Urbana: University of Illinois Press, 1996.

Tuckerman, Henry. "Nathaniel Hawthorne." *Southern Literary Messenger* 17, no. 6 (June 1851): 344–49. *Making of America*. Northwestern University Library, Evanston, IL. http://quod.lib.umich.edu/m/moajrnl/ (accessed 30 April 2009).

Van Buren, Amelia. Letter to Francis Benjamin Johnston, June 7, 1900. Curatorial Research File, The Phillips Collection, Washington, DC.

———. Letter to Susan Macdowell Eakins. May 14, 1886. Archives of Pennsylvania Academy of the Fine Arts.

van Rensselaer, Mariana Griswold. "The Philadelphia Exhibition.—II." *American Architect and Building News* 8, no. 261 (December 1880).

Walker, Peter F. *Moral Choices: Memory, Desire, and Imagination in Nineteenth-Century American Abolition*. Baton Rouge: Louisiana State University Press, 1978.

Wallace, Maurice O., and Shawn Michelle Smith, eds. *Pictures and Progress: Early Photography and the Making of African American Identity*. Durham, NC: Duke University Press, 2012.

Walsh, Megan. *The Portrait and the Book: Illustration and Literary Culture in Early America*. Iowa City: University of Iowa Press, 2017.

Watt, Ian. *The Rise of the Novel: Studies in Defoe, Richardson, and Fielding*. Berkeley: University of California Press, 1957.

Webb, Frank J. *The Garies and their Friends*. 1857. Baltimore: Johns Hopkins University Press, 1997.

Wendorf, Richard. *The Elements of Life: Biography and Portrait-Painting in Stuart and Georgian England*. Oxford: Clarendon Press, 1990.

Werbel, Amy. *Thomas Eakins: Art, Medicine, and Sexuality in Nineteenth-Century Philadelphia*. New Haven, CT: Yale University Press, 2007.

Wharton, Edith. *The House of Mirth*. New York: Penguin Classics, 1993.

Whitman, Walt. "Personalism." *The Galaxy* 5 (May 1868): 540–47.

———. "A Visit to Plumbe's Gallery." *Brooklyn Daily Eagle* 2 July 1846. *Brooklyn Daily Eagle Online*. Reference URL: http://bklyn.newspapers.com/image/50242631 (Accessed August 1, 2014).

Williams, Megan Rowley. *Through the Negative: The Photographic Image and the Written Word in Nineteenth-Century American Literature*. New York: Routledge, 2003.

Williams, Susan S. *Confounding Images: Photography and Portraiture in Antebellum American Fiction*. Philadelphia: University of Pennsylvania Press, 1997.

Willis, Deborah. *Reflections in Black: A History of Black Photographers, 1840 to the Present*. New York: W. W. Norton and Company, 2000.

Willis, Richard. "Intolerance of Colored Persons in New York." *Musical World and New York Times*, December 17, 1853, 122–23.

Wilson, Elizabeth. *Psychosomatic: Feminism and the Neurological Body*. Durham, NC: Duke University Press, 2004.

Wilson, Ivy. *Specters of Democracy: Blackness and the Aesthetics of Politics in the Antebellum U.S.* New York: Oxford University Press, 2011.

Winner, Viola Hopkins. *Henry James and the Visual Arts*. Charlottesville, VA: University of Virginia Press, 1970.

Womack, Autumn. "Visuality, Surveillance, and the Afterlife of Slavery." *American Literary History* 29, no. 1 (Spring 2017): 191–204.

Wood, Marcus. *Blind Memory: Visual Representations of Slavery in England and America, 1780–1865*. Manchester, UK: Manchester University Press, 2000.

Woodall, Joanna, ed. *Portraiture: Facing the Subject*. Manchester, UK: Manchester University Press, 1997.

Woodward, William R. *Hermann Lotze: An Intellectual Biography*. New York: Cambridge University Press, 2015.

Yellin, Jean Fagan. *Harriet Jacobs: A Life*. New York: Basic Civitas Books, 2004.

Young, Harvey. *Embodying Black Experience: Stillness, Critical Memory, and the Black Body*. Ann Arbor, MI: University of Michigan Press, 2010.

Young, Robert M. *Mind, Brain and Adaptation in the Nineteenth Century: Cerebral Localization and Its Biological Context from Gall to Ferrier*. Oxford: Clarendon Press, 1970.

Index

portraiture representing inner life (cont.)
111–19, 170n10; conveying intelli-
gence and, 76, 83–84; expression and,
5–6, 17, 18–19, 20–21, 39, 41, 82, 120,
152, 153, 159n4, 159n6; vs. external
life, 4–5, 6, 17, 160nn11–12; hidden
truth and, 8, 12, 16, 17, 18, 30, 38, 42,
43, 44–45, 71, 111; inner vs. outer
"subject" and, 34–35, 38, 39, 42, 49,
138, 150; literature and, 1–2, 12, 20,
30, 34–36, 38–39, 42, 44, 45–47,
111–19, 135, 175n36; mind and body
and, 79, 81–82, 83, 88, 91–93, 94–96,
97–99, 101–6, 111–19, 135, 137, 138,
171n27, 171n31, 174n16; as not
representing inner life and, 112,
120–23, 124, 127, 129, 159n4;
photography and, 3, 7–8, 15, 16, 39,
42, 47, 66, 157n6; portraiture
aesthetics and, 8, 15, 27, 34–35, 110,
111, 119; sitters "lost in thought" and,
27–29, 79, 81, 82, 83, 88, 99, 100–103,
170n10; X-ray technology and, 140,
150. *See also* portraiture aesthetics;
portraiture characteristics;
psychology of portraiture
Post, Amy, 66, 67, 68
Prichard, James C., 49
print culture, 29, 30, 162n28; fugitive
advertisements and, 54–62
"Prophetic Pictures, The" (Hawthorne),
36–39, 44, 120, 163n50
"pseudo" science. *See* automatism;
cerebralists; electrical psychology;
mesmerism; phrenology;
physiognomy
psychoanalysis, 10, 112, 113, 173n45
"Psychological Counter-Current in
Recent Fiction, A" (Howells), 132–33
"psychologism", 133
psychology: automatism and, 88–89, 96,
97, 99, 110; bodily gesture and, 83, 87,
116–17; emotion and, 114–15, 116–17,
118–19, 159n4; human mind and, 9,
20–21, 22–23, 24, 79, 81, 87, 88–90,

93, 160n13, 161n17, 161n25; intro-
spection and, 22–23, 24, 26–27, 89,
92–93, 96, 102, 170n22; mind and
body and, 81–82, 89–90, 93–94, 106,
112, 119, 152, 172n36, 174n16;
"phantom limbs" and, 81, 95, 171n31;
physiology and, 88, 89, 99, 111–12,
113, 116–17, 137; "pseudo" science
and, 7, 9–10, 24–27, 97, 113, 161n26,
171n32; racism and, 80–81, 97, 98, 99,
171n32, 172n34, 172n36; scientific
enquiry and, 21, 22, 24, 25; somatic
mind and, 6–7, 21, 82, 88, 96, 97,
104–5, 106, 113, 115, 173n45. *See also*
consciousness; psychology discipline
development; psychology of portrai-
ture; selfhood; subjectivity
Psychology, or a View of the Human Soul
(Rauch), 23–24
Psychology, or Elements of a New System
(Schmucker), 23
psychology discipline development,
160–61n15, 173n45; definition and use
of word and, 8–9, 19, 21, 158n18,
159–60n7; early ideas and, 17, 18,
21–24, 89–90; emergence through
portraiture and, 4–5, 8, 9, 11–12, 17,
19–20, 26–27, 42, 79–80, 104–6, 119,
124, 160n8; modern developments
and, 6–7, 112; *Portrait of a Lady*
revisions and, 112, 113; shift from
"soul" to mind and, 9–10, 157n11,
160n13
"Psychology of Controversy, The"
(address, Boring), 22
psychology of portraiture: development
of and, 27–29, 132, 133, 135–36; the
face and, 107–9, 119, 130–31;
modernism and, 109–10, 137;
psychology made visible and, 4–5, 8,
9, 11–12, 17, 19–20, 26–27, 42, 79–80,
104–6, 119, 124, 160n8; psychology of
author through portrait and, 31,
33–34; recursive nature of portrait
and, 16–17, 159n4; selfhood and, 2–3,

slavery (cont.)
 psychology and, 97, 98; published
 narratives of and, 65, 66–68, 167n33,
 167n35; slave auctions and, 54–56, 69,
 167n41; text of fugitive advertise-
 ments and, 54, 60–62, 67–68, 69,
 165n19, 166n23
Smibert, John, 46
Smith, James McCune, 50
Smith, Shawn Michelle, 10
soul, 21, 23–24, 89
Southworth and Hawes studio, 30
"Special Type, The" (James), 111,
 124–27, 175n26, 175n28
Spencer, Herbert, 10, 113
Spitzka, Edward Anthony, 107–8,
 109–10
Stewart, Maria, 48
St. Louis Republican, 57
"Story of a Masterpiece, The" (James),
 111, 120–22, 123, 124
stream of consciousness, 110, 111,
 174n8
Stuart, Gilbert, 37–38, 163n50
subjectivity, 2, 6, 13, 27, 103, 156; Black
 writers and, 49, 51, 72; human mind
 and, 9, 115, 136; mind and body and,
 104, 106; photographic portraits and,
 14–15, 157n6; portraits and literature
 and, 20, 47, 127, 129; X-ray technol-
 ogy and, 137–38
Sully, Thomas, 63
"Sweetheart of M. Briseux, The"
 (James), 111, 134–35, 175n36

Tableaux vivants, 1–2
Taylor, Charles, 109
Techniques of the Observer (Crary), 77
"Therapeutic Uses of the X-Ray, The",
 140
Thinker, The (portrait, Eakins), 83, 85,
 102–4
Thompson, Cephas, 29, 31–33, 34
Thomson, Elihu, 145, 146
Ticknor, George, 32–33

"Tone of Time, The" (James), 111,
 127–30
Transcendental philosophy, 23
Trilling, Lionel, 8
Tuckerman, Henry, 35–36
Twice-Told Tales (Hawthorne), 31
Types of Mankind (Nott and Gliddon), 52

United States Magazine and Democratic
 Review, The, 23
U.S. Army Hospital for Injuries and
 Diseases of the Nervous System, 81

Van Buren, Amelia, 84, 99–102, 104,
 172nn37–38
"Visit to Plumbe's Gallery, A" (review,
 Whitman), 7
visual technologies. See daguerreotype
 photography; photography; portrai-
 ture characteristics; selfies; X-ray
 technology

Watson, Eva Lawrence, 99–100
Wear and Tear (Mitchell), 94
Webb, Frank J., 49, 51, 74, 76, 77,
 168n48, 168n50
Webster, Daniel, 25
Wedgwood, Josiah, 98
Wharton, Edith, 1
"What is an Emotion?" (W. James),
 116–17
Whistling for Plover (painting, Eakins),
 80–82, 90, 92, 94–95, 97–98, 104, 105,
 169nn4–5, 170n6
Whitman, Walt, 7–8, 122–23, 124
Whytt, Robert, 21, 160n13
Willis, Imogen, 66, 67, 69
Willis, Mary Stace, 67
Willis, Nathaniel Parker, 66
Willis, Richard, 66–67
Wings of the Dove, The (James), 111
Womack, Autumn, 11
Wood, George, 86–87
Wood, Marcus, 54, 55, 57, 165n19
Woodall, Joanna, 25

woodcuts, 30
"Work of Art in the Age of Mechanical Reproduction" (Benjamin), 13–14
Wundt, Wilhelm, 22

X-ray technology, 3–4, 12; body as inert and, 138, 145, 150, 151–53, 176n8; diagnostic uses of and, 140–41, 145, 149–50, 152; experiments with and, 145, 146–49, 150, 152; the hand and, 144–45, 151–52; harmful effects and, 145, 146–48, 150, 152, 153; impact on art and culture and, 139–40, 151–52, 176n3; impact on race and gender and, 141, 143–45, 148–49, 176n9; portraiture and inner life and, 140, 150; skin and, 141, 148–49, 151; subjectivity and, 137–38

Yellin, Jean Fagan, 63